What Architects Cook Up

Architekten kochen

Edition **DETAIL**

SIEMENS

Inhalt
Content

Alle Rezepte sind für 4 Personen, wenn nichts anderes angegeben. All recipes serve 4 persons, unless stated otherwise.

Vorwort

»Schreiben Sie Einkaufszettel?«, fragte mich Herman Hertzberger, der bekannte Architekt aus Amsterdam. Als Architekturstudent durfte ich ihn einige Tage durch München führen. Damals wie heute war ich wesentlich erfahrener als Koch denn als Architekt, und so redeten wir über Parallelen zwischen Haus- und Speisenbau. Hertzberger sah den Bummel über den Markt als Weg zum Entwurf. Natürlich wird ein Gericht auf dem Teller sehr davon beeinflusst, ob Sie mit einem fertigen Einkaufszettel – also mit einem Plan – losgehen oder nicht. Doch schon bevor Sie einen Einkaufszettel schreiben, sollten Sie für ein gelungenes Essen zuerst die Randbedingungen untersuchen: Wer isst mit? Kennen Sie die Vorlieben Ihrer Gäste? Wie viel Zeit haben Sie für die Vorbereitung? Welche soziale Wirkung möchten Sie mit dem Essen fördern – vielleicht Respekt und intellektuelle Anregung, ein entspanntes Gruppengefühl oder gar Vertrauen und erotische Anziehung?

Für ein aufwändig gegartes Fleischgericht ernten Sie sehr wahrscheinlich Bewunderung. Wenn Sie zusätzlich ein bekanntes Rezept ungewöhnlich interpretieren, schaffen Sie ein Gesprächsthema – probieren Sie die »dekonstruierte Schlachtschüssel« auf Seite 106. Für die klassische berufliche Einladung – »Schaaatz, heute Abend kommt mein Chef!« – ist ein traditioneller Braten sicher besser geeignet. Zur Schau gestellte kulinarische Kompetenz könnte Konkurrenzverhalten auslösen. Bei einem einfachen Gericht aus warmen, weichen Kohlenhydraten entspannt sich die Gruppe. Denn Nudeln, Reis oder Püree erinnern uns an die frühe Kindheit, als jeder Löffel Brei ein unmittelbarer Ausdruck der Mutterliebe war. Hier wären die Tortellini auf Seite 62 eine gute Wahl. Die Zubereitung der gefüllten Nudeln erfordert Ihren liebevollen Einsatz, für Ihre Gäste ist das Gericht jedoch ohne Anstrengung zu verstehen: Tortellini kennt jeder und sei es als Fertigprodukt. Die zunehmende Beliebtheit solch amorpher Gerichte – dazu gehören auch Risotto, Sushi oder Burger – spiegelt Veränderungen in unserer Gesellschaft: Deutliche Hierarchien nehmen ab, soziale Netzstrukturen wachsen. Das alte Muster für ein vollwertiges Essen war streng gegliedert: Fleisch + zwei Beilagen + Sauce. Es passte gut zur rituellen Mahlzeit in der traditionellen Familie. Da, wo der Patriarch den Braten schneidet, haben Tortellini keinen Platz.

Foreword

"Do you write shopping lists?" Herman Hertzberger, the well-known architect from Amsterdam, asked me. When I was an architecture student I had the privilege of showing him around Munich for a few days. In those days just like now I had a lot more experience as a cook than as an architect, and so this got us talking about the parallels between constructing houses and preparing meals. Hertzberger viewed the stroll through the market as the planning stage. Of course the dish on the plate will obviously be affected by whether or not you started with a finished shopping list – that is to say a plan – or not. But even before jotting down a shopping list, you should first think about the basic requirements for a successful meal: Who will be eating with us? Do you know your guests' preferences? How much time do you have for the preparation? Which social effect do you want to achieve with this meal – respect und intellectual stimulation perhaps, a relaxed feeling as a group or even trust and erotic attraction?

For an impressively cooked meat dish you will very probably win admiration. If, in addition, you interpret a well known recipe in an unconventional way, then you will have something to talk about – try the "deconstructed Schlachtschüssel" on page 106. For the classic professional invitation– "Daaarling my boss is coming this evening" – a traditional roast is certainly more suitable. Showing off with culinary competence could trigger rivalry. With a simple dish of warm, soft carbohydrates the group will relax. Because noodles, rice or mashed potatoes remind us of our early childhood, when every spoonful of cereal was the immediate expression of motherly love. Here the tortellini on page 62 would be a good choice. Preparing the filled noodles requires your loving efforts but for your guests this dish will be seen as something effortless: Everyone knows tortellini, if only as a ready-to-eat meal. The increasing popularity of such amorphous meals – which also include risotto, sushi or burgers – reflects our changing society: Clear hierarchies are declining, social network structures are growing. The old model for a complete meal was strictly arranged: meat + two side dishes + sauce, it suited the ritual meal in the traditional family. There where the patriarch carves the joint, tortellini have no place.

Solche Überlegungen helfen Ihnen, zuerst einmal die richtige Art von Speisen für jede Situation zu finden. Besonders wichtig ist diese kulinarische Grundlagenanalyse für die Lösung von komplexen Aufgaben, wie zum Beispiel der Menüplanung für ein Rendezvous. Oder für ähnliche Situationen, in denen sich eine anfangs instabile Beziehung sehr dynamisch in verschiedene Richtungen entwickeln kann. Weder Küche noch Architektur bestimmen die menschliche Kommunikation, aber beide tragen sehr viel dazu bei.

Wählen Sie also ein geeignetes Gericht. Legen Sie zuerst nur die grobe Richtung fest, so wird sich Ihr Entwurf während des Einkaufs weiter verfeinern, weil Sie das lokale Angebot einbeziehen können. Wenn Sie der Jahreszeit gemäß die frischesten, besten und geschmackvollsten Zutaten wählen, gewinnt das Gericht nicht nur an Geschmack, sondern auch an Tiefe und an Eindeutigkeit. Zu diesem »offenen Einkauf« gehört ein möglichst umfassendes Wissen über die Zutaten und ihre Verarbeitung. An seinem Ende steht ein eigener Rezeptentwurf.

Hertzberger faszinierte an dieser Methode vor allem der Gedanke einer »Befreiung durch das hässliche Rezept«: Eine schöne Skizze kann den Architekten dazu verführen, sich an äußere Formen zu binden und dabei die gleichwertige Entwicklung aller Aspekte einer Bauaufgabe aus den Augen zu verlieren. Kochrezepte sind keine Gedichte, ihr poetischer Charme gleicht dem einer Bedienungsanleitung. Der Koch bleibt deshalb frei von der verflachenden Vereinfachung des schönen Scheins. Was zählt, liegt auf dem Teller und dort ergänzen Duft, Temperatur und Textur die einseitige Wahrnehmung unserer überstrapazierten Augen.
Kengo Kuma löst das Problem mit einer Skizze, die sein kulinarisches Konzept für die japanischen Sobanudeln auf Seite 68 verdeutlicht: Ihm geht es um den Kontrast zwischen neutralen Nudeln und konzentrierter Brühe. So wirkt seine Zeichnung erst auf den zweiten Blick ästhetisch.

Kochen ist einfach, jedenfalls viel einfacher als bauen. Und gerade deshalb können wir Rezeptentwürfe untersuchen, um die Vorgänge auf dem Weg zu einem guten Gebäude zu beleuchten. So stand am Beginn dieses Buchprojektes eine Frage: Was sagt uns die Rezeptkomposition eines Architekten über seine Entwurfsmethoden für komplexe Bauaufgaben?

Such considerations will help you, to begin with, to find the right type of food for every occasion. This culinary analysis of the fundamental basis is especially important to solve complex tasks, such as planning the menu for a date. Or for similar situations where a relationship which is a bit shaky to start with can develop very dynamically in various directions. Neither cooking nor architecture determines interpersonal communication, but both of them make an important contribution to it.

So choose a suitable dish. Start off by deciding the overall direction, then during shopping the plan will become more refined because you can include local produce. If you choose the freshest, best and tastiest ingredients, according to what is in season, then the meal will not only gain in flavour but also in depth and uniqueness. For this "open shopping" one needs a fairly comprehensive knowledge about ingredients and how to prepare them. By the end of your shopping a recipe plan will have been worked out.

What fascinated Hertzberger more than anything else about this method was the idea of "liberation by the nasty recipe": A beautiful sketch can entice the architect into tying himself down to external forms and, in so doing, he loses sight of the equally important development of all aspects of a construction assignment. Cooking recipes are not poems and their poetic charm is like that of an instruction manual. Therefore the cook remains free from the superficial generalisation of something which looks beautiful. That which counts is lying on the plate and the smell, temperature and texture complement our one-sided perception with our overworked eyes.
Kengo Kuma solves the problem with a sketch, which explains his culinary concept for the Japanese soba noodles on page 68: for him the contrast is important between the neutral noodles and the concentrated soup. It is only at second glance that the drawing is aesthetic.

Cooking is simple, at any rate much simpler than building. And that's the very reason we can examine recipes to illuminate the processes leading to a good building. At the beginning of this book project the question was asked: What does an architect's recipe composition tell us about his planning methods for complex construction tasks?

Besonders deutlich haben die Architekten von Ensamble Studio in Madrid auf Seite 16 diesen Zusammenhang dargestellt. Konsequent sehen sie den Beginn der Architektur im Steinbruch und den Beginn eines jeden Schweinebratens im Schlachthof. Das Schmorhuhn der Stuttgarter Architekten Schwarz.Jacobi auf Seite 100 erinnert mich an strukturalistische Bauwerke von Herman Hertzberger, wie das Centraal-Beheer-Gebäude in Apeldoorn. Es ähnelt einem Rohbau, der von seinen wechselnden Nutzern sehr unterschiedlich gestaltet werden kann. Und genauso ist das Rezept offen für die Einflüsse des Landes, in dem es gekocht wird: In Frankreich schmort das Huhn in Rotwein, in Italien eher mit Tomaten, in Spanien kommen Paprika-schoten und Sherry dazu, nahe dem Elsass prägen Speck und Rahm die Sauce. Eine Grundstruktur passt sich regionalen Gegebenheiten an und wird in ihrer Ausführung jedes Mal anders ausfallen. In Vietnam, China oder Thailand gehört sogar der Akt des Essens zu einem offenen Entwurfsvorgang. Dort kommen mehrere Gerichte gleichzeitig in die Mitte des Tischs, sodass der Gast mit jedem Bissen über die Kombination der Speisen in seinem Mund schöpfe-risch bestimmt. So vollendet jeder Teilnehmer sein eigenes Menü, ähnlich wie das Centraal-Beheer-Gebäude sich erst im Gebrauch immer wieder neu definiert.

Eine andere Strategie verfolgt Julia Beer mit einer Lichtskulptur zwi-schen Kochkunst und Mikroarchitektur: Ihre Kroepoek-Leuchte auf Seite 24 scheint auf den ersten Blick nur zufällig essbar zu sein, Farb- und Formwirkung könnten auch mit Schaumstoffen und bun-tem Glas erzeugt werden. Aber in dem Moment, in dem Betrachter an der Lampe knabbern und die Diffusoren dippen, verändert sich nicht nur das Licht, sondern auch die Beziehung zwischen Licht, Raum und Mensch.

Eine zweite wichtige Parallele zwischen Architektur und Kochen betrifft unsere Wahrnehmung der beiden Künste: Dach und Feuer befriedigen unsere Grundbedürfnisse nach Wohnung, Nahrung und Wärme seit Beginn der Zivilisation. Haustypen und regionale Rezepte entwickelten sich über Jahrtausende durch Versuch und Irrtum, ohne bewussten Entwurf. Kein Wunder also, dass viele Menschen Ver-änderungen in Architektur und Küche äußerst misstrauisch betrach-ten. Das frei stehende Haus mit Satteldach und die Rindsroulade mit Kartoffelpüree sind bei uns nach wie vor die beliebtesten Erzeugnisse der beiden Disziplinen, obwohl unsere dicht bevölkerte Welt in beiden Bereichen neue Wege erzwingt.

The architects from Ensamble Studio in Madrid made the connection particularly clear on page 16. They show consistency in viewing the beginning of architecture in the quarry and the beginning of roast pork in the abattoir. The Stuttgart architects Schwarz.Jacobi's recipe for the chicken on page 100 reminds me of structuralist buildings by Herman Hertzberger, such as the Centraal Beheer building in Apeldoorn. It resembles a shell construction, which can be made to look different by its varying users. And in exactly the same way the recipe is open for influences from the country in which the cooking takes place: in France they braise chicken in red wine, in Italy they prefer it in tomatoes, in Spain it's peppers and sherry, near Alsace bacon and cream are noticeable in the sauce. A basic framework can be adapted to regional conditions and it will appear different every time. In Vietnam, China or Thailand the act of eating is even part of a joint design process. There several dishes are on the table simulta-neously, so with every bite the guest decides creatively about the combination of foods in his mouth. Thus every participant completes his own menu – similar to the way, once it is in use, the Centraal Beheer building defines itself anew over and over again.

Julia Beer follows a different strategy with a light sculpture between cookery and micro architecture: at first glance her Kroepoek light on page 24 only seems to be edible by chance, the colour and form effects could also be produced with foam rubber and coloured glass. But at that moment when the observers nibble at the lamp, and dip the diffusers, then not only does the light change but also the relation-ship between light, room and people.

A second important parallel between architecture and cooking con-cerns our perception of the two art forms: roof and fire have satisfied our basic needs for housing, food and warmth since the beginning of civilisation. Types of housing and regional recipes have developed by trial and error over thousands of years, without conscious planning. No wonder then that many people are extremely suspicious of changes in architecture and cooking. Where we live the detached house with a gable roof and the beef roulade with mashed potato are still the most popular products in the two disciplines, although our densely populated world is forcing us along new paths in both areas.

Doch welche Lösungen können wir akzeptieren? Amandus Sattler bedauert, dass selbst kleine Veränderungen im gewohnten System der Wohnformen kaum angenommen werden. Das »Haus der Gegenwart« beispielsweise ist ein Prototyp für flexibles Wohnen. Der Entwurf von Amandus Sattler und seinen Partnern Markus Allmann und Ludwig Wappner wird zwar hoch gelobt, das Haus jedoch selten bewohnt und bisher nicht nachgebaut. Während wir beim Essen, so Sattler, »die leichten Irritationen lieben, die uns verführen und mit der Zunge schnalzen lassen ...«. Sein Münchner Kollege Andreas Hild entgegnet: »Niemand würde guten Köchen oder Architekten die Lust am Experimentieren nehmen wollen. Aber nur für die Küche scheint es einen unausgesprochenen Konsens zu geben, was geht und was nicht. Selbst die wilden Spanier kochen nichts wirklich Ungenießbares. Mich interessiert, ob diese Beschränkung Kreativität übehaupt erst möglich macht.«

Meiner Meinung nach führt jede überwundene Beschränkung zu einem vielschichtigeren Entwurf. Die Kunst in der Küche und in der Architektur liegt darin, Genießern mit äußerst unterschiedlichen Erwartungen anregende Irritationen zu servieren.

Doch an manchen Tagen wollen wir keine neuen Erlebnisse, jede Anregung scheint uns unzumutbar zu sein. Dann muss ein Pudding auf den Tisch. Der ist nach fünf Minuten aufgegessen, und danach ist wieder Raum für neue Experimente. Das ist das Schöne am Kochen.

Ihr Hans Gerlach
München, August 2007

But which solutions can we accept? Amandus Sattler regrets that even small changes in the usual system of housing types find little acceptance. The "Haus der Gegenwart" (house of the present) for example is a prototype for flexible living. Amandus Sattler and his partners Markus Allmann and Ludwig Wappner's design is certainly highly praised, but the house is seldom lived in and so far this building has not been copied. Whilst during a meal we, in Sattler's words, "love the slight provocations which seduce us and allow us to click our tongues in approval ...". His Munich colleague, Andreas Hild, responds: "Nobody wants to deny good cooks or architects the pleasure of experimenting. But it is only in cooking that there seems to be a tacit consensus, of what is and what is not possible. Even the unruly Spaniards do not cook really unpalatable things. What interests me is whether it is even this constraint which makes creativity possible in the first place."

In my opinion every barrier which is overcome leads to a more complex design. In both cooking and in architecture the skill lies in serving exciting provocations to gourmets with widely differing expectations.

But there are some days when we don't want any new experiences, we find every stimulus unacceptable. Then we need custard. After five minutes it has been eaten and then there is room again straightaway for new experiments. That is the good thing about cooking.

Yours, Hans Gerlach
Munich, August 2007

VORSPEISEN
Starters

Ingwerwaffeln
mit Räucherlachs

Patricia & John Patkau, Vancouver

Zutaten für 8 Waffeln

150 g Mehl, 75 g Stärke, 1 TL Backpulver
1 TL Zucker, 2 Eier, 250 ml Buttermilch, 125 ml Sahne
1 EL Öl und etwas Öl für das Waffeleisen
1 Bund Frühlingszwiebeln, Salz, Pfeffer
4 cm Ingwerwurzel, 250 g geräucherter Lachs
100 g Creme fraiche, 100 g Frischkäse
16 Kapuzinerkresseblüten

Außerdem: ein Waffeleisen

1. Für die Waffeln Mehl, Stärke, Backpulver und Zucker mischen. Eier, Buttermilch, Sahne und Öl verrühren und mit den trockenen Zutaten vermengen. Frühlingszwiebeln waschen und welke Blätter entfernen. Eine der Frühlingszwiebeln in feine Ringe schneiden. Ingwer schälen, fein hacken und mit den Frühlingszwiebeln unter den Teig rühren. Den Waffelteig mit Salz und Pfeffer abschmecken.

2. Das Waffeleisen vorheizen und leicht ölen. 2–3 EL Teig darauf verstreichen. Die Waffel ca. 2 Minuten goldbraun backen. So oft wiederholen, bis der Teig aufgebraucht ist, insgesamt sollte die Masse für ungefähr 8 Waffeln ausreichen. Die fertigen Waffeln in ein Küchentuch schlagen und 10 Minuten ruhen lassen.

3. Die einzelnen Blätter der restlichen Frühlingszwiebeln vorsichtig abziehen und einige Sekunden in kochendem Wasser garen. Die Blätter in kaltem Wasser abschrecken und auf einem Küchentuch trocknen. Den geräucherten Lachs in breite Streifen schneiden. Creme fraiche und Frischkäse glatt rühren, mit Salz und Pfeffer würzen. Die Waffeln halbieren, mit der Frischkäsecreme bestreichen und mit Lachsscheiben belegen. Die Waffeln einrollen und mit je einem Frühlingszwiebelblatt vorsichtig zubinden. Die Waffeln mit Kapuzinerkresseblüten garnieren und anrichten.

Ginger waffles
with smoked salmon

Patricia & John Patkau, Vancouver

Ingredients for 8 waffles

150 g flour, 75 g cornflour, 1 tsp. baking powder
1 tsp. sugar, 2 eggs, 250 ml buttermilk, 125 ml cream
1 tbsp. oil and some oil for the waffle iron
1 bunch of spring onions, salt, pepper
4 cm of ginger root, 250 g smoked salmon
100 g crème fraîche, 100 g cream cheese
16 nasturtium blossoms

In addition: a waffle iron

1. To prepare the waffles mix flour, cornflour, baking powder and sugar. Mix eggs, buttermilk, cream and oil and stir in with the dry ingredients. Wash spring onions and remove faded leaves. Cut one of the spring onions into thin rolls. Peel ginger, chop finely and stir into the dough with the spring onions. Season the dough with salt and pepper.

2. Preheat the waffle iron and grease it a little. Spread 2–3 tbsp. dough onto it. Bake the waffle for about 2 minutes until it is golden brown. Repeat this until the dough is all used up. It should be sufficient for about 8 waffles. Wrap the baked waffles in a kitchen towel and leave for 10 minutes.

3. Take the single leaves off the remaining spring onions carefully and boil the leaves in water for several seconds. Rinse them with cold water and dry on a kitchen towel. Cut the smoked salmon into broad strips. Stir crème fraîche and cream cheese until smooth and season with salt and pepper. Cut the waffles in half, spread them with the cheese mixture and fill with the salmon slices. Roll waffles up and carefully tie each one shut with a spring onion leaf. Finally garnish with the nasturtium blossoms and arrange the dish.

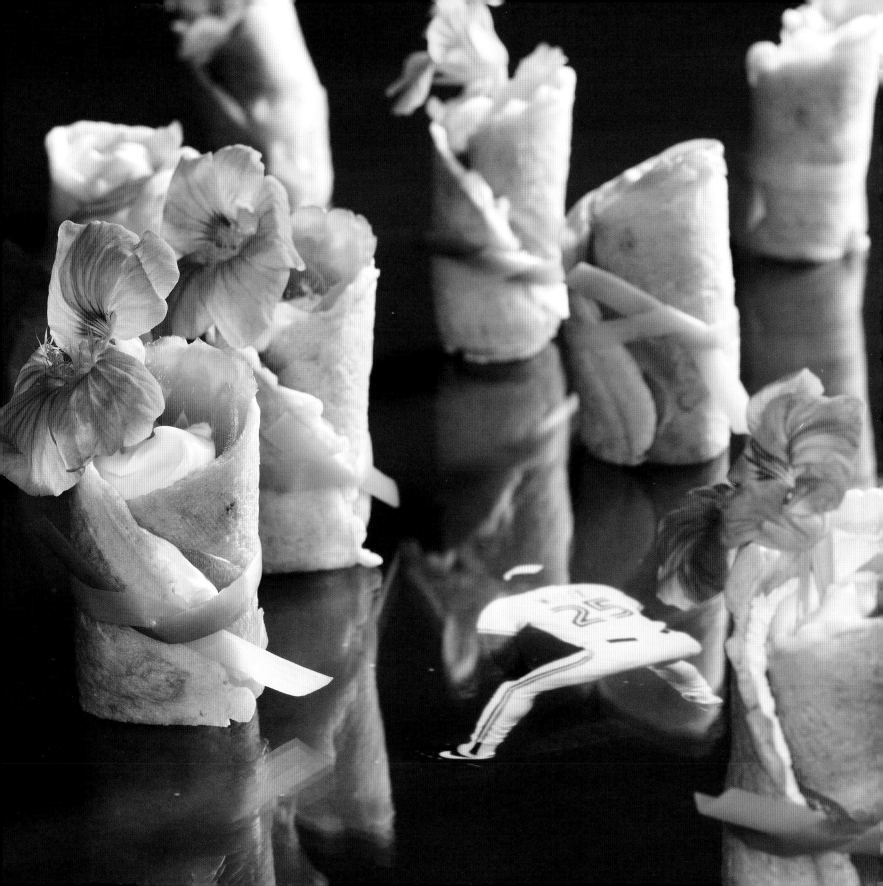

Sørensen's Garten-Brunch

Patkau Architects aus Vancouver gehören zu den renommiertesten Architekten Kanadas. Ihre Bauten zeichnen sich durch expressive Formen aus. Arbeitsmethodik und Entwurfsprozess des Büros basieren auf der Auseinandersetzung mit den Besonderheiten des Ortes. Dabei beziehen die Architekten sich nicht nur auf das unmittelbare gebaute Umfeld, sondern auch auf regionale und kulturelle Unterschiede in Nordamerika sowie den Kontrast zwischen der Dichte der Städte und der Weite des Landes.

So hat John Patkau auch bei der Auswahl der Zutaten für sein Rezept das Hauptaugenmerk auf die regionalen Bezüge gelegt. Wie er selbst von sich behauptet, ist er kein besonders guter Koch. Er liebt es aber, Rezepte zu durchstöbern, mit Essen zu experimentieren und für Freunde zu kochen, wenn es seine Zeit erlaubt. Der im Rezept verwendete Lachs beispielsweise ist fast schon ein Grundnahrungsmittel in British Columbia. Bei einem Abendessen mit Freunden sagte sogar einmal eine Bekannte Patkaus, sie würde auch gerne zum Essen kommen, ohne dass er jedes Mal Lachs serviere. Bei dem Rezept hat John Patkau versucht, drei landestypische Dinge zu vereinen. Erstens: Lachs zu verwenden, der aus den Küstengewässern stammt, zweitens, einen leichten asiatischen Einfluss zu integrieren, da mehr als ein Drittel der Einwohner der Provinz British Columbia asiatischer Abstammung ist, und drittens, einen visuellen Eindruck zu hinterlassen. Für die Präsentation seiner Ingwerwaffeln mit Räucherlachs spannt er den Bogen gekonnt zur Landschaftsarchitektur, indem er durch die Form der aufgestellten Waffeln eine Verbindung zur Kleingartenanlage des dänischen Landschaftsarchitekten Carl Theodor Sørensen herstellt. Die 1952 gestalteten Parzellen dieser Anlage haben alle eine ovale Form, eingefasst von einer Laubhecke. Und vergleicht man den Plan mit den Waffelformen, so besteht tatsächlich eine Ähnlichkeit! Schöne Gärten, interessante Architektur, gutes Essen und die Mischung kanadischer Kultur – das sind die Zutaten, aus denen »Sørensen's Garden Brunch« entstand. Um der Besonderheit der Gartenanlage gerecht zu werden, schlägt John Patkau vor, den Plan auf einem sehr großen Tisch auszubreiten, auf den einzelnen Gärten je eine Waffel zu platzieren und mindestens 80 Verwandte, Bekannte und Freunde einzuladen.

»Reicht Ihr Tisch nicht aus, dann machen Sie nur so viele Waffeln wie Sie Freunde einladen möchten, aber vergessen Sie nicht, zumindest einen Ausschnitt des Gartenplans zu präsentieren.«
John Patkau

Sørensen's Garden Brunch

Patkau Architects from Vancouver are amongst the most renowned architects in the whole of Canada. Their buildings are distinguished by their expressive forms. The working methods and the design process of this office are based on dealing with the special features of the location. At the same time the architects not only refer to the immediate building area but also consider regional and cultural differences in North America as well as the contrast between the density of the cities and the vastness of the country.

So in compiling and selecting the ingredients for his recipe John Patkau also focused his attention on regional considerations. He himself claims that he is not a particularly good cook. But he loves leafing through recipes, experimenting with food and cooking for friends – when time permits. The salmon used in the recipe, for example, is more or less a staple food in British Columbia. At one dinner with friends one of Patkau's acquaintances even said she would also enjoy coming to dinner if for once he did not serve salmon. In compiling the recipe John Patkau tried to combine three things which are typical for his country. First: Use salmon which comes from the coastal waters, secondly integrate a light Asian touch, since more than a third of the people living in the province of British Columbia are of Asian descent, and thirdly leave behind a visual impression. For the presentation of his ginger waffles with smoked salmon he cleverly spans the bow to landscape architecture as he connects the form of the waffle arrangement with a particular garden by the Danish landscape architect Carl Theodor Sørensen. In 1952 the latter designed an allotment area whose plots have an oval shape bordered by a leafy hedge. And if you compare the layout plan with the shape of the waffles there is indeed a resemblance! Beautiful gardens, interesting architecture, good food and the mixture of Canadian culture – those are the ingredients from which "Sørensen's Garden Brunch" originated.

To do justice to the special feature of the garden John Patkau suggests spreading out the layout plan on a very large table, putting a waffle on each separate garden and inviting at least 80 relatives, acquaintances and friends.

"If you do not have such a large table then just make as many waffles as the number of friends you wish to invite but don't forget to at least present a section of the garden plan for all in the room to see."
John Patkau

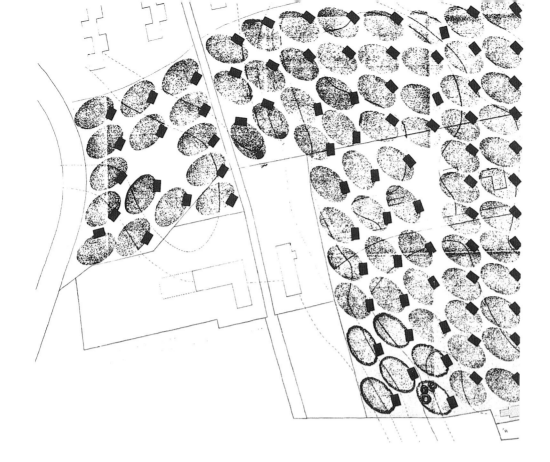

Patkau Architects, John Patkau
Strawberry-Vale-Schule, British Columbia, 1996
Öffentliche Grundschule, die die Betreuung vom
Kindergarten bis zur 6. Klasse umfasst. Der
Neubau ergänzt eine bestehende Schulanlage.

Patkau Architects, John Patkau
Strawberry Vale School, British Columbia, 1996
Public primary school which caters for children
from kindergarten up until the sixth grade. The
new building is an extension to the existing
school premises.

Torre Z-N-O

Antón García-Abril, Madrid

1 kg Spanferkelrippchen
500 g Schweineschmalz oder Öl
Salz, Pfeffer

Die Spanferkelrippchen entlang der Knochen in einzelne Stücke schneiden. Das Schmalz in einem flachen Topf erhitzen. Spanferkelrippchen in heißem Öl oder Schweineschmalz 10–15 Minuten braten, bis sie knusprig braun sind. Vorsicht, das Fett kann spritzen! Torreznos mit Salz und Pfeffer kräftig würzen und mit Brot servieren.

Tipp

Das Fleisch von Spanferkeln ist besonders zart, Rippchen von größeren Tieren sollten Sie etwa eine Stunde lang in Salzwasser knapp unter dem Siedepunkt garen, gut abtropfen lassen und dann erst braten oder grillen. Dazu passen würzige Dips, wie zum Beispiel eine scharf-säuerliche Koriandersalsa: 1 TL Kreuzkümmel rösten und mit 3–4 grob gehackten, milden Peperonischoten, 1 Tomate und 1 TL Salz in einem großen Mörser (oder im Blitzhacker) zerkleinern. 3 Bund Koriander zupfen, die Korianderwurzeln hacken und mit 2 EL Zitronensaft in den Mörser geben, zu einer Paste zerstoßen und mit den Torreznos servieren.

Tapas zur Projektbesprechung

»Wegen der langen Zeitspanne zwischen Frühstück und Hauptmahlzeit, die in Spanien eigentlich erst frühabends gegessen wird, ist es bei den Mitarbeitern in unserem Büro zur Tradition geworden, wann immer es die Arbeit zulässt oder wenn es etwas zu feiern gibt, Torreznos zu sich zu nehmen. Dabei haben wir Gelegenheit, uns um einen Tisch zu versammeln, uns zu unterhalten und das nächste Projekt zu besprechen, während wir die Tapas zusammen genießen. Sie sind zudem ein perfekter Snack, um uns in der Nacht vor einer Projektabgabe wach zu halten und mit Energie zu versorgen.«
Das Team des Ensamble Studios

Torre Z-N-O

Antón García-Abril, Madrid

1 kg sucking pig's ribs
500 g lard or oil
salt, pepper

Cut the sucking pig's ribs along the bones into separate pieces. Heat the lard in a flat pan. Fry the ribs in hot oil or lard for 10–15 minutes until brown and crispy. Be careful, the fat can splash! Season torreznos well with salt and pepper and serve with bread.

Tip

The meat from sucking pigs is particularly tender; ribs from larger animals should be simmered for about one hour in salted water kept just below the boil, drain well before frying or grilling. Spicy dips go well with this dish, like for instance a spicy-sour coriander salsa: sauté 1 tsp. cumin and then cut this up in a large mortar (or in a hand blender) with 3–4 coarsely chopped, mild pepperonis, 1 tomato and 1 tsp. salt. Take the leaves from 3 bunches of coriander, chop the coriander roots and put them in the mortar with 2 tbsp. lemon juice, crush to a paste and serve with the torreznos.

Project Discussions with Tapas

"Because of the long time between the early-morning breakfast and the main meal, which in fact is really only eaten in the early evening, Ensamble workers have adopted this tradition of taking a torreno appetiser whenever possible or for celebrations. It gives us a chance to socialize and to discuss work-related topics. But the most remarkable aspect of eating Torreznos is being able to gather people round one table to enjoy tapas together while discussing the next project. A perfect snack to keep you awake the night before handing in a project to the promoter, to help you burn the midnight oils."
The Team of Ensamble Studio

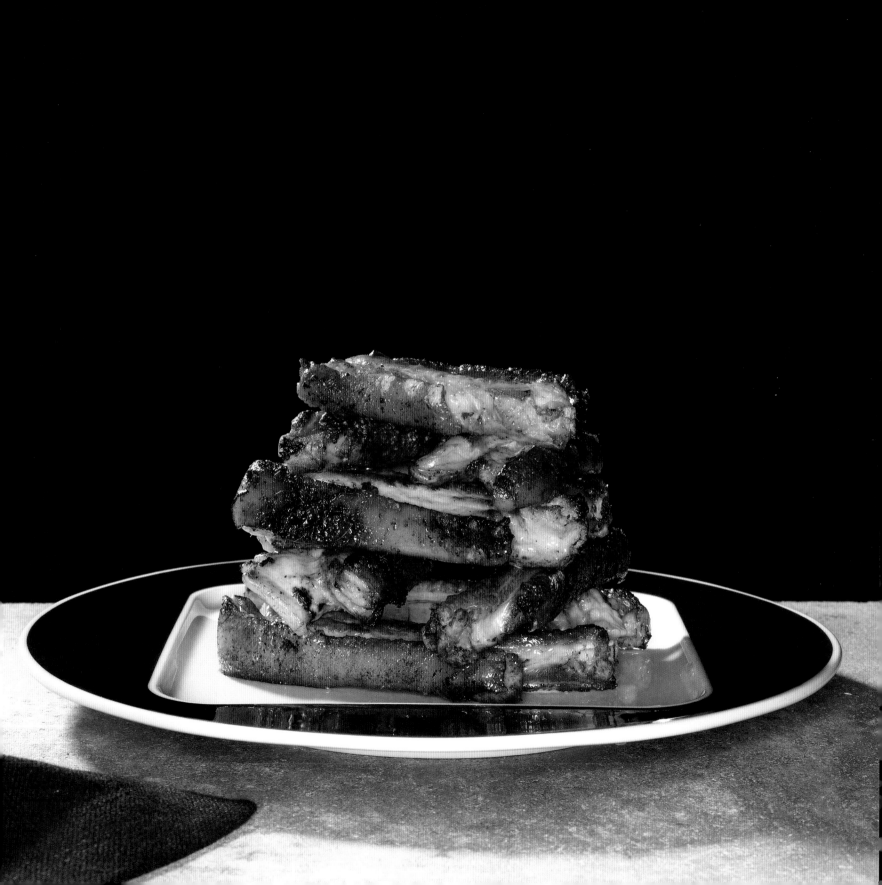

Baukunst | Art of Construction

Große, graue Kristalle charakterisieren den Mondariz-Granit, der traditionell in der Architektur eingesetzt wird.
Big, grey crystals characterise Mondariz granite, which is traditionally used in architecture.

Dynamitstangen, an strategisch günstigen Stellen im Berg platziert, lassen den Stein durch Explosion brechen.
Dynamite, placed at strategically advantageous positions in the mine, will cause the stone to crack open from the explosion.

Einzelne Stücke werden mit Bohrmaschinen vom Felsen gelöst. Es entsteht eine raue Oberfläche.
Single pieces are removed from the rocks by boring machines. This leads to a rough surface.

Schritt 1: Das Basismaterial
Step 1: The base material

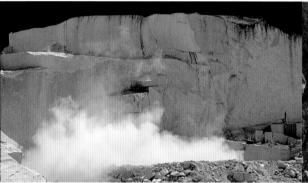

Schritt 2: Die Vorbereitung
Step 2: Force against nature

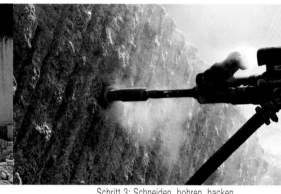

Schritt 3: Schneiden, bohren, hacken
Step 3: Cutting, drilling, hacking

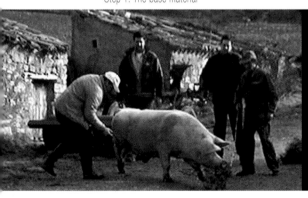

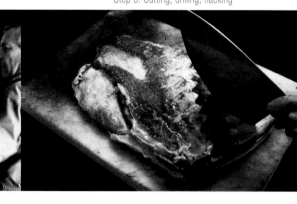

Familie und Freunde versammeln sich zur Schlachtzeremonie, der »Mantanza«. Ein Jahr wurde das Schwein gemästet.
Family and friends gather for the slaughtering ceremony, the "Mantanza". The pig was fattened for one year.

Nach dem Schlachten wird der ausgenommene Körper an einem Haken aufgehängt.
After the slaughtering the disembowelled carcase is hung up on a hook.

Nachdem das Schwein in seine Einzelteile zerlegt ist, werden die Rippen in dicke Scheiben geschnitten.
After the pig has been dissected the ribs are cut into thick slices.

Kochkunst | Haute Cuisine

Der Stein wird sehr sorgfältig gewaschen und poliert,
sodass keine Sprünge darin entstehen.
The stone is washed and polished so carefully that it
does not crack.

Mithilfe eines Baukrans werden die Brocken
zu einer lockeren Mauer gestapelt.
A building crane is used to stack the supports
to form a loosely packed wall.

Die Anordnung mag willkürlich erscheinen,
doch eine versteckte Stahlstruktur hält sie an ihrem Platz.
The arrangement might seem to be random,
but a hidden steel structure keeps everything in place.

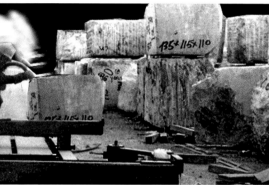 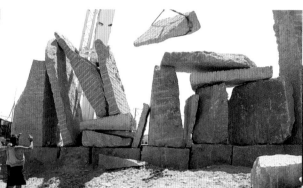 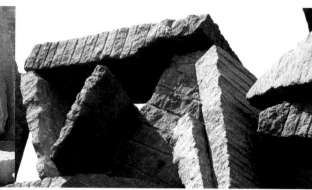

Schritt 4: Bearbeitung des Werkstoffs
Step 4: Working on the material

Schritt 5: Etwas Neues entsteht
Step 5: Something new comes into being

Schritt 6: Die Präsentation
Step 6: The presentation

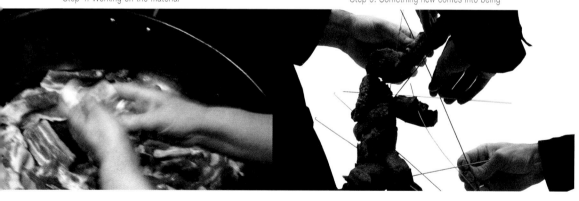 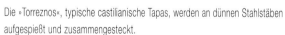 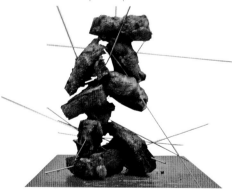

Der Speck wird in Schweineschmalz gebraten,
davon nicht zu viel verwenden, da der Speck selbst fettig ist.
The bacon is fried in dripping –
without using too much as bacon itself is already fatty.

Die »Torreznos«, typische castilianische Tapas, werden an dünnen Stahlstäben
aufgespießt und zusammengesteckt.
The "Torreznos", typical Castilian tapas, are skewered together.

Das Gerüst verleiht dem traditionellen Gericht Stabilität
und einen modernen Nouvelle-Cuisine-Look.
The scaffolding gives the traditional dish stability and a
modern Nouvelle-Cuisine look.

Limpurger Mosaik

Jan Reuter, München

320 g Rinderfilet vom Limburger Weideochsen
(Alternative: gut gereiftes Rinderfilet)
100 g Sojasprossen
2 Zweige Zitronenverbene
4 TL Arganöl, Jozo Sea Salt oder Maldon Sea Salt
Roter Pfeffer aus Pondicherry

1. Das Rinderfilet in 5 mm dicke Scheiben, diese wiederum in 3 cm große Stücke schneiden. Sojasprossen und Verbene waschen, trockenschleudern und verlesen. Die Kräuter fein schneiden und mit dem Öl mischen – so bekommt später das Fleisch einen feinen Zitronengeschmack, ohne dass Zitronensäure das Fleisch angreift.

2. Das Filet mit den Sojasprossen auf 4 Tellern anrichten, mit Salz und Pfeffer würzen. Das Kräuteröl in kleine Dipschälchen verteilen und zum Rinderfilet servieren.

Tipp

Im Vergleich zum Limpurger Weideochsen ist das Kobe-Rind ein Massenprodukt. Nur etwa zwanzig Limpurger kommen jedes Jahr zum Metzger. Die schmecken dafür besonders gut. Produzenten des Limpurger »Boeuf de Hohenlohe« finden Sie über Slowfood. Sojasprossen gibt es auf größeren Märkten, Verbenepflänzchen auch. Die Samen des Arganbaums liefern ein besonders nussig-aromatisches Öl, das in der traditionellen marokkanischen Heilkunde als wahres Lebenselixier gilt. Das Öl von Argandor.de wird von den Frauenkooperativen der Amazigh-Berber in Handarbeit und Bio-Qualität gepresst. Roter Pondicherry Pfeffer ist eigentlich ein schwarzer Pfeffer, der aber besonders schonend getrocknet wird und daher nicht nur die Farbe der reifen Pfefferbeeren behält, sondern auch besonders fruchtig und aromatisch schmeckt. Jozo Sea Salt ist ein Meersalz aus zarten pyramidenförmigen Kristallen – ähnlich wie Maldon Sea Salt. Diese und viele andere edle Salz- und Pfeffersorten finden Sie zum Beispiel im Internet unter www.gewuerzamt.com oder unter www.bosfood.de.

Limpurg Mosaic

Jan Reuter, Munich

320 g filet from a Limpurg ox
(Alternative: well-hung beef filet)
100 g soya sprouts
2 sprigs of lemon verbena
4 TL argan oil, Jozo sea salt or Maldon sea salt
Red pepper from Pondicherry

1. Cut the beef into 5 mm thin slices and cut these into 3 cm pieces. Wash soya sprouts and the verbena, spin it dry and pick off the leaves. Finely chop the herbs and mix with oil – this gives the meat a delicate lemony flavour later, without spoiling the meat with citric acid.

2. Arrange the beef filet with the soya sprouts on 4 plates, season with salt and pepper. Portion out the herbal oil into little dip bowls and serve with the beef filet.

Tip

Compared with the Limpurg ox, Kobe beef is mass-produced; only about twenty Limpurgers are slaughtered each year. But they taste especially good. You can find producers of Limpurg "Boeuf de Hohenlohe" through Slowfood. Soya sprouts can be obtained from larger markets, verbena plants too. The seeds of the argan tree contain particularly nutty aromatic oil, which in Moroccan medicine is considered to be a true elixir. The oil from Argandor.de is hand pressed in bio quality by the Amazigh Berber women's cooperatives. Red Pondicherry pepper is really a black pepper which is dried especially carefully and therefore not only retains the colour of the ripe pepper berries, but also tastes particularly fruity and aromatic. Jozo sea salt is a sea salt made from fine pyramid-shaped crystals – similar to Maldon sea salt. These and many other precious salts and peppers can be found on the Internet at www.gewuerzamt.com or at www.bosfood.de for example.

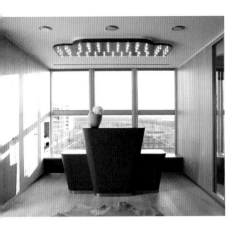

»Ich schätze Klarheit und die Konzentration auf das Wesentliche. Das Ausgangsmaterial spielt dabei eine elementare Rolle, ganz gleich, ob es sich um ein Gericht handelt oder eine Inneneinrichtung. Es in allen Feinheiten und Schattierungen kennen zu lernen, dafür nehme ich mir jede Menge Zeit. Je purer das Material, desto delikater der Umgang damit! Nehmen Sie das Beispiel Furniere: Was nützt mir das exotischste Holz, wenn ich das verwendete Material nicht Stück für Stück eigenhändig aussuche und minutiös darauf achte, dass die Maserung ein schönes Bild ergibt? Die Auseinandersetzung mit den sinnlichen Möglichkeiten eines Materials schärft stets aufs Neue die Sinne für raffinierte Details – und inspiriert zu neuen Kompositionen. Wer das Rezept mit dem Fleisch der Limpurger Weideochsen probiert, wird verstehen, was ich meine!«
Jan Reuter

Über den Nutzen hinaus

Kann denn Luxus Sünde sein? Gerade dem Puristen mag leicht eine Entsagungshaltung unterstellt werden, die es ihm schwer macht, sich sinnlichen Genüssen hinzugeben. Und doch schließt eins das andere häufig nicht aus! Jemanden, den es reizt, Fleisch des Limpurger Weideochsen mit Zutaten wie Arganöl zur Vorspeise zu servieren, der bekennt persönliche Selektivität. Er zeigt Empfänglichkeit für das Raffinement, das einen erhöhten Aufwand erfordert – eben jenen Mehraufwand über das Notwendige hinaus, der eine bloße Speisezubereitung zur Kochkunst mithin zum Luxus werden lässt.

Es ist gerade das Einfache, das fordert: den Hersteller in technischlogistischer Hinsicht, den Konsumenten, indem es ihm einen geschulten Geschmack und differenzierende Aufmerksamkeit abverlangt. Es gilt, das Wesen einer Sache zu ergründen und es durch eine sensible Konditionierung in seinem reichen Gehalt zu präsentieren, ohne es durch künstlich hinzugefügte Effekte zu verfälschen. Die Herausforderung liegt darin, dass das Schlichte keine Unstimmigkeiten zu kaschieren vermag – ein Ungeschick in Fügung oder Form liegt sogleich offenbar.

Die hier zu erkennende Haltung ist dieselbe, die die Arbeit des Büros Jan Reuter Einrichtungen kennzeichnet, das Inneneinrichtungen für Objekt- und Privatkunden plant. Dies geschieht überwiegend auf dem Wege strukturbildender Eingriffe und Sonderanfertigungen. Resultat ist eine akribische Zusammenführung von Ausgangsbestand, Raumfunktionen und Auftraggeberbedürfnissen unter einer klar und authentisch gestalteten Oberfläche.

"I appreciate clarity and concentration on the essential. The material at the starting point plays an elementary role here, whether one is dealing with a dish or with interior fittings. I take a great deal of time to familiarise myself with all the subtleties and nuances of this material. The purer the material, the more delicately it requires handling! Take for example veneers: What use is the most exotic wood, if I do not handpick the material used, piece by piece, to check meticulously that the graining looks beautiful? Examining the physical possibilities of material always sharpens one's senses anew for subtle details – und inspires new compositions. Whoever tries the recipe with the meat of the Limpurg ox will understand what I mean!"
Jan Reuter

Beyond usefulness

Can luxury really be a sin? It is easy to assume that a purist has a tendency to abnegation, which makes it hard for him to give in to sensual pleasures. And yet often the one does not exclude the other! Someone who is tempted to serve the meat of the Limpurg ox with ingredients such as Argan oil for starters displays personal selectivity. He demonstrates receptivity for that refinement which requires greater effort – that greater effort which changes from merely cooking food to the art of cooking and consequently to luxury.

It is in fact the simple which makes demands on the producer from a technical logistical point of view and on the consumer by requiring of him a trained sense of taste and a differentiating awareness. What counts is to penetrate the essential of a thing and present it through sensitive conditioning in all its bounty, without falsifying it with artificially added effects. The challenge lies in the fact that the simple is unable to hide any discrepancies – clumsiness in jointing or form becomes obvious immediately.

The attitude seen here is the same as that which distinguishes the work at the Jan Reuter furnishings office, which plans interior fittings for offices and for private customers. In most cases this occurs by means of structure building measures and customer-specific assignments. The result is a meticulous combination of initial state, room functions and client's requirements beneath a clear and authentically designed exterior.

The office's obsession with detail stretches from the continuity of the alignment of the joints, to the grain patterns extending over large surfaces and also special requirements for fittings. Holism expresses itself in grid systems, which develop their effectiveness through series

Die Detailversessenheit des Büros reicht dabei von der Kontinuität von Fugenbildern und Maserungsverläufen über große Flächen hinweg bis hin zu Sonderanfertigungen von Beschlägen. Ganzheitlichkeit äußert sich in Gestaltungsrastern, die ihre Wirksamkeit durch Raumfolgen hindurch bis in den Außenraum entfalten.

Wesentlich für die Qualität des Ergebnisses sind ein differenzierter Umgang mit Materialität, Farbe, Licht und Proportionen, die sich auf sensibles Gestaltungsvermögen gründen, wie auf langjährige Erfahrung. In der Ausführung verbindet sich eine auf den Prinzipien der Moderne gründende Klarheit mit der Lebendigkeit perfekten Handwerks. Das Wissen um den Aufwand, der bisweilen nötig ist, um den Anschein der Einfachheit zu erzielen, wirkt hierbei als Stifter einer Art Komplizenschaft zwischen Auftraggeber und Inneneinrichter.

Wozu den Aufwand betreiben, wird sich mancher fragen. Es sind Nuancen und Details, die dem Moment beziehungsweise dem Ort das Gepräge geben und ihn über das Alltägliche hinausheben. Jenseits eines jeglichen Nutzendenkens ist eine derartige Kultivierung der Form Selbstzweck und somit wie die Kunst frei. Sie enthebt sich somit auch einem etwaigen Zwang zur Legitimation. Dahinter stehender Antrieb ist allein das Streben nach Pflege respektive Verfeinerung der eigenen Kultur.

of rooms extending to the space outside.

What is essential for the quality of the result is a differentiated way of treating the vehicles materiality, colour, light and proportions, all based on a sensitive designing ability as well as many years of experience. The execution combines clarity based on the principles of modern trends with the vividness of perfectcraftsmanship. The knowledge of the effort sometimes required to maintain the apparent simplicity takes on the function here of bringing about a complicity between the client and the interior furnisher.

Some may ask themselves, why go to such effort? It is these nuances and details, which leave their mark on the moment or the place and lift them above the everyday. Beyond every useful purpose one finds this type of cultivating form as an end in itself, and therefore free, like art. It dispenses with any compulsion to justify itself. The driving force behind this is nothing other than the striving to care for or to refine one's own culture.

Ochsenbrust-Carpaccio mit Grüne-Sauce-Parfait

Christopher Unger, Frankfurt am Main

1 Bund gemischte Kräuter für Frankfurter Grüne Sauce
(z. B. Pimpinelle, Kerbel, Borretsch, Petersilie, Schnittlauch,
Kresse, Sauerampfer)
125 g Mayonnaise, 250 g Sauerrahm, Senf, Essig, Salz, Pfeffer
800 g Ochsenbrust
1 Bund Suppengrün, 3 Zwiebeln, 1 Lorbeerblatt
2 TL schwarze Pfefferkörner
600 g Kartoffeln, 1–2 EL Mehl, 3 Eier, Muskatnuss, 1 EL Butter

Außerdem: ein Waffeleisen

1. Für ein Frankfurter-Grüne-Sauce-Parfait die Kräuter putzen und
sehr fein hacken. Mayonnaise und saure Sahne unterrühren. Mit
Senf, Essig, Salz und Pfeffer abschmecken. Die Sauce auf einem
Tablett flach verstreichen und 2–3 Stunden tiefkühlen.

2. Die Ochsenbrust mit dem Suppengrün, 2 halbierten Zwiebeln, dem
Lorbeerblatt, Pfefferkörnern und ca. 1,5 l leicht gesalzenem Wasser
aufsetzen. Ungefähr 2 Stunden kochen, das Fleisch in der Brühe ab-
kühlen. Die kalte Ochsenbrust von Fettresten befreien und in hauch-
dünne Scheiben schneiden.

3. Kartoffeln schälen und fein reiben. Anschließend in einem saube-
ren Geschirrtuch auspressen. Eine Zwiebel schälen, ebenfalls fein
reiben und unter die Kartoffelmasse mischen. Mehl, Eier, Salz und
Muskatnuss mit den Kartoffeln verrühren. Das Waffeleisen leicht but-
tern, nacheinander 4 Kartoffelwaffeln darin goldbraun ausbacken.
Mit Ochsenbrust und Frankfurter-Grüne-Sauce-Parfait servieren.

Tipp

Mayonnaise können Sie leicht selber zubereiten. Dafür 1 Eigelb mit
1 Messerspitze Senf, Salz, Pfeffer und 1 EL Zitronensaft verrühren.
Mit dem Schneebesen oder einem Pürierstab nach und nach 125 ml
Öl unterschlagen, bis eine feste Creme entsteht.

Beef brisket carpaccio with green sauce parfait

Christopher Unger, Frankfurt on the Main

1 bunch of mixed herbs for Frankfurt green sauce
(e.g. anise, chervil, borage, parsley, chives, cress)
125 g mayonnaise, 250 g thick soured cream, mustard, vinegar, salt,
pepper, 800 g brisket of beef
1 bunch of herbs and vegetables for making soup (leek, carrots, tur-
nip-rooted celery, parsley), 3 onions, 1 bay leaf
2 tsp. black peppercorns
600 g potatoes, 1–2 tbsp. flour, 3 eggs, nutmeg, 1 tbsp. butter

In addition: a waffle iron

1. For a Frankfurt green sauce parfait: clean herbs and chop very
finely. Stir in mayonnaise and sour cream. Season with mustard,
vinegar, salt and pepper. Spread the sauce out thinly on a tray and
freeze for 2–3 hours.

2. Bring brisket of beef to the boil in about 1.5 l lightly salted water
together with the herbs and vegetables for making soup, 2 onions
cut in half, bay leaf, peppercorns. Stew for about 2 hours, allow the
meat to cool in the stock. Remove fat from the cold meat and cut into
wafer-thin slices.

3. Peel potatoes and grate finely. Pass the potatoes through a clean
kitchen towel. Peel an onion, grate finely as well and stir into the
potatoes. Mix flour, eggs, salt and nutmeg with the potatoes. Grease
the waffle iron a little, bake 4 potato waffles in it one after the other
until they are golden brown. Serve with brisket of beef and Frankfurt
green sauce parfait.

Tip

You can prepare the mayonnaise easily yourself. Stir in 1 egg yolk
with a dash of mustard, salt, pepper and 1 tbsp. lemon juice. Gra-
dually stir in 125 ml oil with a whisk or a hand blender until you have
a thick cream.

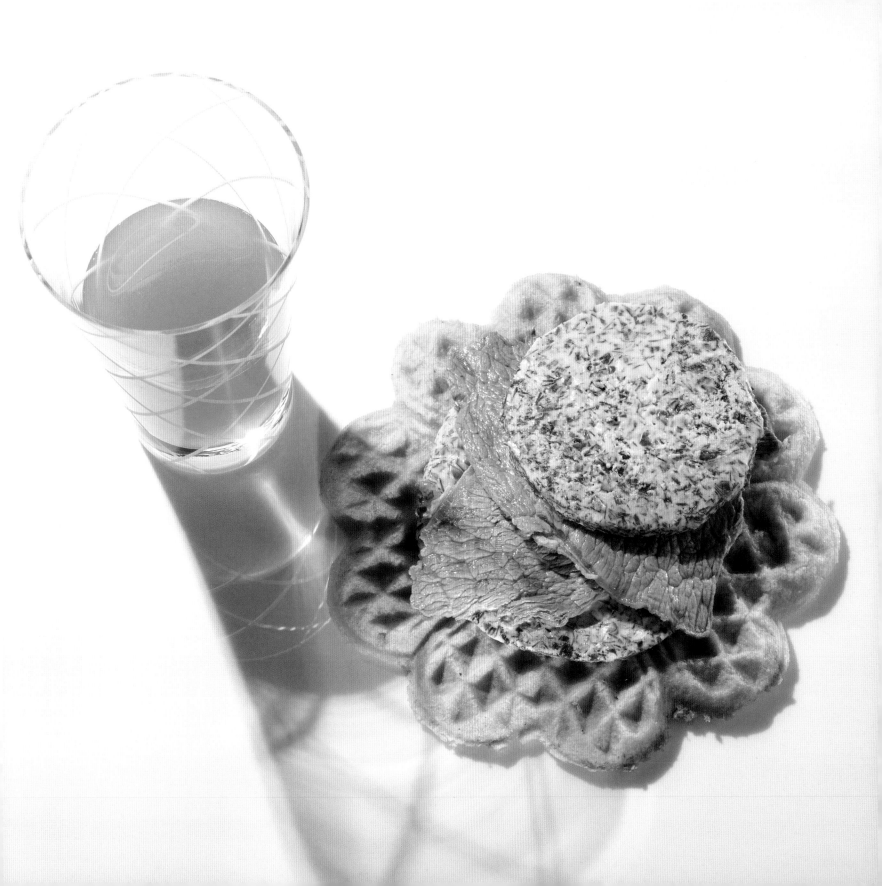

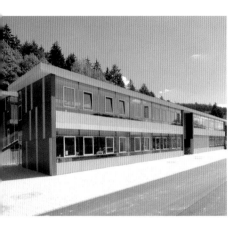

Gebaute Landschaften

Christopher Unger: »Bei geöffnetem Fenster weht im Sommer ein leichter Kräutergeruch vom gegenüberliegenden Flussufer herüber an meinen Arbeitsplatz im Frankfurter Osthafen. Am stärksten von allen riecht man den Schnittlauch, der auf den Feldern der Gärtnereien am Oberräder Mainufer als eines der sieben Kräuter der berühmten Frankfurter Grünen Sauce wächst.«

So wie die Gerüche des Ortes diesen Rezeptbeitrag inspiriert haben, so sind es die Eigenarten der verschiedenen Orte, die der Arbeit des Architekten ihren spezifischen Charakter verleihen. Sie aufzuspüren und einzufangen, ist die Herausforderung bei jedem Bauprojekt. Ein häufig wiederkehrendes Thema ist dabei die Auseinandersetzung mit Architektur und Natur.

Gebaute Landschaft wird zum Dach einer Markthalle und schlägt damit die Brücke zum angrenzenden Bonner Rheinauenpark – im Rahmen der Diplomarbeit von Christopher Unger, die 2001 an der Universität Kassel entstanden ist. Bäume durchdringen die gebaute Struktur und schaffen einen Bezug zwischen den Ebenen. Natur in Architektur.

Ein Golfhotel auf der italienischen Halbinsel Monte Argentario in der Toskana, dessen Entwurf 2001 in Zusammenarbeit mit Garbin Ambrosone Architetti entstand, lehnt sich mit seiner terrassierten und mit Golfrasen übergrünten Struktur flächig an den Hang der hügelreichen Landschaft. Natur auf Architektur.

Die Grundschule in Rod an der Weil und ihre Sporthalle mit Außenanlagen bilden einen klar umrissenen Bebauungsstreifen, umgeben von Wald und Wiesen, von der Natur des Weiltals durchflossen. Begrünte Höfe holen die Natur ins Haus. Das Projekt wurde nach einem 2001 gewonnenen Wettbewerb in der Architektei Mey, Frankfurt am Main, von einem Team um Bernd Mey und Christopher Unger realisiert und 2006 fertig gestellt. Architektur in Natur.

Der Wettbewerbsbeitrag für einen Ausstellungs- und Informationspavillon in der Nähe von Berlin thematisiert auf konsequente Weise den natürlichen Baustoff Holz in Form eines verdrehten Blockhauses. Inmitten einer parkähnlichen Landschaft wird Natur zu Architektur.

Christopher Unger: »In der Küche meiner Großmutter lernte ich schon früh die Grundlagen bodenständiger, regionaler Küche kennen. Seither koche ich mit Leidenschaft Standards, experimentiere aber auch mit feinen Variationen.«

Constructed landscapes

Christopher Unger: "In summer, when the window is open, the light fragrance of herbs blows over from the river bank opposite to my desk overlooking Frankfurt's Osthafen harbour. The strongest smell is of chives which grow in the nursery fields on the Oberräder bank of the Main and which are one of the seven herbs in the famous Frankfurt green sauce."

Just as the smells of the place inspired this recipe contribution, so the peculiarities of different places lend their specific character to the work of the architect. To perceive and capture them is the challenge in every building project. A frequently recurring theme here is the differences occurring between architecture and nature.

A constructed landscape becomes the roof of a covered market and thus builds a bridge to the neighbouring Rheinauen Park in Bonn – within the framework of Christopher Unger's degree thesis, which was undertaken at the University of Kassel in 2001. Trees penetrate the structure and form a link between the two planes. Nature in architecture.

Designed in 2001 in co-operation with Garbin Ambrosone Architetti a golf hotel on the Italian Monte Argentario peninsula in Tuscany, spreads out, with its terraced structure and golf greens, nestling against the slope in this hilly landscape. Nature on architecture.

Rod an der Weil's primary school and its sports hall and grounds form a clearly outlined building strip, surrounded by forest and meadows, with the nature of the Weil valley running through it. Green backyards fetch nature into the house. The project was completed in 2006 at Architektei Mey's architects' office in Frankfurt on the Main by the team Bernd Mey and Christopher Unger after winning a competition in 2001. Architecture in nature.

The competition entry for an exhibition and information pavilion near Berlin picks up the theme of wood as a natural building material in a convincing way in the form of a twisted blockhouse. In the midst of a park like landscape nature becomes architecture.

Christopher Unger: "In my grandmother's kitchen I learnt the basics of grassroots regional cuisine at an early age. Since then I passionately enjoy cooking standard fare, but I also experiment with fine variations."

Kroepoek-Leuchte

Julia Beer, Verena Weikinger, Marina Stoyanova, Wien

Zutaten für eine Leuchte

100–200 Stück Kroepoek (Krabbenchips)
60 kleine durchsichtige Plastikdipschälchen (aus dem Gastronomie-Großhandel), 500 ml Sojasauce, 500 ml Sweet-Chili-Sauce und
500 ml Süß-Sauer-Sauce

Außerdem: Nadel und Faden, Plexiglasplatte ca. 120 x 40 cm,
1 starker Scheinwerfer, 1 leeres Regalsystem oder Traversensystem

1. Die Krabbenchips auffädeln: Dazu den Nylonfaden in lange Stück
schneiden. Mit einer Nadel je 2 kleine Löcher in die Chips stechen,
den Faden durch die Löcher ziehen. Nach jedem Chip einen dickeren
Knoten oder eine Schleife in den Faden knoten, um die einzelnen
Chips auf den Fäden voneinander zu trennen. Nylonfaden lässt sich
gut fädeln, ist aber sehr rutschig – dünne Bratenschnur lässt sich
leichter vernähen, bleibt aber sichtbar.

2. Die fertigen Kroepoek-Schnüre am obersten Regalboden befesti-
gen. Saucen in die Dipschälchen verteilen. Die Plexiglasplatte in etwa
1 Meter Höhe als Regalboden verwenden. Die Schälchen auf der Ple-
xiglasplatte verteilen. Den Scheinwerfer unter das Plexiglas stellen
und durch die Dipsaucen in die Hummerchips leuchten. Nun heißt es
abwarten, bis Ihre Gäste den Mut finden, die Leuchte zu essen.

Gaumenlaune

Die Lust am Essen, das spielerische Moment beim Übersetzen archi-
tektonischer Konzepte in kulinarische Assoziationen und die damit
verbundene konstruktive Umsetzung charakterisieren die Arbeit von
Julia Beer und Verena Weikinger alias Gaumenlaune. Pur und unver-
fälscht präsentiert das Duo die Lebensmittel. Manche Ideen können
dabei rein emotional begründet sein, ein gewisser Witz und Alltags-
launen dürfen mitbestimmen. Die Grenzen zwischen Architektur, Kuli-
narik und Kunst verschwimmen.

Kroepoek light

Julia Beer, Verena Weikinger, Marina Stoyanova, Vienna

Ingredients for one light

100–200 Kroepoeks (prawn crackers)
60 small transparent plastic dip bowls (from a catering wholesaler)
500 ml soya sauce, 500 ml sweet chilli sauce and 500 ml sweet and
sour sauce

In addition: Needle and nylon string, one sheet of Perspex about
120 x 40 cm, 1 strong spotlight, 1 empty shelving system

1. Thread the prawn crackers: Cut the nylon string into long pieces.
With a needle pierce two small holes into each cracker, pull the thre-
ad through the holes. Tie a thicker knot or make a bow in the thread
after each cracker to separate the crackers on the threads from each
other. Nylon is easy to thread, but it is very slippery – thin string is
easier to work with, but it will stay visible.

2. Fasten the finished strings of Kroepoeks to the top shelf. Arrange
the sauces in the small bowls. Use the Perspex sheet at a height of
about 1 m as a shelf. Set out the bowls on the Perspex. Place the
spotlight beneath the Perspex and shine it through the dip sauces
into the prawn crackers. Now you have to wait until your guests find
the courage to eat the lights.

Moods of the palate

The joy of eating, the playful moment while translating architectural
concepts into culinary associations and the constructive way these
are put into practice characterise Julia Beer und Verena Weikinger's
work alias "Moods of the Palate" The duo presents the food in a pure
and natural way. Some of the ideas can be purely emotional respon-
ses, influenced by a certain wit and everyday moods. The boundaries
between architecture, cooking and art become blurred.

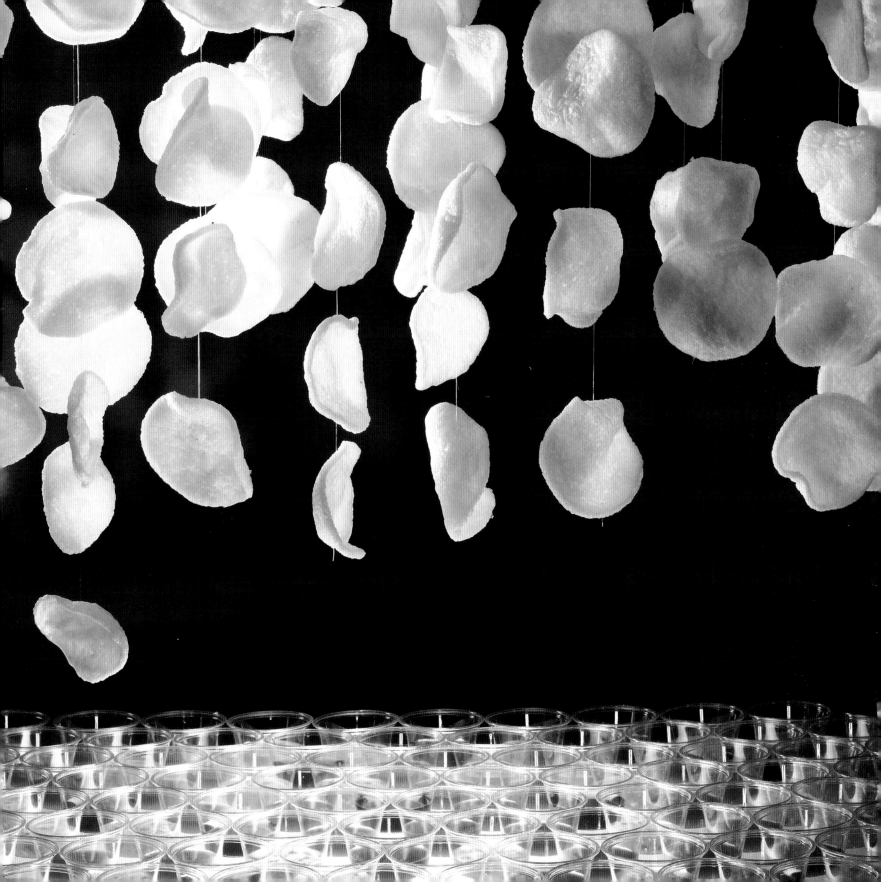

Orientalische Vorspeisen

Bert Kühnöhl, München

Knusperteller

Zutaten für 12 Stück

4 EL Butter, 4 Blätter Filoteigschälchen

Außerdem: 12 französische Brioche-Formen mit gewelltem Rand oder ähnliche Formen für kleine Kuchen oder Tartes

Den Ofen auf 180 Grad vorheizen (Umluft 160 Grad). Butter in einem Topf schmelzen. Die Formen mit einem Backpinsel buttern. Zwei Teigblätter mit der restlichen Butter bestreichen, die anderen beiden Blätter auflegen und leicht andrücken. Jede Teigplatte in 6 Teile schneiden und in die Formen legen, überstehenden Rand abschneiden. Die Teigschälchen 4–6 Minuten im Ofen auf der mittleren Schiene goldbraun backen. Aus den Formen nehmen, abkühlen und als Servierschälchen für orientalische Vorspeisen verwenden. Sobald die Vorspeisen angerichtet sind, sollten Sie sie sofort servieren, damit der Teig schön knusprig bleibt.

Rote Bete mit Kefir

300 g Rote Bete, Salz, 2 Knoblauchzehen
100 ml Kefir, 2 EL Zitronensaft, 2 EL Olivenöl
Pfeffer, 2 EL Pinienkerne

Rote Bete in gesalzenem Wasser ca. 20 Minuten bissfest kochen. Den Knoblauch schälen und fein hacken oder mit einer Prise Salz im Mörser zerstoßen. Rote Bete abkühlen, schälen und grob raspeln. Das Gemüse mit Knoblauch, Kefir, Zitronensaft und Olivenöl mischen, mit Salz und Pfeffer würzen. Pinienkerne in einer Pfanne ohne Fett rösten, bis sie duften. Rote Bete in 4 Filoteigschälchen verteilen, mit Pinienkernen bestreuen und servieren.

Oriental starters

Bert Kühnöhl, Munich

Nibbles

Ingredients for 12 pieces

4 tbsp. butter, 4 sheets of filo dough

In addition: 12 French brioche tins with a wavy brim or similar baking tins for small cakes or tarts

Preheat oven to 180 degrees (convection 160 degrees). Melt butter in a pan. Butter the tins with a pastry brush. Brush two of the filo sheets with the remaining butter, cover these with the other two sheets and press lightly together. Cut each sheet into 6 pieces and line the baking tins, cutting off overlapping edges. Bake the pastry for 4–6 minutes on the middle shelf of the oven until golden brown. Take pastry out of the tins, allow to cool and use as bowls for the oriental starters. As soon as the starters are prepared you should serve them immediately so the pastry stays nice and crispy.

Beetroot and kefir

300 g beetroot, salt, 2 cloves of garlic
100 ml kefir, 2 tbsp. lemon juice, 2 tbsp. olive oil
pepper, 2 tbsp. pine nuts

Cook beetroot al dente in salted water for about 20 minutes. Peel garlic and chop it finely or crush it in a mortar with a pinch of salt. Allow beetroot to cool, peel and grate it coarsely. Mix the vegetables with garlic, kefir, lemon juice and olive oil, season with salt and pepper. Roast pine nuts in a frying pan without fat until you can smell them. Arrange beetroot in 4 filo bowls, sprinkle with pine nuts and serve.

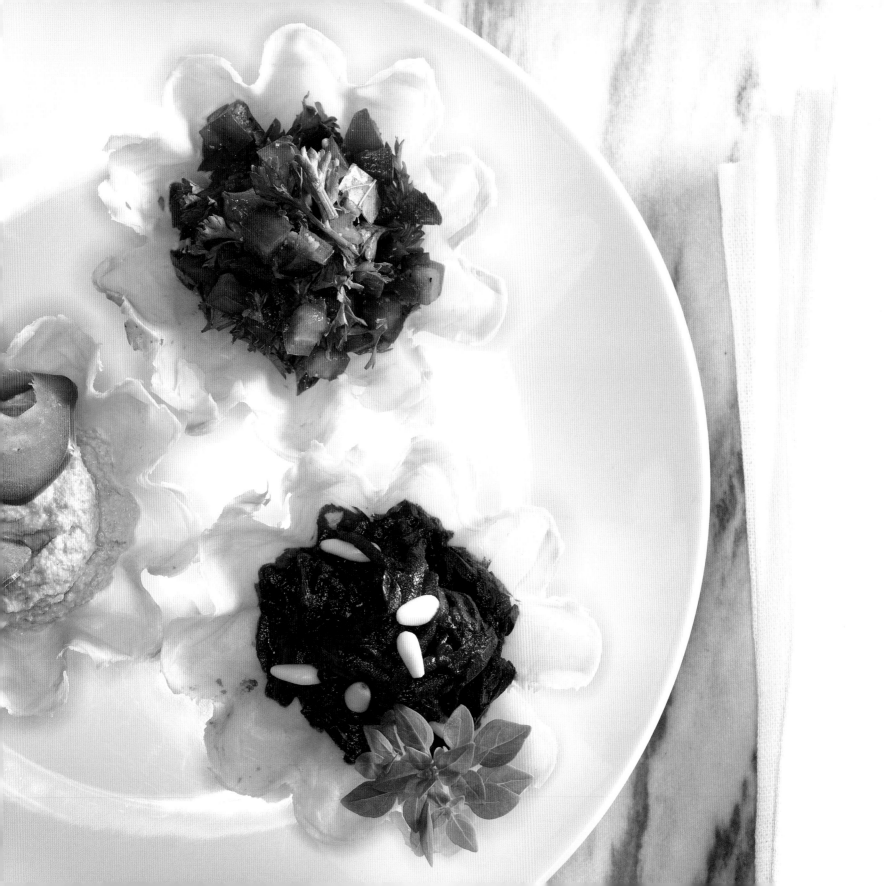

Petersiliensalat

2 Eiertomaten, 2 Bund Petersilie, 1/2 Bund Minze
4 Sardellenfilets, 2 EL Zitronensaft, 2 EL Olivenöl, Salz, Pfeffer

Tomaten waschen und vierteln. Stielansatz und Kerne entfernen, das Fruchtfleisch klein würfeln. Petersilie und Minze waschen, trocken schütteln und mit den Sardellenfilets grob hacken. Alle Zutaten mit Zitronensaft und Olivenöl marinieren. Mit Salz und Pfeffer würzen und in 4 Filoteigschälchen servieren.

Parsley salad

2 plum tomatoes, 2 bunches of parsley, 1/2 bunch of mint
4 anchovy filets, 2 tbsp. lemon juice, 2 tbsp. olive oil, salt, pepper

Wash tomatoes and quarter them. Remove stalks and seeds, cut the flesh into small cubes. Wash parsley and mint, shake them dry and chop coarsely with the anchovy filets. Marinate all ingredients with lemon juice and olive oil. Season with salt and pepper and serve in 4 filo bowls.

Walnuss-Paprika-Creme

100 g Walnusskerne, 2 rote Paprikaschoten, 2 Knoblauchzehen
1 Scheibe Toast vom Vortag , 1 Chilischote, 4 EL Walnussöl, Salz

Walnusskerne in einer Pfanne ohne Fett rösten, bis sie duften. Einige Nüsse grob hacken, beiseite legen. Paprika waschen, Strunk und Kerne entfernen, das Fruchtfleisch grob würfeln. Knoblauch schälen und klein schneiden. Paprika, Knoblauch, Toastbrot, Chilischote und Walnussöl in einem Blitzhacker pürieren, salzen. Die Creme in 4 Filoteigschälchen anrichten und mit einigen gehackten Walnüssen garnieren.

Walnut and peppers cream

100 g walnuts, 2 red peppers, 2 cloves of garlic
1 slice of day-old toast, 1 chilli pepper, 4 tbsp. walnut oil, salt

Roast walnuts in a frying pan without fat until you can smell them. Chop several nuts coarsely and put them aside. Wash peppers, remove stalks and seeds, and coarsely dice the flesh. Peel and chop garlic. Purée peppers, garlic, toast, chilli pepper, walnut oil and salt in a chopper. Arrange the cream in 4 filo bowls and garnish with chopped walnuts.

Trinken

Dazu passen Prosecco, Sherry – oder auch ein eiskalter Tee aus frischer Minze.

Drinks

Prosecco, sherry or ice-cold tea made of fresh mint go well here.

Spannung durch Integration

Baumeister und Großmütter haben uns bis heute in den Bau- und Kochkünsten in Ehrfurcht und Verzückung versetzt. Dieses Wissen gilt es zu erhalten und unsere von Reduktion und neuen Techniken geleitete Kenntnis auf dem Gebiet der Architektur in die historischen Bauten zu integrieren, respektive Omas Rezepte in unsere zeitgenössische Küche einzubinden. In gegenseitigem Respekt hebt das Alte das Neue hervor und umgekehrt. Gemeinsam bilden Alt und Neu wiederum ein kleines Novum.

Baumittel sollten wir als Architekten sparsam, überlegt und ihren Eigenschaften entsprechend einsetzen, damit wir die physikalische Stärke und die Schönheit des Werkstoffes intelligent nutzten können. Dieses Prinzip gilt ebenso für den Nährwert und den Geschmack von Lebensmitteln. Weder Lebens- noch Baumittel sollten zu Tode verarbeitet oder mit künstlichen Stoffen zu Scheinprodukten gedopt werden. Wohl aber können wir den Stand der Technik nutzen, um Materialien in der Architektur und Produkte in der Küche schonend zu verarbeiten und ihre Qualität hervorzuheben. Unter verantwortungsvoller Beachtung von Vorkommen, Anbau und Verarbeitung genießen heimische Materialien und Produkte zwar Vorrang, ein paar Besonderheiten aus anderen Kulturkreisen sparsam dazugefügt, geben dem Ganzen aber eine unerwartete Spannung.

Das Rezept ist im Kontext von Reduktion, Nachhaltigkeit und Integration zu sehen. Dabei könnte man Architektursprache an Beispielen des Berner Ateliers 5, von Peter Zumthor, Carlo Scarpa oder Karljosef Schattner erörtern und sich die Frage stellen, ob deren Architekturauffassung mit der Grundhaltung nachfolgender Menüfolge korrelieren würde.

Die Außenanlagen – Rote Bete mit Kefir, Petersiliensalat

So wie die Außenanlagen die Architektur aufgreifen und auf sie hinführen, empfangen die Vorspeisen den Gast und lassen ihn sich da und dort in ein durchaus längeres Gespräch über Landschaftsarchitektur und vegetarische Kochkunst verwickeln.

Das Gebäude – Lammkarree mit Zucchini (Seite 106)

Der Hauptgang erinnert an einen in konventioneller Bauweise errichteten Massivbau, der die Pylone seiner Tragkonstruktion als gestalterisches Architekturmerkmal nutzt.

Kunst am Bau – Rotwein-Birnen-Strudel (Seite 136)

An dem skulpturalen Werk wird hier neues Material unter Verwendung alter Techniken eingesetzt.

Suspense through integration

In the fields of architecture and the art of cooking, master builders and grandmothers have always filled us with awe and delight. This knowledge has to be preserved and in the field of architecture our knowledge stemming from reduction and new techniques has to be integrated into historical buildings; and in grandma's case we must incorporate her recipes in our contemporary cuisine. Mutually respectful of each other the old emphasises the new and vice versa. In turn, old and new together are something of a novelty.

We architects should use building materials sparingly, deliberately and in keeping with their characteristics, so that we can use the physical strength and the beauty of the material intelligently. The same principle applies to the nutritional value and the taste of food. Neither food nor building materials should be processed to death or doped with artificial substances to become pseudo-products. But we can use state of the art technology to process materials in architecture and products in the kitchen carefully, emphasising their quality. With responsible respect to availability, cultivation and the processing of local materials and products do take precedence, but a few special things from other countries, added sparingly, will create unexpected pleasure.

The recipe has to be seen in the context of reduction, sustainability and integration. In this case architecture language could be explained using examples given by the Berner Atelier 5, Peter Zumthor, Carlo Scarpa or Karljosef Schattner and one could ask oneself whether their opinions of architecture would correlate with the underlying approach of the following series of menus.

Grounds – beetroot with kefir, parsley salad

As the grounds relate to the architecture and lead up to architecture so the starters welcome the guests and let them engage here and there in a longer conversation about landscape architecture and vegetarian cuisine.

The building – rack of lamb with courgette (page 106)

The main dish reminds one of a solid building built by conventional construction methods and using the pylons of its supporting structure as an artistic architectural feature.

Art in building – red wine pear strudel (page 136)

New material is used in this sculptural work making use of old techniques.

Mozzarella-Türme

Marita Wallhagen, Stockholm

1 Bund junge Möhren
2 EL Butter, 3 EL Honig
Salz, Pfeffer
1 dicke und 1 dünne Zucchini, 4 Tomaten, 4 Kirschtomaten
2 Stück Mozzarella, 1 kleiner Romanasalat
100 g Rucolasalat, 1/2 Bund Petersilie
2 EL Balsamessig, 6 EL Olivenöl, 50 g Alfalfa-Sprossen
1 EL Sonnenblumenkerne
1 EL Sesamsamen

Außerdem: 4 Schaschlikspieße aus Holz

1. Möhren schälen, die Enden gerade abschneiden. Mit Butter, Honig und 100 ml Wasser 15 Minuten zugedeckt dünsten. Dabei öfter durchschwenken, damit das Gemüse gleichmäßig glasiert wird. Leicht salzen.

2. Zucchini und Tomaten waschen und trocknen. Zucchini in 6–8 mm dicke Scheiben schneiden und in einer Grillpfanne von beiden Seiten je 2–3 Minuten grillen, salzen und pfeffern. Tomaten und Mozzarella ebenfalls in Scheiben schneiden. Die Salate waschen und in einem Sieb abtropfen. Petersilie waschen, trocken schütteln und mit Balsamessig und Olivenöl mixen – zum Beispiel mit einem Pürierstab. Mit Salz und Pfeffer abschmecken.

3. Zucchini, Tomaten und Mozzarella zu vier Türmen schichten. Mit Schaschlikspießen fixieren und mit je einer Kirschtomate abschließen. An jeden Turm ein Blatt Romanasalat anlegen. Sprossen und Rucolasalat mit der Hälfte der Salatsauce mischen. Möhren und Mozzarella-Türme auf 4 Teller stellen. Rucolasalat anrichten und mit Sonnenblumenkernen und Sesamsamen garnieren. Restliche Salatsauce verteilen.

Trinken

Dazu passt kaltes Mineralwasser mit Gurkenschnitzen und Zitronengrasstängeln zum Umrühren.

Mozzarella towers

Marita Wallhagen, Stockholm

1 bunch of young carrots
2 tbsp. butter, 3 tbsp. honey
salt, pepper
1 fat and 1 thin courgette, 4 tomatoes, 4 cherry tomatoes to garnish
2 pieces mozzarella, 1 small cos lettuce
100 g rocket salad, 1/2 bunch of parsley
2 tbsp. balsamic vinegar, 6 tbsp. olive oil, 50 g alfalfa sprouts
1 tbsp. sunflower seeds
1 tbsp. sesame seeds

In addition: 4 kebab sticks out of wood

1. Peel carrots, cut off the ends straight. Simmer in butter, honey and 100 ml water in a covered saucepan for 15 minutes. Stir often so that the vegetables are evenly glazed. Salt lightly.

2. Wash and dry the courgettes and tomatoes. Cut the courgettes into 6–8 mm thick slices and grill them for 2–3 minutes on each side in a grill pan, season with salt and pepper. Cut tomatoes and mozzarella into slices too. Wash cos lettuce and rocket salad, drain in a sieve. Wash and shake the parsley dry, and mix with balsamic vinegar and oil – using a hand blender for example. Season with salt and pepper to taste.

3. Pile courgettes, tomatoes and mozzarella up to form four towers. Fix them with kebab sticks and put a cherry tomato on the top of each. Put a leaf of cos salad next to each tower. Mix alfalfa sprouts and rocket with half of the salad dressing. Put carrots and mozzarella towers onto 4 plates. Arrange rocket salad, garnish with sunflower seeds and sesame seeds. Divide out rest of salad dressing.

To drink

Mineral water with cucumber shavings and lemon grass stalks for stirring goes well with this.

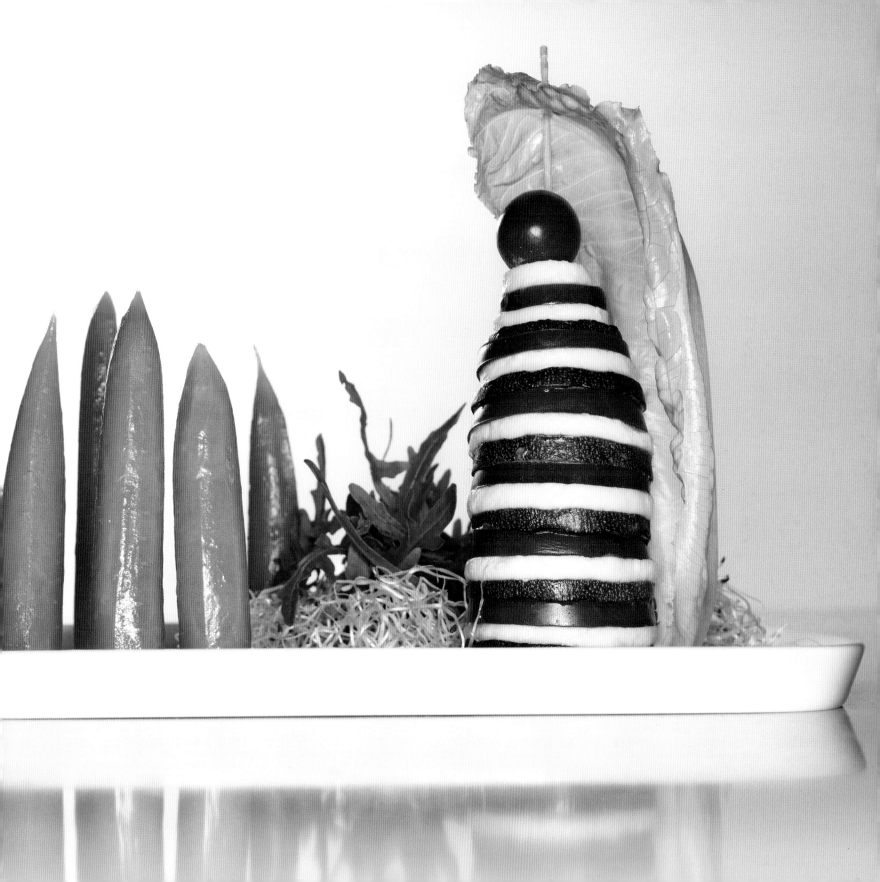

Die Sinne berühren

»Architektur stellt sich als eine Komposition von verschiedenen Materialien und Systemen dar. Auf dieselbe Weise besteht dieses Gericht aus einer Vielzahl von Zutaten, von denen jede einen Beitrag zur Vervollständigung des Ganzen leistet. Sie füllen den Teller mit essentiellen Mineralien, Vitaminen, Proteinen, Fettsäuren und Kohlenhydraten – ein guter Start für eine gesunde Ernährung. Ebenso wichtig ist jedoch, dass die Zutaten die Sinne der Menschen berühren, die das Gericht probieren. Das wünsche ich mir auch von der Architektur.

Die Ingredienzien repräsentieren eine Symphonie aus verschiedenen Texturen und Materialien. Die Karotten stehen gerade wie Stangen, mit einer festen Basis am Teller verankert. Im Gegensatz dazu scheinen die winzigen, zerbrechlichen und verwundbaren Alfalfasprossen geradezu in der Luft zu schweben. Eine kontrastreiche Mischung aus saftigen Tomaten, cremigem Mozzarella und frischen Zucchinis bildet die Mozzarellatürme. Als aufeinander geschichtete Scheiben wachsen sie in die Höhe, gekrönt von einer Cherrytomate. Wie die Skyline einer Stadt bilden sie zusammen mit den Karotten eine wunderschöne Silhouette für das Gericht. Ein großes, dünnes Segel aus Romanasalat, das auch durch Wirsing ersetzt werden kann, lehnt sich majestätisch gegen den Turm. Abhängig vom Anlass kann das Gericht unterschiedlich angeordnet und das angestrebte Aussehen angepasst werden – so wie sich ein architektonisches Objekt an die Umgebung und seine Lage darin anpasst und die Atmosphäre des Ortes festhalten und stärken sollte.

Optisch stehen die Farben der Karotten und der Tomaten im Kontrast zu dem weißen Mozzarella und dem Tiefgrün des Rucola – eine Augenweide, die den Betrachter mit Freude erfüllt. Das kalte Mineralwasser mit Gurkenschnitzen und das Balsam-Essig-Dressing fügen ein weiteres aromatisches Element hinzu. Der Essig mit der frischen Petersilie tanzt mit den anderen Geschmacksträgern auf dem Teller – den süßen, mit Honig glasierten Karotten, dem scharfen Rucola und dem zarten Mozzarella. Der Geschmack ist der in der Architektur oft vergessene dritte Sinn, dessen Rolle jedoch nicht vernachlässigt werden sollte. Er steht im engen Bezug zum Geruchssinn. Bei diesem Gericht hat jedes Gemüse sein eigenes Aroma und seinen individuellen Duft. Sie alle gleichzeitig einzuatmen, sollte sich anfühlen wie ein Spaziergang durch einen wunderschönen Garten mit Blumen, Bäumen und frischer Luft. Architektur sollte an einen solchen Garten erinnern.

Touching the senses

"Architecture is a composition of different materials and systems. In the same manner this dish consists of a number of combined ingredients, each one with its own role to play in order to make the dish complete. They fill the plate with essential minerals, vitamins, proteins, fatty acids and carbohydrates – a good start for a rich and healthy life. But, just as important, they create sensational experiences for people coming into contact with them, and touch all their senses. Something I want architecture to do.

The ingredients represent a symphony of different textures and materials. The rather solid carrots standing straight like towers with a heavy base anchored to the plate in contrast with the tiny, fragile and vulnerable alfalfa sprouts, which are almost floating in the air. A mixture of juicy tomatoes, creamy mozzarella and the fresh courgettes form the mozzarella towers. Like slabs put on top of each other they create a tower crowned with a cherry tomato. Together with the carrots they create a beautiful silhouette for the dish, like a city silhouette. A large thin surface, the Roman salad, (which can be replaced by cabbage), form a sail. Depending on the context, the surroundings and how the dish should look its position can be changed and it can be adapted. Like architecture should adapt to the site and surroundings and capture and strengthen the atmosphere of the site.

Visually the colours of the carrots and the tomatoes in contrast to the white mozzarella and the rocket salad are like candy for the eye and feed you with a sense of happiness. The accompanying drinks and the dressing with balsamic vinegar add a new aromatic element to the setting. Apart from being refreshing they bring new flavours. The vinegar with fresh parsley dances with the other flavours on the plate – the sweet honey-glazed carrots, the spicy rocket and the gentle mozzarella. Taste is the third sense, often forgotten in architecture, but which role should not be neglected. It is closely connected with the olfactory sense. In this dish each vegetable has its own individual taste and fragrance. Inhaling them all at once should be like walking through a garden. Architecture should smell like gardens, with fresh flowers, trees and air.

Living things which can be found in a garden but are often missing in buildings are also emphasised in this dish. Young alfalfa, which has started to grow, together with sunflower and sesame seeds with their potential to grow, manifest the life component. The possibility architecture has to change with time and grow together with its users is an interesting design challenge I would like to explore further.

Das Lebendige, das es im Garten gibt, das bei Bauwerken aber oft fehlt, wird ebenfalls in diesem Gericht hervorgehoben. Junge Alfalfa, im Wachstum begriffen, manifestieren die Lebenskomponente, zusammen mit Sonnenblumen- und Sesamsamen mit ihrem Wachstumspotential. Die Möglichkeit der Architektur, sich mit der Zeit zu verändern und mit den Benutzern zusammen zu wachsen, ist eine interessante Gestaltungsherausforderung, die ich gerne weiter untersuchen würde.

Vergessen Sie bei diesem Gericht nicht, auf den Klang zu hören. Dem Essen zuzuhören ist fast so interessant, wie der Architektur zuzuhören. Was klingt für Sie am besten? Ich mag die Cherrytomate.

Dieses Rezept basiert darauf, dass Architektur und Essen natürlich, gesund und sinnlich sein sollten. Dies beinhaltet die Gesundheit zukünftiger Generationen und der Menschen aus anderen Teilen der Welt. Weiterhin ist es wichtig, der Entwicklung einer umweltverträglicheren Gesellschaft nicht im Wege zu stehen, indem wir ökonomisch mit Ressourcen umgehen und uns des Lebenszyklus von Produkten bewusst sind. So kann Architektur der Schlüssel für das Schaffen von Umgebungen sein, die wahre und starke Gefühle und Erfahrungen vermitteln. Durch diese können wir alle auf einer persönlichen Ebene einen Bezug zu Orten aufbauen und uns in einem höheren Maße um unsere soziale und physische Umwelt kümmern.«
Marita Wallhagen

When eating this dish don't forget to listen to the sound. Listening to food is almost as interesting as listening to architecture. Which part do you think sounds best? I like the cherry tomato.

This recipe is based on the principle that architecture and food should be natural, healthy and sensual. This includes the health of future generations and people in other parts of the world. Then it is important not to stand in the way of building a more environmentally sustainable society by doing more with less, economising with resources and caring about the product's life cycle from cradle to grave. Thus architecture filled with sensuality can be the key to creating environments that give me and other people true and strong emotions and experiences. Through them we can all relate to places on a personal level, live a rich life and care for our social and physical environment at a higher level."
Marita Wallhagen

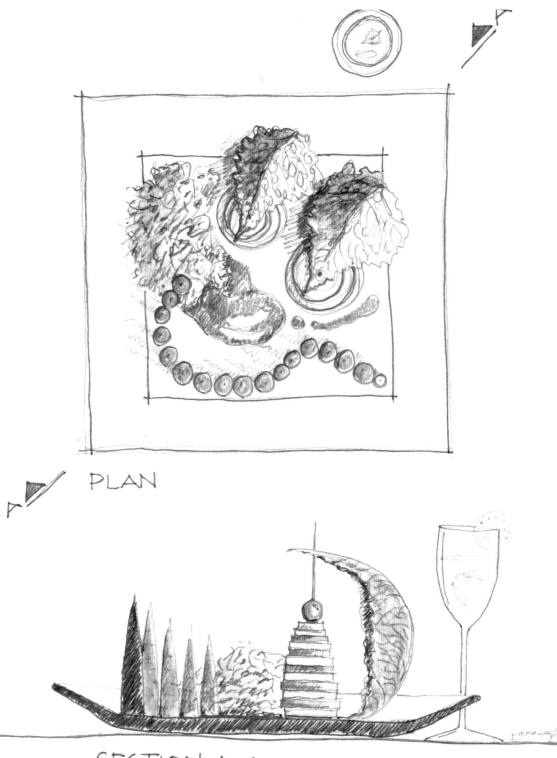

PLAN

SECTION A-A

Amandus Sattler mit/with Christian Henze

Menü der Gegenwart
Menu of the Present

■ Amandus Sattler, DETAIL-Preisträger 2005, lädt im Rahmen des DETAIL-Symposiums die DETAIL-Preisträger 2007 zur Kochsession. Im Münchner Haus der Gegenwart setzt er Gerichte und Architektur auf überraschende Weise in direkten Bezug zueinander. Michael Henze, Chef de Cuisine im Landhaus Henze bei Probstried, steht ihm dabei mit Rat und Tat zur Seite.

■ Amandus Sattler, the 2005 DETAIL prizewinner, invites all the 2007 DETAIL prizewinners to a cooking session within the framework of the DETAIL Symposium. In the "Haus der Gegenwart" in Munich he relates meals and architecture directly to each other in a surprising way. He is supported in word and deed by Michael Henze, chef de cuisine at the Landhaus Henze near Probstried.

Die Akteure: Amandus Sattler von Allmann Sattler Wappner Architekten, München, und Christian Henze, Chef de Cuisine im Landhaus Henze, Probstried

Der Ort: Haus der Gegenwart, München Riem

Das Menü: Vorspeise: Haus der Gegenwart – Ziegenkäse auf Estragon Hauptspeise: Audi terminal – Wolfsbarsch an Vanille Nachspeise: Duravit Messestand – Schokoturm mit Mandeln

Der Kernsatz: »Das Geheimnis einer starken Komposition liegt in der leichten Irritation, die uns verführt und anerkennend mit der Zunge schnalzen lässt.«

The actors: Amandus Sattler from Allmann Sattler Wappner architects' office in Munich and Christian Henze, chef de cuisine at the Landhaus Henze, Probstried

Place: Haus der Gegenwart (House of the Present), Munich Riem

The menu: Starter: Haus der Gegenwart – goat's cheese on tarragon, Main course: Audi terminal – sea bass with vanilla, Dessert: Duravit fair stand – chocolate tower with almonds

The core sentence: "The secret of a strong composition lies in the slight provocation which seduces us and allows us to click our tongue in approval."

Gerichte passend zur Architektur

Eigentlich wollte Amandus Sattler anlässlich des DETAIL-Symposiums 2007 während der BAU-Messe in München ganz andere Gerichte kochen. »Unbedingt eines dieser genialen Risottos, weich cremig und feucht, bei dem man unter ständigem Rühren gleich zu Beginn zwei Gläser Martini zugießt, und nachdem sich die kräftige Alkoholwolke verzogen hat, ein fantastischer, fast berauschender Duft aus dem Topf aufsteigt, und der Reis dieses Aroma vollständig aufnimmt. Oder ein herrlich frisches Genueser Pesto. Genüsslich werden die feinen Zutaten wie frischer Basilikum, Knoblauch, Pinienkerne und Parmesankäse mit dem Wiegemesser zerkleinert und mit dem trüben, kaltgepresssten Olivenöl zu einem sämigen Brei verrührt«, verrät der Münchner Architekt. Aber die Vorgabe des DETAIL-Verlags lautete, Rezepte vorzustellen, die etwas mit der Architektur des Büros Allmann Sattler Wappner Architekten zu tun haben, und so gibt es nun andere köstliche Speisen.

Dishes which go with architecture

Amandus Sattler really wanted to cook totally different dishes for the occasion of the DETAIL Symposium 2007 during the BAU construction fair in Munich. "Definitely one of those brilliant risottos, soft, creamy and moist where from the start you pour two glasses of Martini in whilst stirring continuously, and then when the strong cloud of alcohol has passed a fantastic, almost intoxicating smell wafts from the saucepan and the rice absorbs this aroma completely. Or a marvellously fresh Genoese pesto. With relish the fine ingredients such as basil, garlic, pine nuts and Parmesan cheese are chopped up with a chopping knife and mixed with a cloudy cold-pressed olive oil to a thick pulp", the Munich architect confesses. But the task set by the DETAIL publishers was, to present recipes which have something to do with the architecture in Allmann Sattler Wappner architects' office in Munich and therefore we are preparing other delicious meals.

Trauben-Estragon-Salat

2 Schalotten
2 EL Estragonessig
6 EL Olivenöl
Salz, Pfeffer
400 g blaue und grüne Trauben
4 Bund Estragon
200 g Ziegenfrischkäse oder 8 Ziegenfrischkäsetaler

1. Die Schalotten schälen und fein würfeln. Essig mit Olivenöl und Schalottenwürfeln verrühren. Die Sauce mit Salz und Pfeffer abschmecken.

2. Trauben und Estragon waschen und gut abtropfen lassen. Die Trauben halbieren und wenn nötig entkernen. Am schnellsten geht das mit Hilfe einer großen Pinzette. Alle vorbereiteten Zutaten miteinander mischen und mit Ziegenkäse anrichten.

Tipp
Christian Henze verziert den Salat mit einem Balsam-Essig-Sirup. Dafür 100 ml Apfelsaft mit 100 ml Balsam-Essig und 1 TL Zucker sirupartig einkochen, abkühlen und über den Salat träufeln.

Grape tarragon salad

2 shallots
2 tbsp. tarragon vinegar
6 tbsp. olive oil
salt, pepper
400 g blue and green grapes
4 bunches of tarragon
200 g goat cream cheese or 8 goat cheese medallions

1. Peel the shallots and dice them finely. Stir in vinegar with olive oil and diced shallots. Season the sauce with salt and pepper to taste.

2. Wash grapes and tarragon and drain well. Cut the grapes in half and remove pips if necessary. The fastest way to do this is to use big tweezers. Stir in all of the prepared ingredients with each other and serve with goat cream cheese.

Tip
Christian Henze decorates the salad with a balsamic vinegar syrup. To make this reduce 100 ml apple juice with 100 ml balsamic vinegar and 1 tsp. sugar to form a syrup, allow to cool, then drip it over the salad.

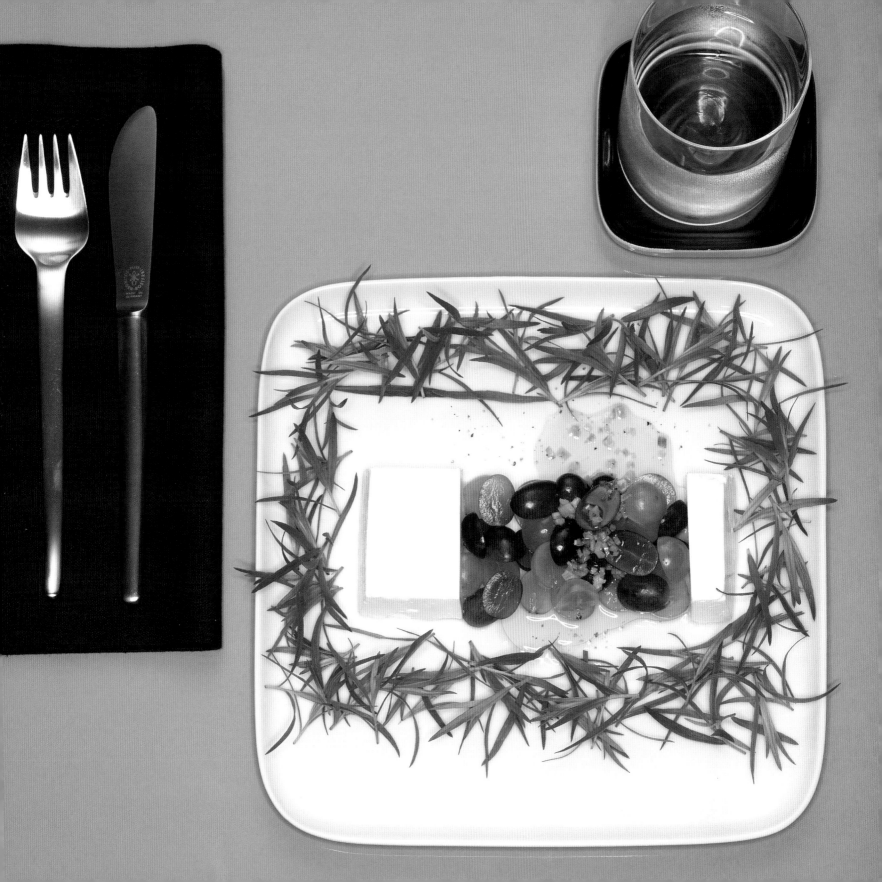

Von der Idee zum Rezept

Gekocht wird im Münchner Haus der Gegenwart auf dem Gelände der Bundesgartenschau, das aus einem Wettbewerb der Süddeutschen Zeitung zum Thema Wohnen in der Zukunft hervorgegangen ist. Entwurf: Allmann Sattler Wappner Architekten. Verankert in einem grünen Heckenlabyrinth sitzt der Wohnkubus auf dem Grundstück, das Untergeschoss von den Sträuchern verdeckt, das Obergeschoss gleichsam darüber schwebend. Dieses Bild verleitete Amandus Sattler zur direkten kulinarischen Umsetzung – Ziegenkäse mit Feldsalat. Der Haken: das ist zwar schmackhaft und bekannt,

From the idea to the recipe

Cooking takes place in the Munich Haus der Gegenwart in the grounds of the Bundesgartenschau, (Federal Garden Show). The house came into being as a result of a competition run by the Süddeutsche Zeitung on the theme of living in the future. Design: Allmann Sattler Wappner Architects. Standing within a green hedge maze the small house living cubicle in the grounds, the bottom storey is hidden by bushes while the top storey towers above them. This picture led Amandus Sattler to put this straight into culinary practice – goat's cheese with corn salad. The catch: it is indeed tasty and

aber gerade deshalb noch nicht ganz befriedigend. Denn das Haus der Gegenwart dreht die Gesetzmäßigkeiten um. Unten ist oben, was sonst zusammengehört, wird getrennt. So haben die Kreativen des Münchner Büros die Funktionen Kochen und Wohnen in den ersten Stock verlegt, Bad und Schlafzimmer sind ebenerdig. Architektonisch mit minimalen Mitteln umgesetzt, sind die Übergänge zwischen Privatheit und Öffentlichkeit, Haus und Garten fließend. »Die Hecken dominieren die Entwurfsidee. Sie bieten Privatheit, eröffnen neue Räume und karikieren das deutsche Ideal der Einfriedung mit der Thuja-Hecke«, erklärt Amandus Sattler. Und so beherrscht Estragon die Vorspeise, den Salat, den der Architekt bei diesem Kochevent für seine Gäste ausgewählt hat. Nicht als Kräuter fein darüber gestreut, sondern anstelle des Blattsalates und ohne jede Scheu mit vollen Händen verwendet – noch dazu in einer Kombination, die kulinarische Gewohnheiten auf den Kopf stellt, mit süßen Weintrauben und salzigem Ziegenkäse.

well-known but for that very reason not totally satisfactory. For the house of the present turns the rules on their heads. Down is up, what usually belongs together is split up. So these creative people from the Munich office have removed the functions of cooking and living to the first storey, bathroom and bedroom areon the ground floor. Brought about architecturally with minimal means, there is no clear dividing line between private and public, house and garden. "The hedges dominate the layout idea. They provide privacy, open up new spaces and caricature the German ideal of fencing off with cypress hedges", explains Amandus Sattler. And therefore tarragon dominates the starter, the salad the architect has chosen for his guests at this cooking event. Not as herbs, finely strewn over the top but instead it replaces a leafy salad and not cautiously but lavishly – and, what is more, in a combination which overturns usual culinary practices, with sweet grapes and salty goat's cheese.

Gedämpfter Wolfsbarsch mit grünen Bohnen

400 g Kenia-Bohnen
1 Knoblauchzehe
2 Zwiebeln
4 Wolfsbarschfilets, geschuppt (je ca. 200 g)
2 EL Olivenöl, Salz, Pfeffer
100 ml Weißwein
100 ml Fischfond
1 Vanilleschote
1 unbehandelte Zitrone
100 ml Sahne
1 Zweig Kerbel zum Garnieren
2 EL kalte Butter

1. Backofen auf 70 Grad vorheizen. Bohnen waschen, die Enden abschneiden. Die Bohnen 6–8 Minuten bissfest kochen, abgießen und kalt abschrecken. Knoblauch und Zwiebeln schälen und in Scheiben schneiden. Die Wolfsbarschfilets mit Küchenkrepp trocken tupfen, mit Olivenöl bestreichen und mit Salz und Pfeffer würzen. Knoblauch, Zwiebeln, Weißwein und Fischfond in einer Pfanne aufkochen. Fischfilets einlegen und bei mittlerer Hitze zugedeckt 6–8 Minuten dämpfen.

2. Die Vanilleschote längs halbieren und das Mark mit einem Messerrücken herauskratzen. Zitrone waschen und trocknen, die Schale fein abreiben. Wolfsbarsch aus der Pfanne nehmen und im Ofen warm stellen. Den Fischsud durch ein Sieb in einen kleinen Topf gießen, Vanilleschote und -mark, Zitronenschale und Sahne dazugeben. Die Sauce 5 Minuten cremig einkochen.

3. Kerbel waschen und trocken schütteln, Blätter abzupfen. Vanilleschote aus der Sauce nehmen, die kalte Butter würfeln und mit einem Schneebesen oder einem Pürierstab in die Sauce mixen, abschmecken. Fisch, Bohnen und Sauce auf Teller verteilen und mit Kerbel garnieren.

Steamed sea bass with green beans

400 g green beans
1 clove of garlic
2 onions
4 sea bass filets, scaled (each about 200 g)
2 tbsp. olive oil, salt, pepper
100 ml white wine
100 ml fish stock
1 vanilla pod
1 untreated lemon
100 ml cream
1 sprig of chervil for the garnish
2 tbsp. cold butter

1. Preheat oven to 70 degrees. Wash and top and tail the beans. Cook beans al dente for 6–8 minutes. Pour off the hot water and rinse the beans in cold water. Peel garlic and onions and cut into slices. Dab the sea bass filets dry with a kitchen towel, brush with olive oil and season with salt and pepper. Bring garlic, onions, white wine and fish stock to the boil in a pan. Add fish, cover and steam on medium heat for 6–8 minutes.

2. Cut the vanilla pod in half, lengthwise and scrape out the inside with the back of a knife. Wash lemon, dry it and grate the peel finely. Take sea bass out of the pan and put it in the oven to keep it warm. Pour the fish stock through a sieve into a small pot, add vanilla including the pod, lemon peel and cream. Reduce the sauce for 5 minutes until it is creamy.

3. Wash chervil and shake dry, pluck off the leaves. Remove vanilla pod from the sauce, dice the cold butter and mix it into the sauce using a whisk or a hand blender, season. Arrange fish, beans and sauce on plates and garnish with chervil.

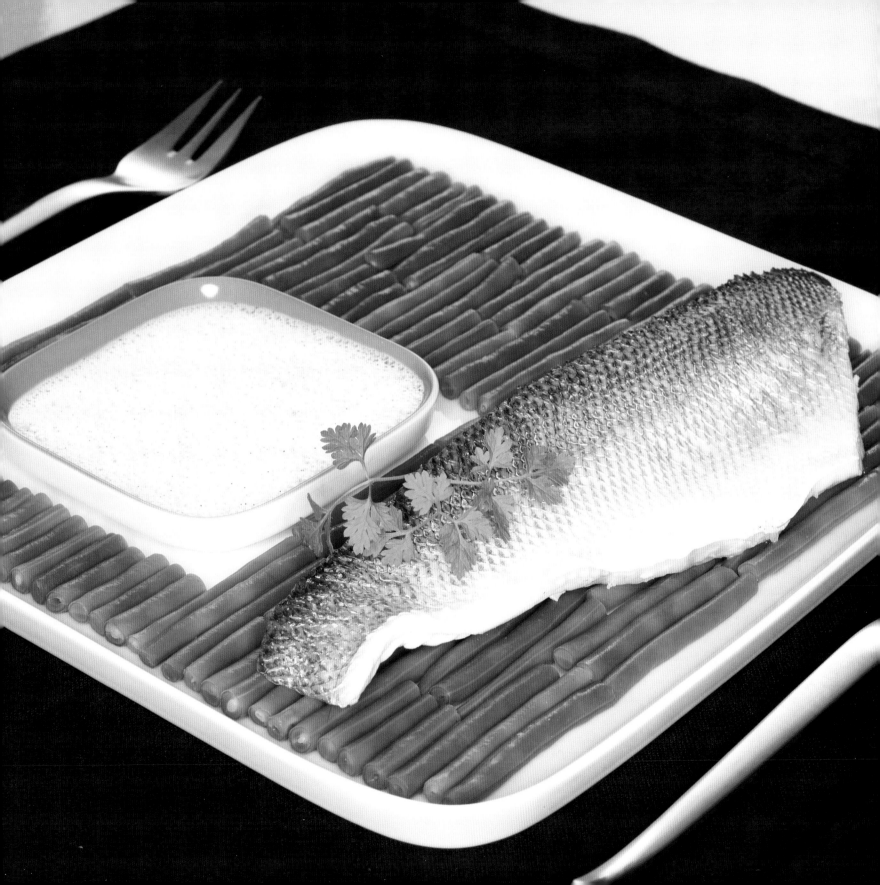

Jetzt wird zubereitet

»Wer hat noch eine Estragon-Hand frei?« Vier Leute zupfen bereits die Blätter von den Büscheln. Der grüne Haufen wächst schnell, aber es soll ja auch für einige Portionen reichen. Der Gastgeber schneidet die Trauben der Länge nach durch, während Profikoch Christian Henze die Zwiebeln blanchiert. Dann wird Beides in einer großen Schüssel mit dem Estragon gemischt und abgeschmeckt. »Ziel ist es, alle Geschmacksnerven zu bedienen«, sagt der Küchenchef, »im Moment sind wir noch etwas einseitig, mehr Essig könnte nicht schaden.« »Ich bin kein Essigfan«, meutert der Architekt und gießt

Now to the preparations

"Who still has a tarragon hand free?" Four people are already pulling the leaves off the bunches. The green pile is growing fast but then it is supposed to be enough for quite a few portions. The host cuts the grapes in half, lengthways whilst Christian Henze, the professional chef, blanches the onions. Then these are mixed together with the grapes and the tarragon in a large bowl and seasoned to taste. "The aim is to satisfy all the gustatory nerves", says the chef, "at the moment we are a little one-sided, a little more vinegar would not harm." "I am not a vinegar fan", protests the architect and pours

nur widerwillig etwas nach. Auch mit Pfeffer, Salz und Olivenöl muss nachgebessert werden, der geschmackliche Feinschliff ist gar nicht so einfach, nicht nur bei großen Mengen. Der Spaß kommt dennoch nicht zu kurz, denn nun geht es an die Verzierung der schmalen, flachen Salatteller mit Balsamico-Essig-Sirup, der vorher mit dem Einkochen des Essigs mit Zucker vorbereitet wurde. Amandus Sattler fängt an, unter allgemeinem Lob und kritischem Gemurmel mit dem dünnen Sirupfaden aus der Flasche Muster auf die Teller zu malen. Die Gäste beteiligen sich bald begeistert an der kreativen Herausforderung und entwickeln dabei beachtlichen gestalterischen Ehrgeiz, der in gewagten Schlangenlinien, gerasterten Hecken-strukturen, organischen Zellverbänden und japanischen Schrift-zeichen seinen Ausdruck findet. Danach werden einige Stücke Ziegenfrischkäse in die Mitte der Teller gesetzt und mit Estragonsalat umrahmt. Das Ergebnis ähnelt tatsächlich verblüffend dem Ent-wurfskonzept des Hauses der Gegenwart.

some more in very reluctantly. The pepper, salt and olive oil have to be added as well. The finishing touches to the flavour are not so easy, and not only where large quantities are involved. But there is still room for fun because now it is time to decorate the narrow flat salad plates with balsamic vinegar syrup which was prepared before by reducing the vinegar with sugar. Amidst general praise and critical murmuring Amandus Sattler begins pouring thin syrup from a bottle to form patterns on the plates. The guests soon take part enthusiastically in this creative challenge and soon develop considerable ambitions in designing, which find expression in daring zigzags, grid-like hedge structures, organic clusters and Japanese characters. After that a few pieces of the goat cream cheese are placed in the centre of the plate and surrounded by the tarragon salad. The result looks astonishingly like the design concept for the house of the present.

Von der Fischhaut zur Fassade

Unbekümmert kreativ und etwas überraschend ist auch die Wahl der Hauptspeise: »Fisch mit Vanille und Knoblauch – das hat mich an unseren Showroom erinnert, den wir in München für Audi planen«, gesteht Amandus Sattler. »Da kollidiert eine strenge Außenform mit einer inneren Kurvensituation. Und diese Spannung wollte ich auf das Rezept übertragen.« Dynamik, Asymmetrie und Transparenz sind die wesentlichen Gestaltungsmerkmale der neuen Audi corporate architecture. Doch der Bauplaner entdeckt noch mehr Gemeinsamkeiten zwischen dem Entwurf aus seinem Büro und dem Fischgericht: Die Doppelfassade besteht aus einem Industrietrapezblech und einem vorgehängten Lochblech mit rautenförmigen Ausstanzungen. Den schillernden Effekt, der bei dieser Konstruktion entsteht, fand er in der feinen Schuppenstruktur der Fischhaut wieder. »Zugegeben, etwas gewagt, aber mal sehen, wie das ankommt.« Und es ist nicht ganz klar, ob er sich dabei auf sein Bauprojekt oder die Menüzusammenstellung bezieht. Bei der praktischen Ausführung des kulinarischen Teils gibt Christian Henze, Gründer der Christian Henze Kochschule im smart Motel in Kempten, bereitwillig Ratschläge: »Damit er gleichmäßig bräunt, legen wir den Fisch mit der Hautseite in die kalte Pfanne und erhitzen erst danach. Würde man den Fisch in eine heiße Pfanne geben, würde sich die Haut zusammenziehen und Wellen werfen.« Er schneidet die Kartoffeln in gleich große Stücke, »dann werden sie gleichzeitig gar«, und streicht für die Vanille-Sahne-Sauce das Mark mit einem Messer aus den Schoten. Sorgfältig richtet Amandus Sattler inzwischen die grünen Bohnen auf den quadratischen Tellern an – das Auge isst bekanntlich mit.

Der Architekt und seine Visionen

Assoziationen mit seinen Bauprojekten kommen Amandus Sattler nicht nur beim Anblick von Ziegenkäse oder Fischhaut, sondern auch bei Schokolade, die er ausgesprochen gerne mag. Von der Vision eines Schokomuffins mit Mandelsplittern zum Messestand von Duravit auf der ISH 2003 ist es da nicht weit. Der Stand lässt sich als eine Landschaft aus dunklen Holzelementen beschreiben, die als kontrastreiche Präsentationsfläche für das weiße Porzellan der Sanitärobjekte dient. Die Schokolade ist für den Münchner Architekten ein Synonym für eine verbindende Masse, die sich in Strukturen formen lässt und geschmackliche und strukturelle Eigenschaften einbindet. Der Clou des Rezeptes: Das Dessert wird warm serviert, wie ein in kurzer Zeit zusammengebauter Messestand.

From fish skin to façade

The choice of the main dish is unabashedly creative and somewhat surprising: "Fish with vanilla and garlic – this reminded me of the showroom which we are planning in Munich for Audi", Amandus Sattler admits. "There a rigid external form collides with an inner curve situation. And I wanted to carry this tension over into the recipe." Dynamics, asymmetry and transparency are the essential design characteristics of the new Audi corporate architecture. Yet the construction planner discovers even more things in common between the design from his office and the fish dish: The double façade consists of industrial trapezoidal sheet metal and a curtain of perforated plate with diamond shaped cut-outs. He found the shimmering effect which this construction causes reflected in the fine scaled structure of the fish skin. "Admittedly somewhat audacious but let's see how it goes down." And it is not clear whether he is referring to his building project or to the composition of the menu. For the practical workmanship of the culinary part Christian Henze, the founder of the Christian Henze Kochschule (school of cooking) in the smart Motel in Kempten, willingly gives advice: "To make sure it browns evenly we put the fish with the skin side downwards into the cold frying pan and then turn on the heat. If we put the fish in a hot frying pan then the skin would contract and go wavy." He cuts the potatoes into even sized pieces, "then they will be finished at the same time," and he scrapes the inside of the vanilla pods with a knife to make the vanilla cream sauce. Amandus Sattler meanwhile carefully arranges the green beans on square plates – it's a fact that the way food looks is also important.

The architect and his visions

Amandus Sattler does not only associate things with his building projects when he sees goat's cheese or fish skin, but also chocolate, which he really loves. So it is not a big leap from the vision of a chocolate muffin with almond flakes to Duravit's stand at the ISH 2003 fair. The stand could be described as a landscape composed of dark wooden elements which serves as a high contrast presentation area for the white porcelain of the sanitary appliances. For the architect from Munich chocolate is a synonym for a connective mass, which can be shaped into structures and which includes taste and structural properties. The chief attraction of the recipe: the dessert is served warm, like a fair stand which is erected in a short space of time.

Schokoladenkuchen

150 g Kuvertüre, zartbitter
50 g Butter und etwas Butter für die Förmchen
2 Eier
75 g Zucker und etwas Zucker für die Förmchen
Salz
35 g gemahlene Mandeln
1 EL Espresso
35 g Mehl
Puderzucker

Außerdem: 4 Souffléeförmchen

1. Backofen auf 180 Grad, ohne Umluft, vorheizen. Kuvertüre und Butter klein schneiden und in einer Metallschüssel über einem Topf mit kochendem Wasser schmelzen. Die Eier trennen. Eigelbe mit dem Zucker schaumig schlagen. Anschließend das Eiweiß mit einer Prise Salz steif schlagen.

2. Mit einem Backpinsel die Förmchen buttern und mit Zucker ausstreuen. Geschmolzene Kuvertüre mit der Eigelbmasse verrühren. Mandeln, Espresso und Mehl mit der Schokoladenmasse vermischen und dann das Eiweiß mit einem Schneebesen unterheben. Die Schokomasse in die Förmchen füllen und ca. 12 Minuten backen.

3. Die Schokoladenkuchen aus dem Ofen nehmen, mit Puderzucker bestreuen und noch warm servieren.

Chocolate cakes

150 g plain chocolate coating
50 g butter and a little butter for the baking dishes
2 eggs
75 g sugar and a little sugar for the baking dishes
salt
35 g ground almonds
1 tbsp. espresso
35 g flour
icing sugar

In addition: 4 small soufflé dishes

1. Preheat oven to 180 degrees, do not use convection. Cut plain chocolate coating and butter into small pieces and melt them in a metal bowl over a pot of boiling water. Separate the egg yolks from the whites. Whisk yolks and sugar until frothy. Then beat egg whites with a pinch of salt until stiff.

2. Butter the soufflé dishes with a pastry brush and sprinkle with sugar. Stir melted chocolate into the yolks. Mix almonds, espresso and flour with the chocolate mixture, then fold in the egg white with a hand whisk. Spoon the chocolate mixture into the soufflé dishes and bake for about 12 minutes.

3. Take the chocolate cakes out of the oven, sprinkle with icing sugar and serve while still warm.

NUDELN&SUPPEN

Noodles & Soups

Spaghetti mit gegrillter Paprika

Mario Cucinella, Bologna

Je eine große rote und grüne Paprikaschote
8 Sardellenfilets in Öl, 2 Knoblauchzehen, 1 EL sizilianische Kapern
Apulisches Olivenöl (am besten das von Mario Cucinella)
1 Bund Petersilie, 1–2 Peperoncini, 80 g Weißbrot vom Vortag
300 g Spaghetti N° 5, Meersalz aus Trapani

1. Paprikaschoten waschen und abtrocknen, mit einer langen Grill-zange direkt über einer offenen Flamme von allen Seiten grillen, bis die Haut fast schwarz ist und viele Blasen wirft (Sie können die Scho-ten auch halbieren und mit der Hautseite nach oben auf einem ge-ölten Blech bei 250 Grad im Backofen 12–15 Minuten grillen). Die Paprikaschoten mit einem feuchten Tuch zudecken und 5 Minuten ruhen lassen, anschließend mit einem kleinen Messer die Haut ab-ziehen. Das Fruchtfleisch in Streifen schneiden.

2. Sardellenfilets ebenfalls in Streifen schneiden und mit 2–3 EL Öl in eine kleine Pfanne geben. Knoblauch schälen und fein schneiden. Die Hälfte davon zusammen mit den Kapern in die Pfanne geben. Alles zusammen 1–2 Minuten hellbraun anbraten, Paprikastreifen zugeben. Nach weiteren 2 Minuten die Herdplatte ausschalten, leicht salzen.

3. Petersilie waschen, trocken schütteln, zupfen und hacken. Peper-oncini ebenfalls hacken. Das Weißbrot reiben oder grob zerpflücken und im Mixer zerkleinern. 2–3 EL Öl in einer zweiten Pfanne erhitzen, die Brotbrösel darin unter häufigem Rühren hellbraun rösten. Den restlichen Knoblauch mit Petersilie und Peperoncini zugeben, noch eine Minute rösten. Vom Herd nehmen.

4. Nudeln in einem großen Topf mit Salzwasser bissfest kochen, abgießen, aber nicht vollständig abtropfen lassen. Die feuchten Nudeln mit den Paprikastreifen mischen und auf dem Herd zwei Minuten erhitzen. Abschmecken, anrichten und mit Brotbröseln bestreuen.

Spaghetti with grilled peppers

Mario Cucinella, Bologna

2 large peppers, 1 red and 1 green
8 anchovy filets in oil, 2 cloves of garlic, 1 tbsp. Sicilian capers
Apulian olive oil (preferably Mario Cucinella's)
1 bunch of parsley, 1–2 peperoncini, 80 g stale white bread
300 g spaghetti N° 5, Trapani sea salt

1. Wash and dry peppers, grill them with long tongs directly over an open flame from each side until the skin is almost black and bliste-ring. You can also cut the peppers in half and grill them in the oven with the skin side up on a greased baking tray for 12–15 minutes at 250 degrees. Cover the peppers with a moist cloth and leave to stand for 5 minutes, then remove the skins with a small knife. Cut the flesh into strips.

2. Cut anchovy filets into strips as well and put into a small pan with 2–3 tbsp. oil. Peel garlic and chop finely. Put half of it into the pan together with the capers. Brown all of this for 1–2 minutes until light brown, add pepper strips. After two more minutes turn the heat off and add a little salt.

3. Wash parsley, shake dry, pluck it and chop it. Chop peperoncini too. Grate the white bread or break it coarsely into pieces and then cut it up in the mixer. Heat 2–3 tbsp. oil in a second pan and roast the breadcrumbs in it until they are light brown. Stir frequently. Add the remaining garlic with parsley and peperoncini, roast for another minute. Remove from heat.

4. Cook noodles al dente in a large pan of salt water. Pour the water off, but do not drain them completely. Mix the moist noodles with the pepper strips and heat on the stove for two minutes. Season, and sprinkle with breadcrumbs before serving.

Geheimnisse der italienischen Küche

»Die italienische Küche ist weit verbreitet und steht für großartige Kochkunst. Die Esskultur gehört zum Alltag und ist fest in der Familientradition verankert. Auch die Qualität der Produkte spielt eine große Rolle. Es genügt ein Büffelmozzarella mit ein wenig schwarzem Pfeffer und schon entsteht ein Hauptgericht, ohne etwas gekocht zu haben.

Der Ursprung für meine persönliche kulinarische Leidenschaft liegt in meiner Familie und ist geprägt von meinen sizilianischen Tanten, insbesondere von meiner Mutter, die aus Genua stammt. Diese beiden Kulturen treffen oft aufeinander, und es entstehen immer wieder neue Gerichte. So wie die vielfältigen, kulinarischen Genüsse ständig wachsen, sammeln sich im Laufe eines Menschenlebens auch Erinnerungen, Klänge und Bilder an. Seit unserer Kindheit werden wir geprägt von den verschiedensten Eindrücken, aber auch unterschiedlichen Geschmäckern. Was das Essen anbelangt, sind das in meinem Fall die hausgemachte Tomatensauce, 'Capponate' mit frischem Gemüse aus dem Garten meines Onkels und das Pesto meiner Mutter mit frischem Basilikum aus Prà in Genua.

Das Geheimnis der italienischen Küche liegt in der Verbindung zwischen der Familie und der weit verbreiteten Kochkunst. Man sagt oft, dass man zu Hause besser isst als in einem Restaurant, weil die Tradition und das kulinarische Wissen der Familie so groß sind, dass es seinesgleichen sucht. Einige Gerichte sind enorm wichtig für das seelische Gleichgewicht. In den größten Stressmomenten ist das für mich immer ein wunderbarer, hausgemachter – streng genommen von meiner Mutter zubereiteter – Teller 'trenette al pesto'.«
Mario Cucinella

Die Thematik des Experimentierens ist für Mario Cucinella sowohl in kulinarischer Hinsicht als auch in der Architektur ein wesentlicher Aspekt. Die kontinuierliche Suche nach neuen Impulsen, ungewöhnlichen Resultaten und die Anwendung neuer Technologien stellen große Herausforderungen dar. Die Arbeit im Team und die Unterstützung zahlreicher Fachleute spielen bei der Entstehung von qualitätvoller Architektur eine wichtige Rolle. Geschmackvolles wächst aus dem gemeinsamen Arbeiten mit Beteiligten unterschiedlicher Traditionen, Kulturen und Hintergründen. So wie das Architekturbüro einen Ort der Vielfalt an Zuständigkeiten darstellt, an dem unterschiedliche Naturelle zusammentreffen, ist die Küche der Treffpunkt, in der unter vielfältigen Einflüssen Genussvolles entsteht.

Secrets of Italian cooking

"Italian cuisine is widespread and stands for splendid cooking. The eating culture belongs to everyday life and is firmly rooted in the family tradition. The quality of the products also plays a major role. Some buffalo mozzarella with a little bit of black pepper and there you have main meal without doing any cooking.

The origins of my personal culinary passion lie in my family and are marked by my Sicilian aunts, and most especially by my mother, who comes from Genoa. Both these cultures often meet and more and more recipes are the outcome. Just as diverse, culinary pleasures constantly increase so memories of sounds and images are collected in the course of a person's lifetime. From childhood onwards we are marked by the most varying impressions but also by different tastes. In my case, as far as food goes, these are homemade tomato sauce, 'Capponate' with fresh vegetables from my uncle's garden and my mother's pesto made from fresh basil from Genoa.

The secret of Italian cuisine lies in the connection between the family and the widespread art of cooking. It is often claimed that you can eat better at home than in a restaurant because tradition and the culinary knowledge of the family are so great that they are unparalleled. Some dishes are of enormous importance for some people's sense of inner harmony. For me in moments of great stress this means a wonderful, homemade plate of 'trenette al pesto' – strictly speaking made by my mother."
Mario Cucinella

The subject of experimenting is an essential aspect for Mario Cucinella both from a culinary and an architectural point of view. The continual quest for new impulses, unusual results and the use of new technologies all represent great challenges. Working in a team and being supported by numerous experts plays an important role in the formation of qualitative architecture. Something full of taste grows out of working jointly with participants from differing traditions, cultures and backgrounds. Just as the architecture office is a place where there are a variety of competences, where different temperaments meet so the kitchen is the meeting place where enjoyable results arise as a result of a wide variety of influences.

MCA Mario Cucinella Architects

University Building in Beijing, Peking, als sogenanntes »Sino-Italian Ecological and Energy-Efficient Building« (SIEEB), ein italienisch-chinesisches Gemeinschaftsprojekt auf dem Campus der Pekinger Tsinghua Universität (S. 56)
Informationspavillon »eBo« an der Piazza Re Enzo in Bologna, bestehend aus zwei ellipsenförmigen, transluzenten Gebäuden (links und unten)

MCA Mario Cucinella Architects

University Building in Beijing, (Peking), as a so called "Sino-Italian Ecological and Energy-Efficient Building" (SIEEB), a joint Italian-Chinese project on the Peking Tsinghua University campus (p. 56)
Information pavilion "eBo" on the Piazza Re Enzo in Bologna, consisting of two ellipse-shaped, translucent buildings (left and below)

Parametrische Pasta mit Limettensauce

Bernhard Franken, Frankfurt am Main

2 rote Paprika
2 unbehandelte Limetten
2 EL Butter, 1 EL Zucker, 1/2 Bund Petersilie, 5 EL Olivenöl
Salz, Pfeffer
8 Lasagneplatten

Außerdem: Epilog Helix 24 Mid-Sized Laser System

1. Backofen auf 260 Grad vorheizen (Umluft 240 Grad). Paprika waschen, halbieren und die Kerne entfernen. Mit den Schnittflächen nach unten auf ein leicht geöltes Blech legen und 15 Minuten im Ofen garen. Dabei darf die Haut schwarz werden. Paprika aus dem Ofen nehmen und mit einem nassen Küchentuch zudecken. Die Paprikaschoten nach 10 Minuten mit einem kleinen Messer häuten.

2. Limettenschale abreiben, den Saft auspressen. Butter in einem Topf erhitzen und mit dem Zucker karamellisieren. Mit Limettensaft ablöschen. 200 ml Wasser und die Limettenschale zugeben. Sauce 10 Minuten bei mittlerer Hitze kochen. In der Zwischenzeit die Petersilie waschen, trocken schütteln und mit 3 EL Olivenöl in einem Blitzhacker pürieren. Das Petersilienöl unter die Limettensauce rühren, mit Salz und Pfeffer abschmecken. Geschälte Paprika in 2 EL Olivenöl 5 Minuten dünsten, ebenfalls abschmecken.

3. Die rohen Teigplatten mit dem Laser so schneiden, dass dabei stabile, gleichzeitig elegante Strukturen entstehen. 2 breite flache Töpfe mit Salzwasser aufkochen. Je 4 Lasagneplatten in die beiden Töpfe geben und knapp unter dem Siedepunkt 8 Minuten garen. Die Lasagneplatten mit zwei flachen Schaumlöffeln vorsichtig nacheinander aus dem Wasser heben. Mit Limettensauce und Paprika anrichten.

Tipp
Dazu passt Portulaksalat mit Wildkräutervinaigrette.

Parametric pasta with lime sauce

Bernhard Franken, Frankfurt on the Main

2 red peppers
2 untreated limes
2 tbsp. butter, 1 tbsp. sugar, 1/2 bunch of parsley, 5 tbsp. olive oil
salt, pepper
8 sheets of lasagne

In addition: Epilog Helix 24 Mid-Sized Laser System

1. Preheat oven to 260 degrees (convection 240 degrees). Wash peppers, cut them in half and remove the seeds. Place with the cut side downwards on a lightly greased tray and cook in the oven for 15 minutes. It does not matter if the skin goes black. Take peppers out of the oven and cover them with a wet kitchen towel. After 10 minutes skin the peppers with a small knife.

2. Grate the lime peel, squeeze out the juice. Heat up butter in a pan and caramelise with the sugar. Deglaze with lime juice. Add 200 ml water and the lime peel. Cook sauce for 10 minutes on medium heat. In the meantime wash parsley, dab it dry and purée in a chopper with 3 tbsp. olive oil. Stir the parsley oil in with the lime sauce, season with salt and pepper. Cook peeled paprika in 2 tbsp. olive oil for 5 minutes, also season to taste.

3. Cut the raw lasagne sheets with the laser in such a way, that stable, yet at the same time elegant, structures will be formed. Boil salt water in 2 low wide pans. Place 4 lasagne sheets into each pan and simmer for 8 minutes just below boiling point. Carefully remove the lasagne sheets one after the other from the water using 2 flat skimmers. Serve with lime sauce and peppers.

Tip
Purslane salad with herb vinaigrette goes well with this dish.

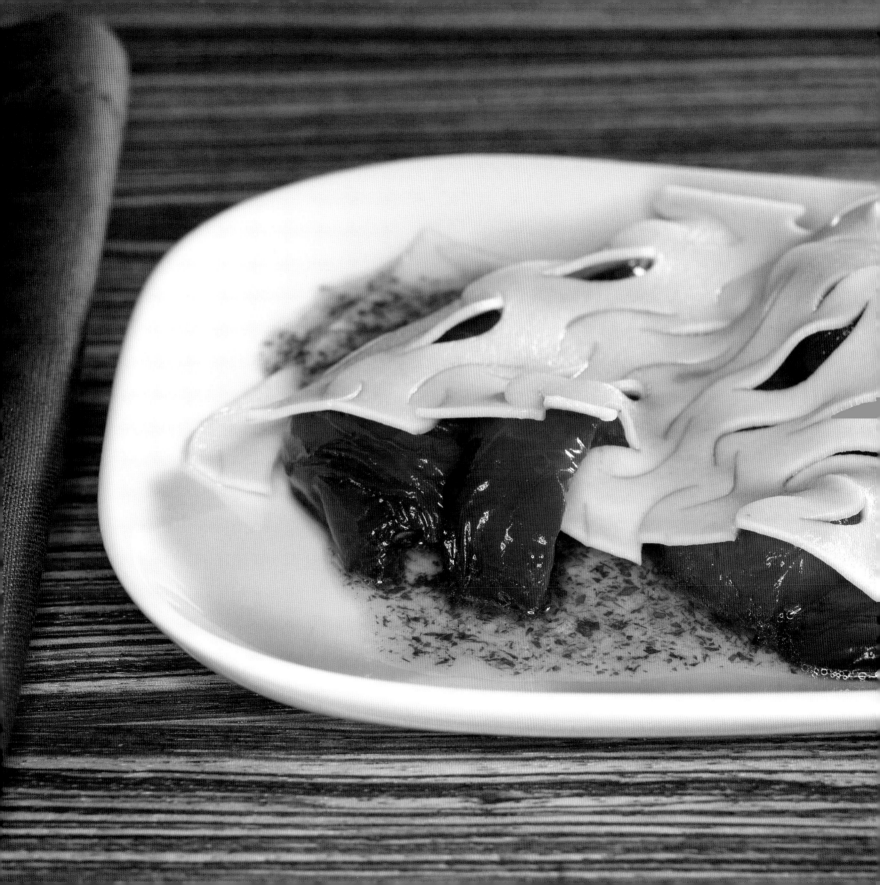

Nudel-Unikate vom Laser

Eine hausgemachte Nudel ist noch immer der Stolz jeder italienischen Köchin. Der Teig einer Tortelloni etwa wird mit der Hand geknetet, geschnitten, gefüllt und gefaltet. Moderne Pastafabrikation dagegen spiegelt das Grundprinzip der industriellen Produktion wider: Standard und Repetition. Nudeln werden aus dem Extruder zu kilometerlangen Spaghetti gepresst, mit einem Formwerkzeug werden immer gleiche Orecchiette gestanzt.

In der industriellen Welt erleben wir aber zur Zeit den Beginn eines Paradigmenwechsels von der Massenproduktion hin zur kundenindividuellen Massenfertigung. Inzwischen ist eine Produktion von Kleinserien zu Großserienfertigungspreisen mit der Qualität der Serienproduktion möglich, zum Beispiel mittels »parametrischer«, das heißt, vom Computer vollständig gesteuerter Fertigungsprozesse.

In der Architektur ermöglichen die computergestützten Fertigungsmethoden nicht nur andere Produktionsweisen, sondern auch neue Formgebungen. Seit 1999 hat das Büro Franken Architekten zahlreiche Projekte mit Animationssoftware durch »parametrische Prozesse« entworfen und mit CNC (Computerized Numerical Control) Methoden umgesetzt. Dabei wird nicht mit einer Formvorstellung begonnen, die man dann mit dem Rechner umsetzt, sondern in einer »Versuchsanordnung« im Rechner generiert sich die Form aus Randbedingungen von selbst. Die Kunst des Entwerfers ist die Gestaltung des Prozesses und die Einstellung der Randbedingungen. Im Projekt »Dynaform« (Bild oben), einem Ausstellungspavillon für die IAA 2001 für BMW in Frankfurt, besteht das Tragwerk aus Schnittebenen in einer freien Form, den so genannten »dynaframes« (Bild Mitte). Die Träger werden computergesteuert als brennstrahlgeschnittene Hohlkastenprofile (Bild unten) gefertigt.

Die »parametrische Pasta« überträgt dieses Prinzip auf die Nudelherstellung. Serielle Lasagneplatten werden mit einem Laser so geschnitten, dass sie sich beim Kochvorgang zu einmaligen Unikaten verwandeln. Die Formgebung der Schnittkurven erfolgt über einen parametrischen Prozess, in dem eine Basisgeometrie (Zeichnung 1) eine Referenzgeometrie (Zeichnung 2) mit regelmäßigen eingeschriebenen Kurven steuert. Durch die Verformung der Basisgeometrie entsteht ein unregelmäßiges, aber sich kontinuierlich veränderndes Kurvenbild (Zeichnung 3). Durch das Kochen der Nudeln klaffen die Kurven auf, es bildet sich ein spannendes Relief (Zeichnung 4). Jeder Koch kann sein Nudelrelief individuell gestalten, indem er vor dem Lasern die Basisgeometrie nach persönlichem Geschmack verformt.

Original noodles from laser

A homemade noodle is still the pride of every Italian cook. Tortellini dough for example is kneaded by hand, cut, filled and folded. Modern pasta production on the other hand reflects the fundamental principle of industrial production: Standard and repetition. Noodles are pressed out of the extruder to kilometre-long spaghetti and with a mould the same ear shaped pieces (orecchiette) are punched.

In the industrial world we are however currently experiencing the start of a paradigm change away from mass production towards customer individualised mass-producing. Meanwhile limited-lot production can now produce things at large-scale production prices and with the quality of mass production, using, for example, of "parametric", that means totally computer-controlled, production processes. In architecture computer-supported production methods not only make different ways of producing possible, but also new designs. Since 1999 Franken architects' office has designed numerous projects using animation software and put them into practice by means of CNC (Computerized Numerical Control) methods. Hereby not only the concept for the form is started, which is done by the computer, but in an "experimental set up" on the computer the form generates itself from the given constraints. The art of the designer consists of forming the process and setting the constraints. In the "Dynaform" project (top picture above), an exhibition pavilion for the IAA 2001 for BMW in Frankfurt the supporting structure consists of intersecting planes in a free form, so-called "dynaframes" (centre picture). The beams are produced under computer control as focal line cut (picture below) hollow tubular sections.

The "parametric pasta" transfers the principle of this paradigm change to noodle production. Celery lasagne sheets are cut with a laser in such a way that during the cooking process they are changed into unique originals with non-reproducible shapes. Giving shape to the intersecting curves results from a parametric process, in which a basis geometry (drawing 1) controls a reference geometry (drawing 2) with regular entered curves. As the basis geometry is shaped an irregular but continually changing curve diagram is brought about (drawing 3). When the noodles are cooked the curves gape open and an exciting relief is formed (drawing 4). Every cook can design his noodle relief individually, by forming the basis geometry before using laser, according to his personal taste. The guests will receive tailormade noodles.

Zeichnung 1
Drawing 1

Zeichnung 2
Drawing 2

Zeichnung 3
Drawing 3

Zeichnung 4
Drawing 4

61

Tortellini

Ralf Malter, Berlin

400 g Mehl, 6 Eier, Salz, 1 Hühnerbrustfilet (ca. 200 g)
Pfeffer, 1 EL Olivenöl, 300 g Brokkoli, 50 g Parmesan
150 g Butter, Zimt-, Nelken- und Muskatpulver
1/2 Bund Petersilie

Außerdem: Nudelmaschine oder Nudelholz

1. Ofen auf 180 Grad vorheizen (Umluft 160 Grad). Mehl, 4 Eier und 1 TL Salz zu einem glatten Teig verkneten. Nudelteig in Folie wickeln und mindestens 30 Minuten ruhen lassen.

2. Hühnerbrustfilet salzen und pfeffern, mit Olivenöl in einer ofenfesten Pfanne goldbraun anbraten, in den Ofen schieben und 10 Minuten fertig garen. Brokkoli in kleine Röschen schneiden und in kochendem Salzwasser 3–4 Minuten bissfest kochen. Die Röschen abgießen, kalt abschrecken und in einem Sieb abtropfen lassen. Parmesan fein reiben. Die Hühnerbrust aus dem Ofen nehmen, kurz abkühlen und mit dem Brokkoli in kleine Würfel schneiden. Mit 3 EL Butter und den restlichen Eiern vermengen, mit Salz, Pfeffer, Zimt, Nelken und einer Prise Muskat würzen.

3. Nudelteig sehr dünn ausrollen und 10 cm große Teigkreise ausstechen. Jeweils 1 EL der Füllung auf jeden Teigkreis geben. Die Ränder dünn mit Wasser bepinseln. Den Teig zu einem Halbkreis zusammenfalten und leicht andrücken. Die Enden um den Zeigefinger legen und zu einem Ring zusammendrücken.

4. Petersilie waschen, trocken schütteln und grob hacken. Tortellini in reichlich Salzwasser 4–6 Minuten kochen. Restliche Butter in einem Topf aufschäumen, bis sie leicht braun ist und nussig riecht. Tortellini auf Teller verteilen, mit Butter übergießen und Petersilie bestreuen.

Trinken
Dazu passt Les Vieilles Vignes Grenache Blanc 2005, ein Weißwein vom Weingut Jean Gardies aus dem Roussillon, mit weicher Fruchtnote und vollem, buttrigem Aroma.

Tortellini

Ralf Malter, Berlin

400 g flour, 6 eggs, salt, 1 chicken breast filet (about 200 g)
pepper, 1 tbsp. olive oil, 300 g broccoli, 50 g Parmesan
150 g butter, mixed spices (cinnamon, cloves and nutmeg)
1/2 bunch of parsley

In addition: pasta machine or rolling pin

1. Preheat oven to 180 degrees (convection160 degrees). Knead flour, 4 eggs and 1 tsp. salt until the dough is smooth. Wrap pasta dough in foil and leave to stand for at least 30 minutes.

2. Salt and pepper the chicken breast filet, brown it with olive oil in an ovenproof pan from both sides, then braise in the oven for 10 minutes. Chop the broccoli into small florets and cook al dente in salted boiling water for 3–4 minutes. Pour off the water, rinse the broccoli in cold water and drain in a sieve. Finely grate Parmesan. Take the chicken breast out of the oven, leave to cool then dice together with the broccoli. Mix 3 tbsp. of butter with the two remaining eggs, season with salt, pepper and the mixed spice.

3. Roll out the pasta dough very thinly and cut into circles 10 cm in diameter. Place 1 tbsp. of the filling onto each circle of dough. Brush the edges lightly with water. Fold the dough into semicircles and press lightly together. Wrap the ends around your index finger and press together to form a ring.

4. Wash parsley, shake dry and chop coarsely. Boil tortellini in plenty of salted water for 4–6 minutes. Froth the remaining butter in a pot until it is slightly brown and has a nutty smell. Portion out the tortellini on plates, pour the brown butter over the tortellini and sprinkle with parsley.

To drink
Les Vieilles Vignes Grenache Blanc 2005 is recommendable here; from the Jean Gardies vineyard, located in Roussillon, this white wine has a soft note of fruit and a rich, buttery aroma.

»Bürokochen« mit Folgen

»Im Sommer 1985 absolvierte ich vor dem Beginn meines Studiums ein dreimonatiges Praktikum im Architekturbüro Elmar Kraemer in Saarbrücken. In diesem Büro war es Brauch, dass einmal im Monat ein Mitarbeiter in einer ca. 1 m x 1 m kleinen Kochnische ein Abendessen für das ganze Team zubereitete, das anschließend in geselliger Runde im Büro des Chefs verspeist wurde. Kurzerhand wurde ich in die Folge der Köche aufgenommen. Natürlich wollte ich in der kleinen Küche etwas Besonderes herstellen, und so fiel meine Wahl auf selbst gemachte Tortellini, die mit wenigen Instrumenten und Kochgeräten mit günstigen Zutaten handwerklich in Serie herzustellen sind, aber trotzdem sehr gut schmecken.

Zu der damaligen Zeit erstellte ich für verschiedene Architekten des Büros Pläne, seinerzeit noch mit Tusche am Zeichenbrett. Jeder der Architekten hatte seine Vorstellung, wie ein Plan auszusehen hätte und mit welcher Schriftart zu beschriften sei. Meine eigenen Ansichten blieben dabei auf der Strecke. Daher kam ich auf die Idee, zu dem Rezept einen Speiseplan zu zeichnen, den ich so ausführen konnte, wie es mir gefiel. Ich ließ mehrere Pausen von meinem Plan herstellen und deckte mit den Plänen den Tisch so, dass jeder der Kollegen eine Art Untersetzer mit der Kochanweisung und dem Rezept unter seinem Teller liegen hatte. Die Tortellini und mein Plan wurden sehr gelobt und das Rezept mit dem Speiseplan in das Bürokochbuch aufgenommen.

Der Kontakt zum Büro von Herrn Kraemer ist nie ganz abgerissen. 22 Jahre später bin ich Büropartner von Herrn Kraemer und leite die Niederlassung in Berlin.

Meine Freude am Kochen hat mich als Hobbykoch zur Teilnahme an Koch- und Weinkennerwettbewerben geführt. Nebenbei betreibe ich einen kleinen Weinhandel mit hauptsächlich französischen Weinen. Die Tradition des Bürokochens wird in unserem Büro bis zum heutigen Tag fortgeführt.

Das bei den Tortellini angestrebte Ziel, mit einfachen Mitteln und nur wenigen Zutaten ein günstiges, überzeugendes Produkt herzustellen, verfolge ich auch bei meiner Arbeit als Architekt. Beispielhaft sind nebenstehend zwei Projekte gezeigt. Ein Einfamilienhaus in Falkensee bei Berlin, bei dem als Hauptthema sorgfältig verarbeiteter roter Ziegel für Dach und Wände eingesetzt wurde, und ein Mehrfamilienhaus in Saarbrücken, das unter Einsatz von standardisierten Holzfassadenelementen in einem Stahlbetonskelett realisiert wurde.«
Ralf Malter

"Office-cooking" with consequences

"In the summer of 1985, before starting my studies, I completed a three-month internship at the Elmar Kraemer's architect's office in Saarbruecken. It was the custom in this office that once a month one of the staff members prepared a dinner for the whole team in a small kitchenette about 1 m x 1 m in size, then we enjoyed a friendly meal together in the boss's office. Straightaway I joined the ranks of the chefs. Of course I wanted to cook something special in the small kitchen and so I chose to make homemade tortellini, which can be made with few tools and cooking devices, with inexpensive ingredients made and produced in large quantities by hand, yet still taste very good.

At that time I was drawing plans for different architects at the office, back then we still used drawing ink at the drawing board. Each architect had his own idea of how a plan should look and which type of lettering should be used. My own views did not count. That's why I had the idea of drawing up a bill of fare to go with the recipe, which I could produce however I liked. I had several copies of my drawing made and set the table with the plans in such a way that each colleague had something like a place mat with the cooking instructions and the recipe beneath their plate. I was complimented on the tortellini and my plan, and the recipe with the bill of fare was added to the office cookbook.

I have always kept in touch with Mr. Kraemer's office since my internship, and during my studies in Duesseldorf and my various jobs in offices in Berlin. 22 years later I am Mr. Kraemer's office partner and in charge of the branch in Berlin.

My enjoyment of cooking has led me to participate in cooking competitions and wine connoisseur contests as an amateur cook. On the side I have a little wine business dealing mainly in for French wines. The tradition of office-cooking has still continued in our office up until the present day.

The objective when making tortellini, to make a cost-effective, convincing product from simple means and using only few ingredients, is what I aiming at in my work as an architect as well. Opposite two exemplary projects are shown. A one-family house in Falkensee near Berlin, where the main theme meant using carefully made red bricks for the roof and the walls, and a multiple family house in Saarbruecken. This was made using standardized timber facade elements in a reinforced concrete skeleton structure."
Ralf Malter

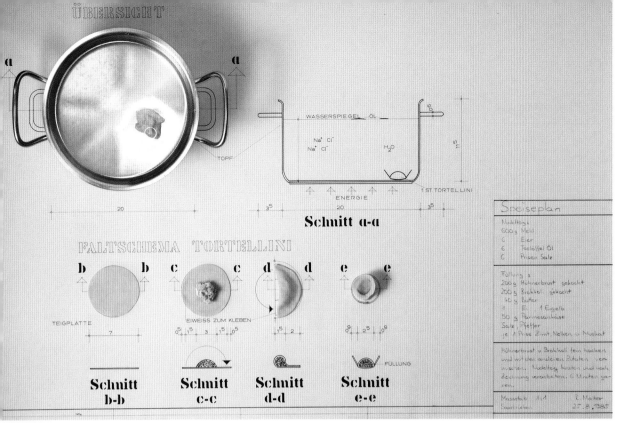

Von der Skizze zum Entwurf

Das Tischset wurde kurzerhand zur Modell-
vorlage für das Entwerfen der Tortellini.
So entsteht bei jeder Idee zuerst eine
Skizze, bevor dann aus dem Entwurf das
Endprodukt wird – entweder Tortellini oder
ein Gebäude.

From sketch to design

The place mat suddenly became the draft
model for designing the tortellini. Thus for
every idea one starts with a sketch, before
having a design which leads to the end
product – either tortellini or a building.

Yin-und-Yang-Suppe

Edith Heuser, Frankfurt am Main

Rote-Bete-Suppe

300 g rote Bete, 1 Apfel, 1 Zwiebel, 2 EL Butter
100 ml Weißwein, 400 ml Brühe, 3 EL Sahne, 3 EL Sauerrahm
1 EL Zitronensaft, Salz, Pfeffer

Rote Bete, Apfel und Zwiebel schälen. Den Apfel vierteln und das Kerngehäuse entfernen. Das Gemüse in Würfel schneiden und 10 Minuten mit der Butter dünsten. Mit Weißwein ablöschen und mit Brühe aufgießen. Die Suppe 30 Minuten bei schwacher Hitze kochen, anschließend pürieren und mit Sahne, Sauerrahm, Zitronensaft, Salz und Pfeffer verfeinern.

Kürbissuppe

1 Zwiebel, 2 cm Ingwerwurzel, 300 g Hokkaido-Kürbis
2 EL Butter, 100 ml Milch, 300 ml Brühe, Salz
2 TL Currypulver, 1/2 Bund Petersilie

Zwiebel und Ingwer schälen und klein würfeln. Die Kerne aus dem Kürbis herauskratzen, das Fruchtfleisch klein schneiden. Zwiebel, Ingwer und Kürbis 10 Minuten mit der Butter dünsten. Mit Milch und Brühe auffüllen. 30 Minuten bei schwacher Hitze kochen, pürieren und mit Salz und Currypulver abschmecken. Die Petersilie waschen, trocken schütteln und grob hacken.

Anrichten

Die beiden Suppen in zwei Messbecher füllen. Einen Messbecher in jede Hand nehmen und beide Suppen gleichzeitig von links und rechts in die Suppenteller gießen. Mit Petersilie bestreuen und servieren.

Yin-and-Yang-Soup

Edith Heuser, Frankfurt on the Main

Beetroot soup

300 g beetroot, 1 apple, 1 onion, 2 tbsp. butter
100 ml white wine, 400 ml stock, 3 tbsp. cream, 3 tbsp. thick
soured cream, 1 tbsp. lemon juice, salt, pepper

Peel beetroot, apple and onion. Core and quarter the apple. Dice the vegetables and cook in butter for 10 minutes. Pour in white wine and stock. Simmer soup on low heat for 30 minutes, then purée and refine with cream, soured cream, lemon juice, salt and pepper.

Pumpkin soup

1 onion, 2 cm ginger root, 300 g Hokkaido pumpkin
2 tbsp. butter, 100 ml milk, 300 ml stock, salt
2 tbsp. curry powder, 1/2 bunch parsley

Peel and finely dice onion and ginger. Scratch the pips out of the pumpkin, finely cut the flesh. Cook the onion, ginger and pumpkin in the butter for 10 minutes. Top up with milk and stock. Simmer on a low heat for 30 minutes, purée and season with salt and curry powder. Wash parsley, shake it dry and chop coarsely.

To arrange

Fill both soups into two measuring jugs. Holding one measuring jug in each hand pour both soups into the soup bowls simultaneously from left and right. Strew with parsley and serve.

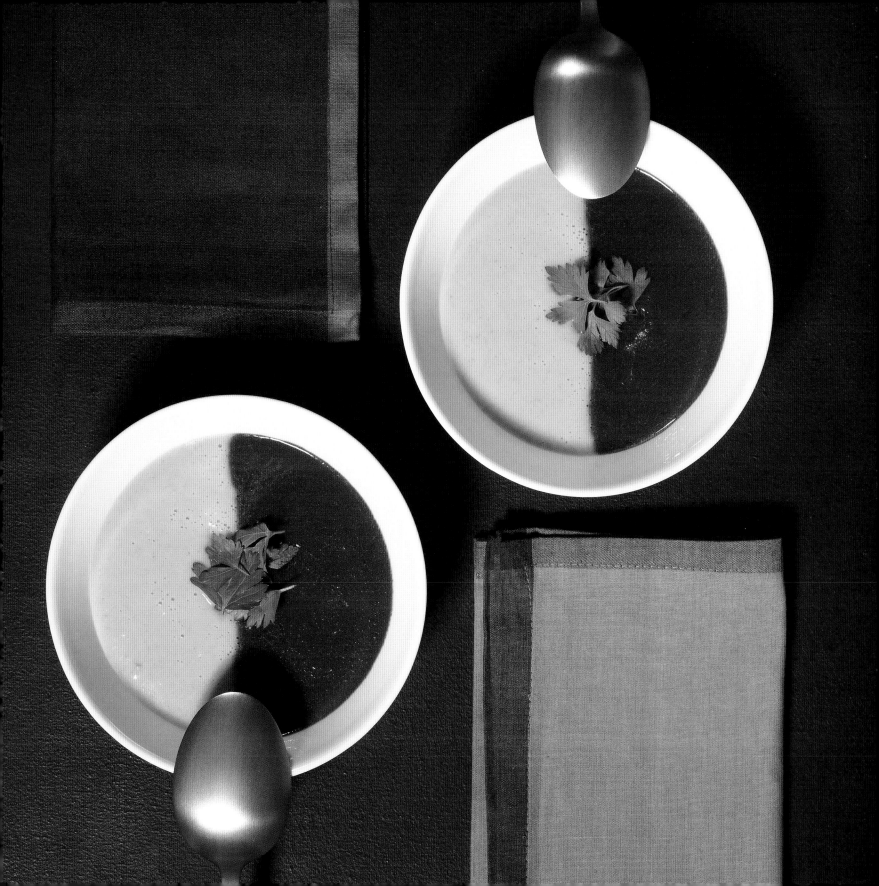

Kamo Seiro Soba

Kengo Kuma, Tokio

1 Entenbrust (ca. 250 g)
2 EL Öl, Salz
1/2 Bund Lauchzwiebeln
200 g japanische Buchweizennudeln
800 ml Enten- oder Geflügelbrühe

1. Die Haut der Entenbrust mit einem scharfen Messer rautenförmig einritzen. 1 EL ÖL in einer beschichteten Pfanne erhitzen, die Entenbrust salzen und 10 Minuten auf der Hautseite braten. Währenddessen die Lauchzwiebeln waschen, putzen, in 4 cm lange Stücke schneiden. Die Entenbrust wenden, die Lauchzwiebelstücke in die Pfanne geben. Zusammen 4–6 Minuten fertig garen, danach aus der Pfanne nehmen und auf einem Teller ruhen lassen.

2. Nudeln nach Packungsanweisung kochen, mit kaltem Wasser abschrecken, abtropfen lassen und mit 1 EL Öl mischen. Brühe aufkochen, die Entenbrust in dünne Scheiben schneiden. Lauchzwiebeln und Entenfleisch auf vier Schälchen verteilen. Mit der kochenden Brühe begießen. Die kalten Nudeln separat servieren, sodass jeder Gast mit seinen Stäbchen jeweils ein paar Nudeln aufnimmt und in die heiße Brühe taucht – ähnlich wie in einen Dip.

Tipp

Selbst gemachte Geflügelbrühe schmeckt am besten: 1 Suppenhuhn oder die Knochen einer gebratenen Ente in einen großen Topf geben und knapp mit Wasser bedecken. 1 Zwiebel ungeschält halbieren und mit 3 gequetschten Knoblauchzehen in den Topf geben. Alles aufkochen. Den aufsteigenden Schaum mit einem Sieblöffel abschöpfen. Die Brühe bei schwacher Hitze 1–2 Stunden kochen, bis das Fleisch sich fast von selber von den Knochen löst. Nach einer halben Stunde kräftig salzen. Die Brühe vorsichtig durch ein feines Sieb oder ein Passiertuch gießen.

Kamo Seiro Soba

Kengo Kuma, Tokyo

1 duck breast (about 250 g)
2 tbsp. oil, salt
1/2 bunch spring onions
200 g Japanese buckwheat noodles
800 ml duck or poultry stock

1. Cut diamond shapes into the skin of the duck using a sharp knife. Heat 1 tbsp. oil in a coated frying pan, salt the duck breast and fry for 10 minutes skin side down. Meanwhile wash and clean the spring onions and cut them into 4 cm pieces. Turn the duck breast, add the pieces of spring onion to the pan, cook together for 4–6 more minutes, then remove from pan and leave to stand on a plate.

2. Cook noodles according to instructions on the packet, rinse in cold water, drain and mix with 1 tbsp. oil. Boil the stock, cut duck breast into thin slices. Divide spring onions and duck meat into four small bowls. Pour boiling stock on top. Serve the cold noodles separately so that every guest picks up a few noodles at a time with his chopsticks and dips them into the hot brew – similar to into a dip.

Tip

Homemade poultry stock tastes the best: Put 1 boiling fowl or the bones of a roasted duck into a large saucepan and barely cover with water. Halve an unpeeled onion and put this into the saucepan together with 3 crushed garlic cloves. Bring everything to the boil. Remove the scum with a skimmer, as it arises. Simmer the stock on a low heat for 1–2 hours until the meat almost comes off the bones by itself. After half an hour salt well. Carefully strain the stock through a fine sieve or cloth.

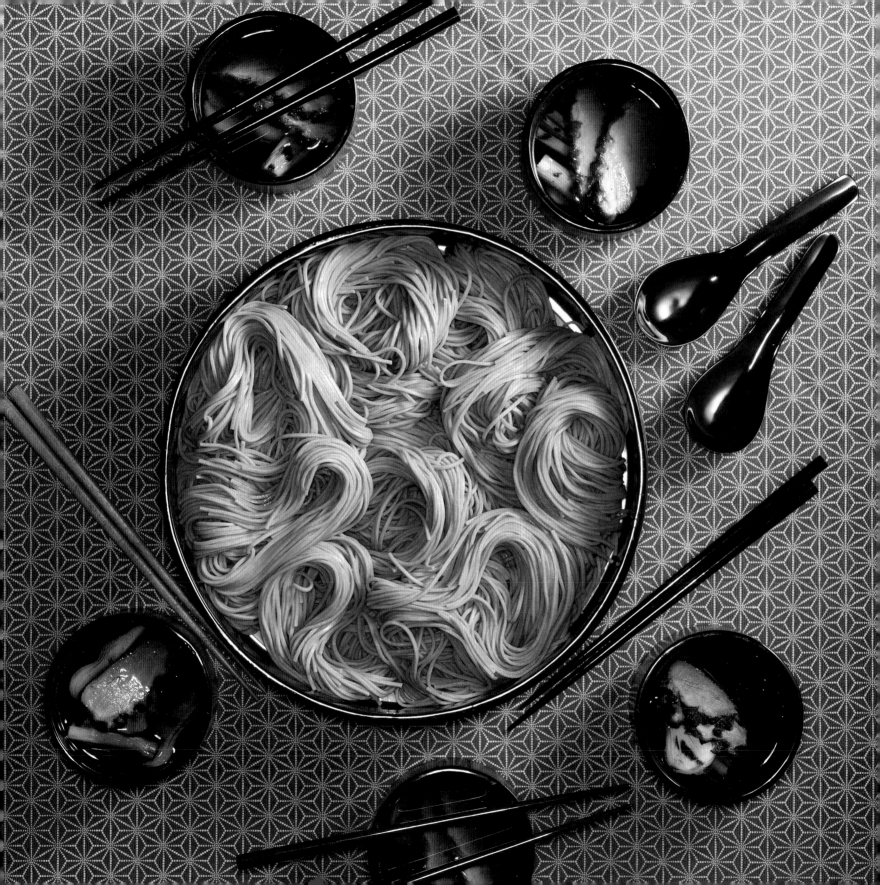

»Ich will die japanische Tradition in einer sehr modernen und zeitgenössischen Art wiederbeleben«, beschreibt Kengo Kuma seine Architektursprache.

Die Umsetzung dieses Anspruchs gelingt durch die sensible Kombination einer zeitgemäßen Architektursprache mit der traditionell starken Bindung zur Natur. Die Verwendung der Materialien in Bezug auf Umgebung, Situation und Bauaufgabe spielt hierbei eine große Rolle. Angemessene Materialen werden gefunden, neue Werkstoffe erforscht. So gelingt es Kengo Kuma – wie bei seinem Steinmuseum in Nasu (2000) – durch den Einsatz des Materials dem Gebäude eine ausgeprägte Identität zu geben und gleichzeitig eine starke Einheit mit der Umgebung zu erzeugen.

"I want to revive the Japanese tradition in a very modern and contemporary way", Kengo Kuma describes his architectural language. The realization of this claim will be accomplished by a sensitive combination of a contemporary architectural language with the traditional strong bond with nature. The use of the materials in relation to the environment, situation and the construction plays a big role here. Adequate materials are being found, new materials explored. Thus Kengo Kuma succeeds – as with his Stone Museum in Nasu (2000) – in giving the building a prominent identity through the use of the material and at the same time creating a strong unity with the environment.

Gegensätze als Quintessenz

Kalte »Soba« (Buchweizennudeln) werden in einem quadratischen Holzkasten serviert, dem »Seiro«. Zur rechten Seite des Seiros befindet sich eine Porzellantasse, die sehr heiße Entenbrühe enthält. Darin schwimmen dunkles Entenfleisch und dicke Scheiben gegrillten japanischen Lauches, an der Oberfläche sammelt sich durchsichtiges Entenfett. Als erstes tunkt man die kalten Soba von der linken Seite in die heiße Suppe auf der rechten Seite, dann steckt man die Soba in den Mund. Kalt trifft auf heiß, fest trifft auf flüssig, Quadrate treffen auf Kreise, Wasser trifft auf Öl ... Diese Kontraste zu genießen, wie sie aufeinanderprallen, ist der Inbegriff der »Kamo Seiro Soba«.

Opposites as a quintessence

Cold soba (buckwheat noodles) is served in a square, wooden box called a »seiro«. To the right of the seiro a porcelain cup is placed containing extremely hot soup made from duck stock. Floating in the soup there are duck meat and thick slices of grilled Japanese leek, and on the surface there is transparent duck fat. First you dip the cold soba on the left into the hot soup on the right then you put the soba into your mouth. Cold meets hot, solid meets liquid, squares meet circles, water meets oil... Enjoying all these contrasts as they encounter each other is the essence of »Kamo Seiro Soba«.

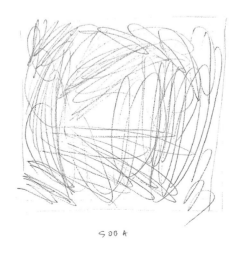

SOBA

+

DUCK SOUP

KENGO KUMA
MAR 27 2007

Kengo Kuma & Associates
Plastic House, Tokio, 2002,
Kunststofflamellen (S. 70 oben)
Steinmuseum in Nasu, 2000, vulkanischer
Shirakawastein (S. 70 Mitte und rechts)
Historisches Museum, Nasu, 2000,
gepresstes Strohpaneel (S. 70 unten)

Kengo Kuma & Associates
Plastic House, Tokyo, 2002,
plastic louvres (p. 70 top)
Stone Museum in Nasu, 2000, volcanic Shi-
rakawa stone (p. 70 centre and right)
Nasu History Museum, 2000, pressed straw
panel (p. 70 below)

Andreas Aug mit/with Alexander Tschebull

Sinn und Sinnlichkeit
Sense and Sensibility

■ Eine Kostprobe seiner kulinarischen Suche nach Qualität und dem vollendeten Geschmack präsentiert Andreas Aug in der Siemens lifeKochschule im Erlebniskochen-Haus nahe Hamburg. Bei der Umsetzung unterstützt ihn Sternekoch Alexander Tschebull, Chef de Cuisine im Restaurant Allegria in Hamburg. Sie schicken die Geschmacksnerven ihrer Gäste gemeinsam auf eine intensive Reise.

■ Andreas Aug in his "experience cooking" at Siemens lifeKochschule in the Erlebniskochen-Haus near Hamburg presents us a sample of his culinary search for quality and perfect flavour. He is assisted in this task by star chef Alexander Tschebull, Chef de Cuisine at the Allegria restaurant in Hamburg. The pair of them send our gustatory nerves on an intensive journey.

Die Akteure: Andreas Aug von sigeko-Ingenieure, Hamburg, und Alexander Tschebull, Küchenchef im Restaurant Allegria, Hamburg
Der Ort: Siemens lifeKochschule im Erlebniskochen-Haus bei Hamburg
Das Menü: Duett vom Seeteufel – Dreierlei vom Huhn – Variationen von der Erdbeere
Das Rezept ist klar strukturiert, der Erlebnisbogen spannt sich vom Salzigen über das Süßsalzige zum Süßen. Eine Steigerung entsteht durch die steigende Anzahl der Hauptkomponenten.
Der Kernsatz: »Mit Sinn kochen oder entwerfen, führt zu sinnlichen Erlebnissen, dabei ist gute Qualität auch ohne Worte zu verstehen.«

The actors: Andreas Aug from sigeko-Ingenieure, and Alexander Tschebull, chef de cuisine at the Allegria restaurant, Hamburg
Place: Siemens lifeKochschule at the Erlebniskochen-Haus near Hamburg
The menu: Duet of Monkfish – Trilogy of Chicken – Variations on a Strawberry. The recipe is clearly structured, the bow of experience spans from savoury, via sweet-savoury to sweet. There is a progression due to the increasing number of main components.
The core sentence: "Cooking or planning with the senses results in sensual experiences, good quality can be appreciated without words."

Kochen und Architektur als Passion

»Der gestaltende Architekt und der kreative Koch sind im besten Fall Künstler, die mit intensiver Leidenschaft nach der perfekten Form und dem vollendeten Geschmack suchen«, bringt Andreas Aug in einem Satz seine Ansicht über den Zusammenhang zwischen Architektur und Kochen auf den Punkt. Auch er ist seit seiner Ausbildung zum Koch in Lüneburg ein Suchender, zuerst bei seiner Arbeit in Cutter's Restaurant in Los Angeles, dann im Sheraton in Essen, schließlich – nach seinem Besuch der Hotelfachschule Heidelberg – als selbstständiger Gastronom, bevor er sich 1988 der Architektur zuwendet. Mit dem Diplom der Fachhochschule Hamburg in der Tasche führt ihn seine Suche weiter in verschiedene Architekturbüros in Hamburg, Los Angeles und Taipeh, bevor er sich 1998 wieder selbstständig macht, diesmal als Architekt mit dem Büro ArcServ. Nach einer Fortbildung zum Sicherheitsingenieur gründet er sigeko-Ingenieure.

Cooking and architecture as a passion

"The designing architect and the creative cook are at best artists who are looking with intensive passion for the ideal form and the perfect taste", Andreas Aug hits the nail on the head with this one sentence concerning his view of the connection between architecture and cooking. He too has been a searcher since qualifying as a chef in Lunenburg, first of all in his work at Cutter's Restaurant in Los Angeles, then at the Sheraton in Essen, finally – after attending professional hotel school in Heidelberg – as a self-employed gastronomist, before turning to architecture in 1988. With his degree from the Hamburg University of Applied Sciences in his pocket, his search continued to take him through various architects' offices in Hamburg, Los Angeles und Taipei before becoming self-employed again in 1998, this time as an architect with the ArcServ office. After further training as a safety engineer he founded the firm sigeko-Ingenieure.

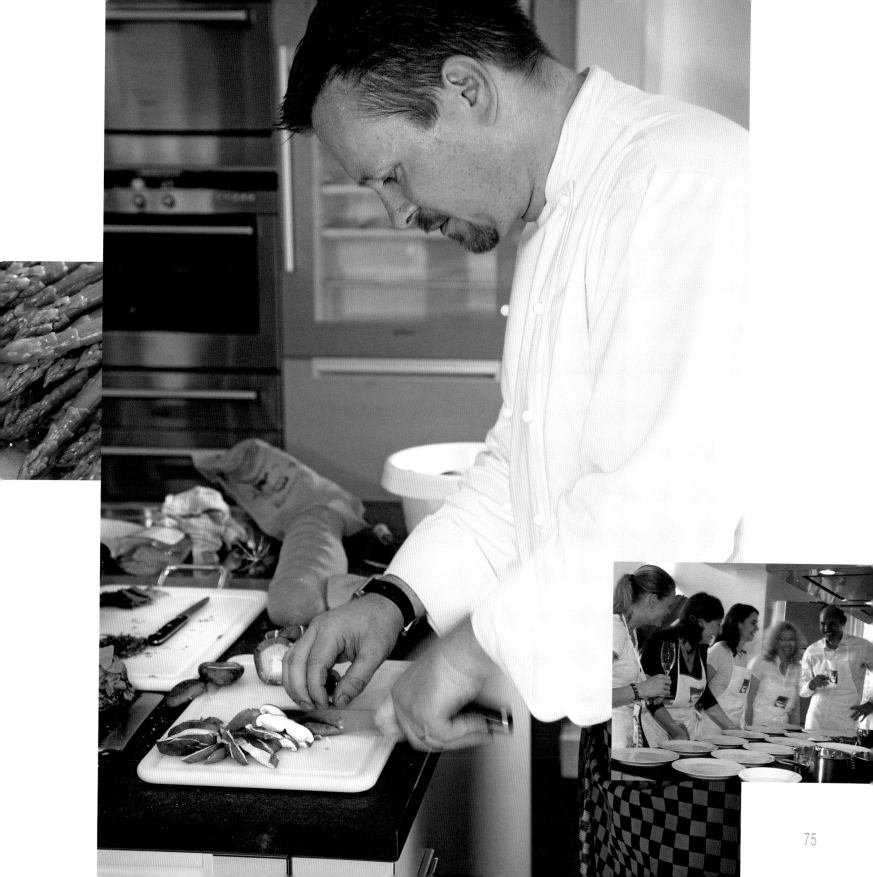

Seeteufel mit schwarzem Risotto und Safranschaum

3 Schalotten, 5 EL Butter
100 g schwarzer Vollkornreis aus dem Piemont
Salz, Pfeffer, 0,2 g Safranfäden
300 ml Weißwein, 200 ml Sahne
200 g grüner Spargel, 1/2 Lauchstange
1 Möhre, 150 g Shiitake
1 Seeteufelfilet (400–500 g), 4 Seeteufelbäckchen
1 EL geriebene Zitronenschale

1. Schalotten schälen und fein würfeln. Die Hälfte davon mit 2 EL Butter 2 Minuten dünsten. Den schwarzen Reis zugeben, 2 Minuten weiter dünsten. 400 ml Wasser aufgießen, salzen und ca. 40 Minuten bei schwacher Hitze zugedeckt garen. Falls nötig, noch etwas Wasser nachgießen. Safranfäden mit 100 ml Weißwein sirupartig einkochen. Sahne zugeben und einkochen, bis die Sauce cremig wird.

2. Die Spargelenden abschneiden. Spargel 5 Minuten kochen, abschrecken, in 4 cm lange Stücke schneiden. Lauch putzen, Möhre schälen und zusammen in dünne Streifen schneiden. Shiitakestiele abschneiden, die Kappen in Scheiben schneiden. Seeteufelfilet in 8 Medaillons schneiden.

3. Restlichen Weißwein mit dem Wurzelgemüse aufkochen. Seeteufelbäckchen auf das Gemüse legen, salzen und 3 Minuten garen. Medaillons würzen und mit 2 EL Butter in einer beschichteten Pfanne 8-10 Minuten braten. Die Pilze mit der restlichen Butter 3 Minuten dünsten, mit dem Spargel 2 Minuten fertig garen. Das Gemüse zusammen mit der Garflüssigkeit der Fischbäckchen unter den Reis mischen, abschmecken. Die Safransauce aufkochen und mit einem Pürierstab schaumig mixen. Das schwarze Risotto mit Seeteufel, Wurzelgemüse und Safranschaum anrichten, mit Zitronenschale garnieren.

Trinken

Trinken Sie dazu einen trockenen, spritzigen Champagner. Zum Beispiel den PremierCru, Selection aus Cumiers von René Geoffroy.

Monkfish with black risotto and saffron foam

3 shallots, 5 tbsp. butter
100 g black wholegrain rice from Piedmont
salt, pepper, 0.2 g strands of saffron
300 ml white wine, 200 ml cream
200 g green asparagus, 1/2 leek
1 carrot, 150 g shiitake
1 monkfish filet (400–500 g), 4 monkfish cheeks
1 tbsp. grated lemon rind

1. Peel and finely dice shallots. Sauté half of them in 2 tbsp. butter for 2 minutes. Add the rice, cook for further 2 minutes. Pour on 400 ml water, add salt and simmer on a low heat, covered, for approx. 40 minutes. If necessary add a little more water. Reduce saffron strands to syrup in 100 ml white wine. Add cream and reduce until the sauce is creamy.

2. Cut off the ends of the asparagus. Boil asparagus for 5 minutes, rinse in cold water, cut into 4 cm long pieces. Clean the leek, peel the carrot and cut them together into thin strips. Cut off the shiitake stalks, slice the tops. Cut the monkfish filet into 8 medallions.

3. Boil the rest of the white wine with the root vegetables. Place the monkfish cheeks on the vegetables, salt and cook for 3 minutes. Season medallions and fry in 2 tbsp. butter in a coated frying pan for 8-10 minutes. Sauté the mushrooms for 3 minutes in the remaining butter; continue to cook with the asparagus for 2 minutes. Mix the vegetables, together with the cooking water from the fish cheeks, into the rice, season to taste. Bring the saffron sauce to the boil and purée with a hand blender until frothy. Arrange the black risotto together with the monkfish, root vegetables and saffron foam, garnish with lemon rind.

To drink

With this meal drink a dry, tangy champagne. For example Premier Cru, Selection from Cumiers by René Geoffroy.

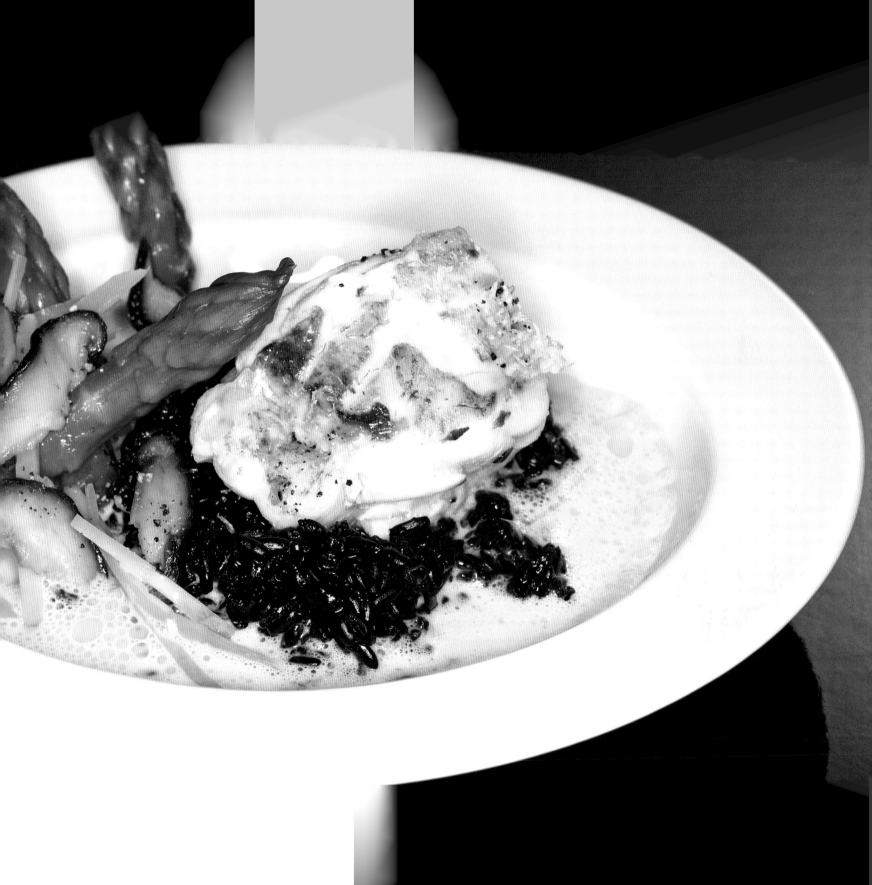

Ein Menü für Freunde

Mit einer Kostprobe seiner kulinarischen Suche verwöhnt der Architekt im Erlebniskochen-Haus bei Hamburg Freunde und Kollegen – mit einem Duett vom Seeteufel, Dreierlei vom Huhn und Variationen von der Erdbeere. Der lange Tisch aus Kirschbaumholz ist bereits mit eleganten Weingläsern, weißen Kerzen und Rosen eingedeckt. Durch die zweigeschossige Fensterfront an der Giebelseite des Hauses fällt der Blick auf die leicht abfallenden Spargelfelder am Kiekeberg, davor eine große Terrasse aus dunklen Holzbohlen. Ein Kamin unterteilt 120 Quadratmeter in Kochen und Tafeln. Hier fühlt

A menu for friends

The architect pampers his friends and colleagues at the Erlebniskochen-Haus in Hamburg with a sample of his culinary searching – with a Duet of Monkfish, Trilogy of Chicken and Variations on a Strawberry. The long cherry wood table has already been set with elegant wine glasses, white candles and roses. Through the two-storey window front on the gable side of the house one looks out onto the asparagus fields slightly sloping down to Kiekeberg, in front of them there is a large veranda made of dark wooden sleepers. An open fireplace divides 120 square metres into cooking and tables.

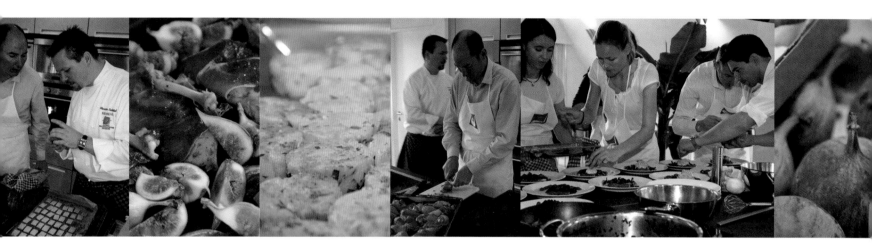

sich der Gastgeber gleich heimisch, denn seine Rezepte entstanden in ganz ähnlicher Umgebung, in seinem Ferienhaus in einem kleinen Dorf in Mecklenburg-Vorpommern, wo er sich gerne hin und wieder mit Familie und Freunden zurückzieht, um sich beim Lesen, Malen und Kochen zu entspannen.

Here the host really feels at home because his recipes originated in very similar surroundings, in his holiday home in a small village in Mecklenburg-West Pomerania, where he occasionally enjoys getting away from things with family and friends to relax while reading, painting and cooking.

Regionale Zutaten und der Geschmack des Südens

Auf der schwarzen Granit-Arbeitsplatte der T-förmigen Kochinsel stehen die Zutaten schon bereit: gehäutete Schalotten in einer weißen Schale, blasse Artischockenherzen in einer Edelstahlschüssel, Pinienkerne in einem Glasschälchen. Daneben finden sich sauber getrennt Brustfilets, Keulchen und Leber vom Perlhuhn. Dazwischen verstreut: lange Küchenmesser, Schwingbesen, Probierlöffel, Salz und Pfeffer, Olivenöl, Sahne, Backpapier und Messbecher. Auf einem flachen Teller setzen sich das samtige Grün und das kräftige Rosé geviertelter Feigen in Szene, während schwarzer Risotto-Reis

Regional ingredients and the flavour of the south

On the black granite working-surface of the T-shaped island suite the ingredients are already to start: peeled shallots in a white bowl, pale artichoke hearts in a stainless steel bowl, pine nuts in a little glass bowl. Next to these, and cleanly separated, there are guinea fowl breast filets, legs and liver. Strewn amongst them: long kitchen knives, whisks, tasting spoons, salt and pepper, olive oil, cream, greaseproof paper and measuring jugs. On a flat plate the velvet green and the bright pink of quartered figs catch one's eye while some black risotto rice bubbles away in harmony with some saffron sauce

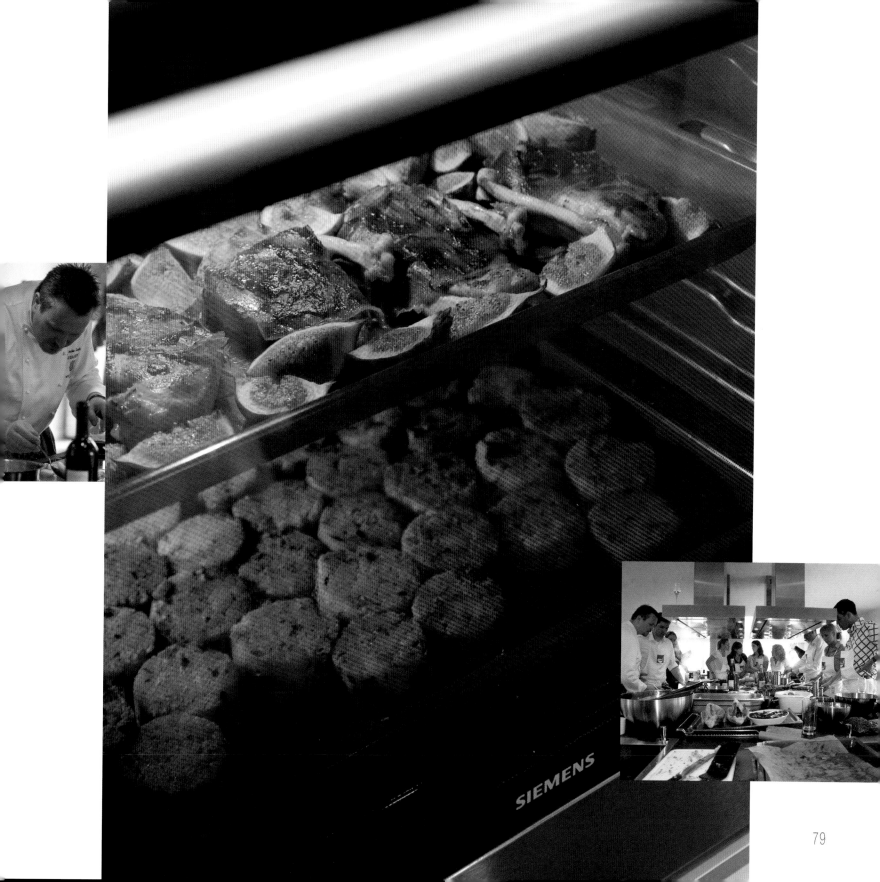

Perlhuhn mit Artischocken

250 g Knödelbrot, 200 ml Milch, 1 Bund Estragon, 2 Eier
Salz, Pfeffer, Muskat, 2 Schalotten, 2 Perlhuhnbrüste ohne Haut
2 Perlhuhnkeulen, 2 EL Öl, 400 ml Rotwein, 2 rote Zwiebeln
4 junge Artischocken, 2 EL Zitronensaft, 4 EL Olivenöl
4 frische Feigen, 4 EL Feigenkonfitüre oder Pflaumenmus
4 Scheiben Serrano-Schinken, 150 g Butter

1. Knödelbrot mit warmer Milch 15 Minuten einweichen. Estragon zupfen, mit Knödelbrot und Eiern mischen, mit Salz, Pfeffer und Muskat würzen. Ein 80 cm langes Stück Alufolie doppelt nehmen und ölen. Den Knödelteig in der Folie fest einrollen, die Enden zudrehen. Die Rollen in schwach siedendem Wasser 20 Minuten garen.

2. Schalotten schälen und fein würfeln. Perlhuhnteile würzen und mit dem Öl anbraten. Das Perlhuhn aus der Pfanne nehmen, die Schalottenwürfel hinein geben. Mit Rotwein ablöschen, einkochen, bis nur noch 3–4 EL übrig sind. Zwiebeln schälen, halbieren und in Streifen schneiden. Die oberen zwei Fünftel der Artischocken mit einem Sägemesser abschneiden. Zähe äußere Blätter mit einem kleinen Messer entfernen. Die Stiele auf ca. 10 cm kürzen und schälen. Artischocken der Länge nach halbieren, das »Heu« mit einem Teelöffel entfernen. Die Hälften in dünne Scheiben schneiden. Zwiebeln und Artischocken mit Zitronensaft und Olivenöl marinieren.

3. Backofen auf 170 Grad vorheizen (Umluft 150 Grad). Feigen waschen und vierteln. Perlhuhnbrüste mit Konfitüre bestreichen, mit Schinken umwickeln. Perlhuhn und Feigen in einer ofenfesten Form 15–20 Minuten im Ofen garen. Die Knödelrolle in 12 Scheiben schneiden, mit 3 EL Butter goldbraun braten. Das Artischockengemüse aufkochen, mit Salz und Pfeffer abschmecken. Restliche Butter in Würfel schneiden. Die Rotweinreduktion erhitzen und die Butterwürfel nacheinander unterrühren, sodass eine cremige Emulsion entsteht. Perlhuhn, Feigen, Artischocken und Estragonplätzchen anrichten. Mit Rotweinbutter servieren.

Trinken

Dazu passt ein gehaltvoller, blumigen Champagner. Zum Beispiel der Oeil de Perdrix, Rosé von Jean Vesselle aus Bouzy.

Guinea fowl with artichokes

250 g bread dumplings, 200 ml milk, 1 bunch of tarragon, 2 eggs
salt, pepper, nutmeg, 2 shallots, 2 guinea fowl breasts without skin
2 guinea fowl legs, 2 tbsp. oil, 400 ml red wine, 2 red onions
4 young artichokes, 2 tbsp. lemon juice, 4 tbsp. olive oil
4 fresh figs, 4 tbsp. fig jam or plum jam
4 slices of Serrano ham, 150 g butter

1. Soak bread dumplings in warm milk for 15 minutes. Pull off the tarragon leaves, mix with the bread dumplings and eggs, season with salt, pepper and nutmeg. Take an 80 cm long piece of tinfoil, fold it double and grease it with oil. Roll the dumpling dough up tightly in the foil, twist the ends shut. Simmer for 20 minutes.

2. Peel shallots and dice finely. Season the guinea fowl parts and fry them in oil. Remove the guinea fowl from the pan and put in the diced shallots. Deglaze with red wine until there is only 3–4 tbsp. left. Peel and halve onions and cut them into strips. Cut off the top two fifths of the artichokes using a serrated knife. Remove the tough outer leaves with a small knife. Shorten the stalks to 10 cm and peel them. Cut the artichokes in half, lengthwise and remove the choke with a teaspoon. Cut the halves into thin slices. Marinate onions and artichokes with lemon juice and olive oil.

3. Preheat oven to 170 degrees (convection 150 degrees). Wash figs and quarter them. Brush guinea fowl breasts with jam, then wrap with ham. Grill guinea fowl and figs in an ovenproof dish for 15–20 minutes in the oven. Cut the dumpling roll into 12 slices and fry in 3 tbsp. butter until golden brown. Bring the artichokes to the boil, season with salt and pepper. Dice the remaining butter. Heat up the remaining red wine and stir in the butter dices one after another until you have a creamy emulsion. Arrange guinea fowl, figs, artichokes and tarragon cookies. Serve with red wine-butter mix.

To drink

A good choice here is a rich, flowery champagne. For example Oeil de Perdrix, Jean Vesselle Rosé from Bouzy.

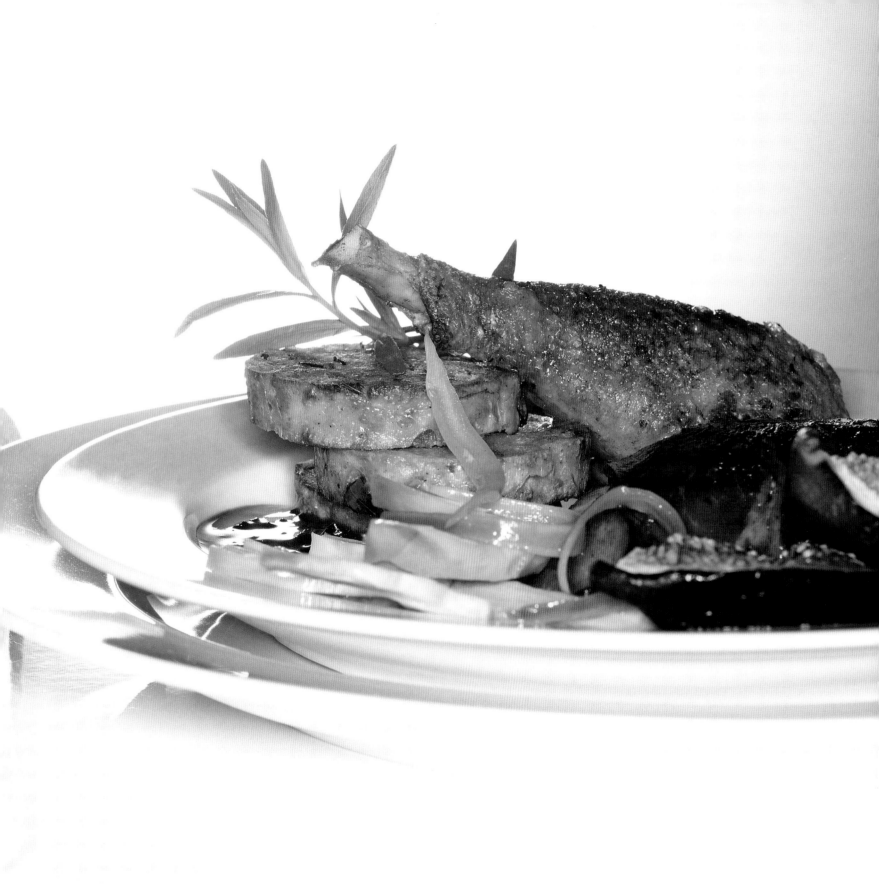

einträchtig neben einer Safransauce auf dem Induktionskochfeld vor sich hin köchelt. Gehackte Minze und geraffelte Orangenschalen verbreiten einen frischen Duft. »Ich mag es, wenn regionale Produkte verwendet werden. Unser Huhn zum Beispiel kommt vom Bauernhof in Mecklenburg und der Seeteufel aus der Ostsee. Die Erdbeeren holen wir in Gramkow vom Feld«, verrät Andreas Aug. »Trotzdem verzichte ich nicht auf Produkte aus anderen Ländern. Das erinnert mich an unsere Urlaube in Italien, Spanien und Frankreich. Den schwarzen Reis kennen wir aus Norditalien. Er schmeckt wundervoll sanft und nussig und sieht fantastisch aus.«

on the induction hob. Chopped mint and coarsely grated orange peel gives off a fresh fragrance. "I like it if regional products are used. Our bird, for example, comes from a farm in Mecklenburg and the monkfish from the Baltic. We get the strawberries from a field in Gramkow", divulges Andreas Aug. "All the same I don't refuse to use products from other countries. They remind me of our holidays in Italy, Spain and France. We know the black rice from Northern Italy. It tastes wonderfully mild and nutty and it looks fantastic."

Der Chefkoch geht zur Hand

Bei der Umsetzung der eingereichten Rezepte im Erlebniskochen-Haus geht ihm Alexander Tschebull, Chef de Cuisine im Restaurant Allegria in Hamburg, zur Hand. Die beiden kennen sich, der Architekt ist öfter zu Gast im Allegria, das im Winterhuder Fährhaus ganz in der Nähe seiner Wohnung mit ambitionierter austro-mediterraner Küche aufwartet. Und sie ergänzen sich gut: Während Andreas Aug still und konzentriert im Hintergrund die Hühnerbrustfilets häutet – die Haut wird später frittiert und für die Dekoration verwendet – kümmert sich Alexander Tschebull um die Show. Er bezieht die eintreffenden Gäste gleich in den Kochprozess mit ein, teilt ihnen Aufgaben zu und demonstriert nebenbei ein paar Profitricks, beispielsweise wie Karamellisieren garantiert ohne Klumpen gelingt. »Jeder Topf hat eine Stelle, die zuerst heiß wird«, erklärt der Profikoch. Um diese zu finden, bedeckt er den Topfboden mit einer dünnen Schicht Zucker und stellt ihn auf die heiße Herdplatte. »Dort wo der Zucker zuerst

The chef lends a hand

When preparing the recipes which have been given to them in the Erlebniskochen-Haus Alexander Tschebull, Chef de Cuisine in the Allegria restaurant in Hamburg, lends a helping hand. The two know each other; the architect is a frequent guest in the Allegria, which serves up ambitious Austro-Mediterranean fare in the Winterhuder Fährhaus, right near his home. And they complement each other well: Whilst Andreas Aug concentrates on skinning the chicken filets quietly in the background – the skin will be deep-fried later and used for decoration – Alexander Tschebull takes care of the show. He involves the guests in the cooking process straight away as they arrive, gives them tasks to complete and while he does so demonstrates a few tricks of the trade, for example how to caramelise successfully with absolutely no risk of lumps. "Every saucepan has one spot which gets hot first", the professional chef explains. To find out where that spot is he covers the bottom of the saucepan with a thin layer of

schmilzt, schütten wir den Rest hin. Aber nicht alles auf einmal, damit es nicht anbrennt und nicht umrühren! Das gibt nur unnötig Klumpen.« Sobald der Zucker braun wird, gibt er Butter dazu. Das Fett löst die klebrige Masse vom Topfboden und fertig ist die Vorführung. »Den Karamell jetzt aber bitte nicht probieren oder gar anfassen«, warnt der Koch sein Publikum, »das verursacht gemeine Brandblasen und man kann die klebrige Masse nur schlecht von den Fingern lösen.« Dann kippt er die Schalotten dazu, schwenkt den Topf ein paar Mal und löscht mit Wein ab. Die Gäste haben sich inzwischen um die große Kochinsel versammelt und werkeln fleißig mit. Die einen wickeln den Serrano-Schinken um die Perlhuhnbrustfilets, andere tauchen die Erdbeeren für das Dessert zur Hälfte in geschmolzene Zartbitterschokolade. »Nicht in kaltem Wasser abkühlen, sonst entsteht dieser unansehnliche graue Schleier, und wir wollen hier einen schön glänzenden Schokobezug«, weist Alexander Tschebull seine Schützlinge an. Ein junger Mann in weißem Hemd und Schürze brät die Estragonplätzchen, während an anderer Stelle die Seeteufelmedaillons dünsten und die Shiitake-Pilze in der Butter schwitzen. Der ganze Raum ist durchzogen von würzigem Duft, es zischt und brutzelt und knistert und dampft. Die beiden Köche behalten den Überblick und die Ruhe, stimmen sich nur hin und wieder kurz miteinander ab. Andreas Aug findet sogar noch Zeit, seine Vorgehensweise bei der Zusammenstellung eines Menüs darzulegen: »Ein Gericht sollte aufgehen, das heißt, dass ich alle Produkte nutze, nicht endlose Vorbereitung für Saucen und Fonds habe und am Ende Reste, die sich in der professionellen Küche zwar weiterverarbeiten lassen, zu Hause aber nur den Kühlschrank verstopfen.«

Die Qualität – wichtigstes Kriterium

»Als Koch und Architekt suche ich beim Entwurfsprozess immer nach objektiven Beurteilungskriterien«, zieht Andreas Aug sein Fazit. »Bei vielen Kollegen beider Genres erkenne ich genau diese Bemühungen. Selten sprechen sie darüber. Meistens ist zu wenig Zeit, Geduld und Verständnis beim Zuhörer vorhanden. Und dennoch wird es verstanden!« Gute Qualität ist eben auch ohne Worte spürbar, wenn es gelingt, Zutaten und Rahmenbedingungen sowohl in der Architektur als auch beim Kochen miteinander in Einklang zu bringen. Immer wieder kehrt der Geschmack auf die Zunge zurück, dringt der Geruch in die Nase, erscheint das Bild vor dem geistigen Auge. Die perfekte Form zieht den Blick auf sich. Man möchte anhalten, betrachten, durchschreiten, berühren und verstehen.

sugar and puts it on the hotplate. "There where the sugar melts first is where we tip the rest in. But not all at once so that nothing burns and don't stir! That just causes unnecessary lumps." As soon as the sugar goes brown he adds butter. The fat loosens the sticky mixture from the bottom of the pan and there the demonstration ends. "But please don't taste the caramel yet or even touch it", the chef warns his audience, "that causes nasty burn blisters and it's hard to get the sticky stuff off your fingers." Then he tips in the shallots, shakes the pan a few times and deglazes with wine. Meanwhile the guests have converged around the large island suite and are busily at work. Some are wrapping the Serrano ham round the guinea fowl filets – others are dipping the strawberries for the dessert halfway into melted plain chocolate. "Don't cool it in cold water, otherwise this unattractive grey film forms and we want the chocolate coating to be nice and shiny", Alexander Tschebull teaches his protégées. A young man in a white shirt and an apron is frying the tarragon dumplings, whilst somewhere else someone is steaming the monkfish medallions and sautéing the shiitake mushrooms in butter. The whole room is full of spicy smells, there's a hissing and sizzling and crackling and steaming. Both chefs keep an eye on everything and keep calm, only occasionally consulting each other for a moment. Andreas Aug even finds enough time to explain his methods when putting together the menu: "A dish should add up, that means that I use up all the products, that I don't spend endless hours preparing sauces and stocks leaving me with leftovers, which in a professional kitchen would be used up for something but at home only cram the fridge."

The quality – most important criterion

"As a cook and an architect I always look for objective assessment criteria during the designing process", Andreas Aug sums it up. "With many colleagues from both fields I recognise exactly these efforts. They seldom speak about them. Usually there is too little time, patience and understanding on the part of the listener. However they do understand!" Good quality really is obvious even without words if one succeeds in bringing ingredients and the basic conditions into line, whether it be in architecture or in cooking. Time and again we can conjure up the taste on our tongue, the smell to our nose and the way things looked in our mind's eye again. The perfect form attracts attention. You want to stop and take a closer look, wander through, touch and understand.

Erdbeervariationen

80 g Zucker, 700 g Erdbeeren, 80 g Zartbitterschokolade
250 ml Sahne, 2,5 Blatt Gelatine, 4 EL Orangenlikör
1 TL geriebene Zitronenschale, 4 EL Weißwein
2 EL Zitronensaft, 2 Eiweiß, 100 g Frischkäse
50 g Puderzucker, 100 g Quark
1 Scheibe TK-Blätterteig, 2 EL gehackte Pistazien

1. Zucker mit 150 ml Wasser aufkochen. Erdbeeren waschen, 12 schöne Beeren aussuchen. Die restlichen Erdbeeren putzen, pürieren und durch ein Sieb streichen. Für eine Erdbeermousse die Gelatine in kaltem Wasser einweichen, nach einigen Minuten ausdrücken und mit 2 EL Orangenlikör in einem kleinen Topf schmelzen. Die Gelatine mit 250 g Erdbeerpüree mischen. Sahne steif schlagen, unterziehen und 3 Stunden kühlen.

2. Schokolade in einer kleinen Metallschüssel über einem Topf mit kochendem Wasser schmelzen. 8 Erdbeeren zur Hälfte in die Schokolade tauchen und auf Backpapier legen. Für ein Sorbet 250 g Erdbeerpüree mit Zuckersirup, Orangenlikör, Weißwein und Zitronensaft verrühren. Eiweiß steif schlagen und unter das Püree heben. Die Erdbeermasse in eine Metallschüssel füllen und im Tiefkühlfach gefrieren, ab und zu umrühren.

3. Den Backofen auf 200 Grad vorheizen (Umluft 180 Grad). Frischkäse und Quark mit 2 EL Puderzucker mischen. Den Blätterteig auftauen, vierteln und 6 Minuten backen. Danach mit Puderzucker bestäuben, 4 Minuten fertig backen. Teigstücke aus dem Ofen nehmen, abkühlen und quer halbieren. Die Böden mit Frischkäsecreme bestreichen. 4 Erdbeeren in Scheiben schneiden und auf den Frischkäse legen. Die Deckel auflegen und leicht andrücken.

4. Einen Esslöffel in heißes Wasser tauchen und je 4 Nocken von Sorbet und Mousse abstechen. Mit den Blätterteigschnitten anrichten und mit Schokoerdbeeren, Erdbeersauce, Pistazien garnieren.

Trinken
Dazu passt ein halbtrockener Champagner, zum Beispiel ein Grand Cru Avize, Demi-sec von Franck Bonville.

Strawberry variations

80 g sugar, 700 g strawberries, 80 g plain chocolate
250 ml cream, 2.5 sheets gelatine, 4 tbsp. orange liqueur
1 tsp. grated lemon peel, 4 tbsp. white wine
2 tbsp. lemon juice, 2 egg whites, 100 g cream cheese
50 g icing sugar, 100 g quark
1 slice frozen puff pastry, 2 tbsp. chopped pistachios

1. Bring sugar to the boil in 150 ml water. Wash strawberries, set aside 12 nice berries. Clean the rest of the strawberries, purée and strain through a sieve. For a strawberry mousse soak the gelatine in cold water, squeeze out after a few minutes and melt in a small pan with 2 tbsp. orange liqueur. Mix the gelatine with 250 g puréed strawberries. Whip cream stiff, fold in and cool for 3 hours.

2. Melt chocolate in a small metal bowl over a saucepan of boiling water. Dip 8 strawberries half into the chocolate and place on baking paper. For a sorbet mix up 250 g strawberry purée with sugar syrup, orange liqueur, white wine and lemon juice. Beat egg whites stiff and fold into the purée. Fill the strawberry mixture into a metal bowl and freeze in the freezer compartment, stir occasionally.

3. Preheat the oven to 200 degrees (convection 180 degrees). Mix cream cheese and quark with 2 tbsp. icing sugar. Thaw the puff pastry, cut into 4 pieces and bake for 6 minutes. Sprinkle with icing sugar, bake for a further 4 minutes. Remove pastry from the oven, cool and cut in half diagonally. Spread the bottom halves with the cream cheese and quark mixture. Slice 4 strawberries and put them on top. Put pastry lids on and press lightly together.

4. Dip a tablespoon into hot water and carve out 4 blobs each of sorbet and mousse. Serve with the puff pastry slices and garnish with the chocolate strawberries, strawberry sauce and pistachios.

To drink
With this dish a half-dry champagne is suitable, for example a Grand Cru Avize, demi-sec from Franck Bonville.

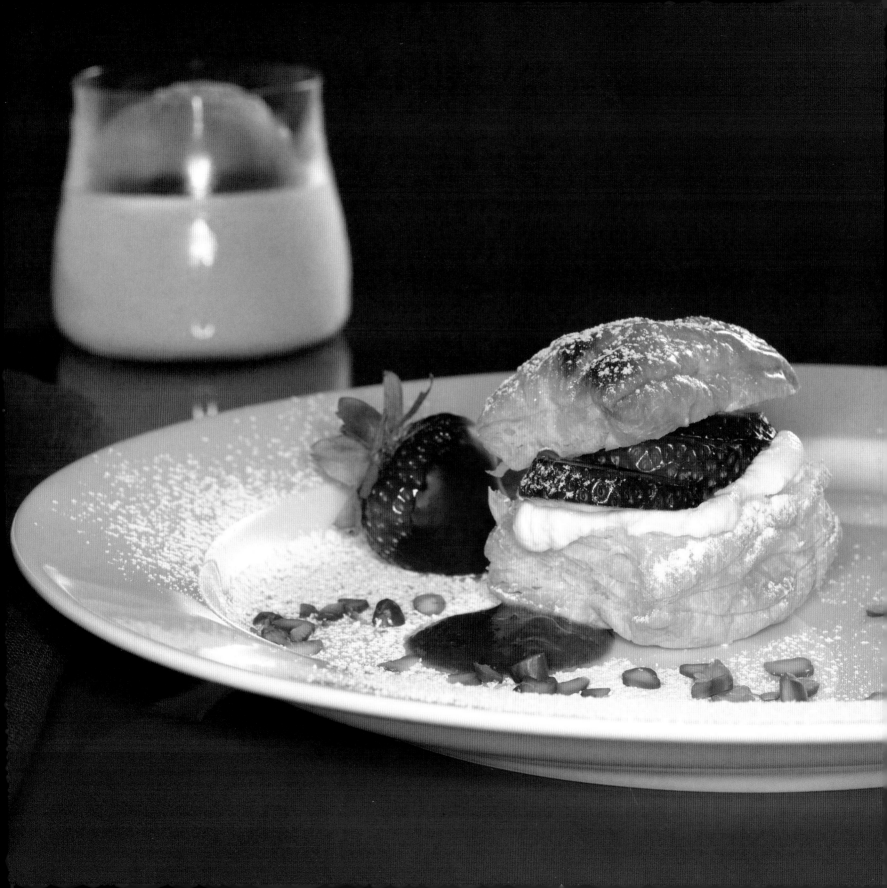

FISCH&FLEISCH
Fish & Meat

Essen der Elemente

Heiko Gruber, Rüdesheim

Erde: Kartoffelstreifen mit schwarzem Salz

500 g Kartoffeln, 1 Bund Thymian, 2 l Pflanzenöl
2 TL schwarzes Salz aus Hawaii (Tipp Seite 20)

Kartoffeln schälen und in 2 cm dicke Streifen schneiden. Thymian waschen, trocken schütteln und die Blätter abzupfen. Öl in einem Topf oder einer Friteuse erhitzen. Die Kartoffelstreifen erst 5–6 Minuten bei 140 Grad vorgaren, dann 2–3 Minuten bei 180 Grad knusprig und goldbraun frittieren. Kartoffeln abtropfen lassen und mit Thymian und Salz würzen. Heiß servieren.

Wasser: Forelle mit Artischockenschuppen

8 Forellenfilets, 4–6 kleine Artischocken, 2 EL Zitronensaft
1/2 Bund Estragon, 200 g Riesengarnelen (roh, ohne Schalen)
Salz, Pfeffer, 2 EL Butter

1. Die oberen zwei Fünftel der Artischocken mit einem Sägemesser abschneiden. Zähe äußere Blätter mit einem kleinen Messer entfernen. Die Stiele auf 10 cm kürzen und schälen. Artischocken der Länge nach halbieren, das »Heu« mit einem Teelöffel entfernen. Die Hälften in dünne Scheiben schneiden und anschließend mit dem Zitronensaft marinieren.

2. Estragon waschen und trocken schütteln, die Blätter abzupfen. Die Garnelen längs halbieren, dunkle Darmreste entfernen. Estragon und Garnelen in einem Blitzhacker pürieren, mit Salz und Pfeffer würzen. Die Forellenfilets dünn mit der Garnelenpaste bestreichen. Artischockenscheiben trockentupfen und schuppenförmig auf die Filets legen, leicht andrücken. Butter in einer beschichteten Pfanne erhitzen. Die Filets auf der Artischockenseite bei schwacher Hitze 8 Minuten braten, vorsichtig wenden und 5 Minuten fertig garen.

Dinner of the elements

Heiko Gruber, Rüdesheim

Earth: Potato strips with black salt

500 g potatoes, 1 bunch of thyme, 2 l vegetable oil
2 tsp. black salt from Hawaii (tip page 20)

Peel potatoes and cut into 2 cm thick strips. Wash thyme, shake dry and pluck off the leaves. Heat up oil in a pot or a deep fryer. Start by blanching the potato strips for 5–6 minutes at 140 degrees then fry them for 2–3 minutes at 180 degrees until they are crispy and golden brown. Drain the potatoes and season with thyme and salt. Serve hot.

Water: Trout with artichoke scales

8 trout filets, 4–6 small artichokes, 2 tbsp. lemon juice
1/2 bunch of tarragon, 200 g king prawns (raw, without shell)
salt, pepper, 2 tbsp. butter

1. Cut off the top two fifths of the artichokes using a serrated knife. Remove the tough outer leaves with a small knife. Shorten the stalks to 10 cm and peel them. Cut the artichokes in half, lengthwise and remove the choke with a teaspoon. Cut the halves into thin slices and then marinade them in the lemon juice.

2. Wash the tarragon and shake dry, pluck off the leaves. Cut the prawns in half, lengthwise and remove remaining parts of the dark intestines. Purée the tarragon and prawns in a chopper and season with salt and pepper. Coat the trout filets thinly with the prawn paste. Dab the artichoke slices dry and arrange them on the trout to look like scales, press slightly. Heat the butter in a coated pan. Fry the fish with the artichoke side downwards on a low heat for 8 minutes, turn carefully and cook for a further 5 minutes.

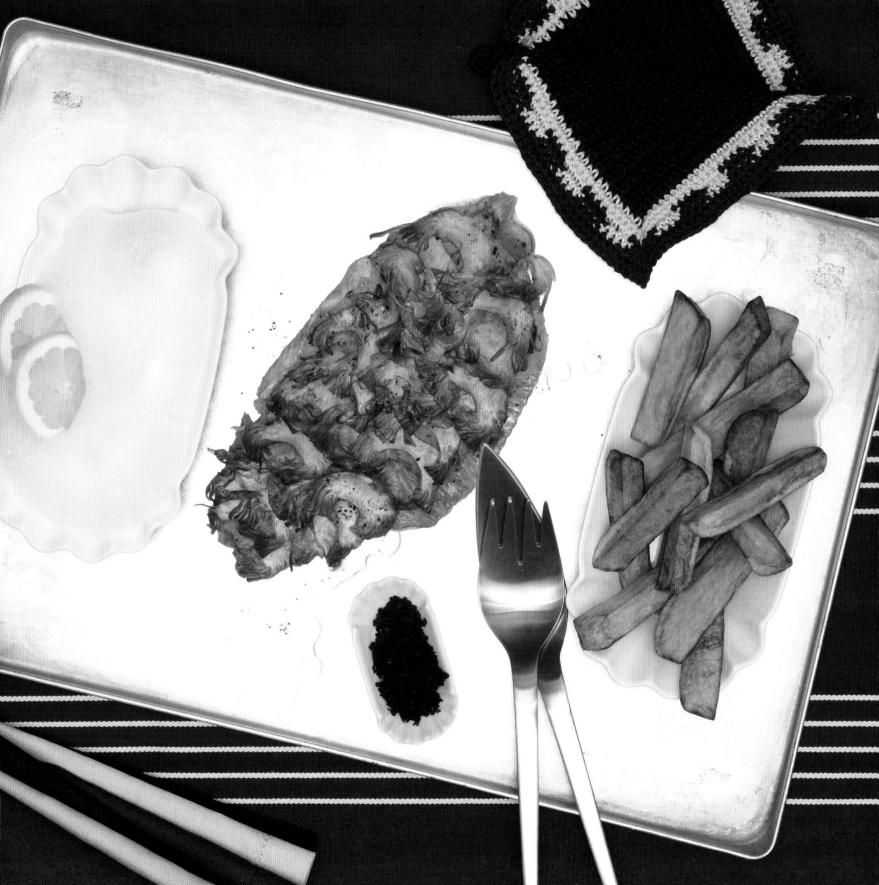

Luft: Zitronenschaum

Zutaten für ein Schaumbad

1 g Soja Lecithin (aus der Apotheke), 135 ml Zitronensaft
115 ml Wasser, 2 EL Zucker, 1 Prise Salz

Alle Zutaten verrühren, bis sich Zucker und Salz aufgelöst haben. Mindestens 2 Stunden abgedeckt in den Kühlschrank stellen. Das kalte Zitronenwasser mit einem Pürierstab mixen, bis sich dichter Schaum bildet. Etwas Schaum mit einem Esslöffel abschöpfen und mit Fisch und Kartoffeln servieren. Die restliche Flüssigkeit zurück in den Kühlschrank stellen und bei Bedarf neu aufschäumen.

Grundbausteine mutig kombiniert

»Als ich von dem Wettbewerb erfuhr, war ich begeistert und es gingen mir zwei Ansätze durch den Kopf: Servieren wir nicht unseren Kunden täglich ein spezielles Menü und versuchen dabei, aus einer Kombination von Ideen, Materialien, Berechnungen und unzähligen Skizzen ihren Geschmack zu treffen? Und zum anderen fällt mir die Gemeinsamkeit mit der Innenarchitektur auf, die mit allen Sinnen zu erfassen ist, gleichsam dem Essen: ein Sehen, Fühlen, Schmecken und Riechen. Nun galt es, diese ersten Eindrücke, die sich mir wie ein Stempel aufdrückten, umzulenken und sie in meine Formensprache umzusetzen. Gleichzeitig sollte mein Rezeptvorschlag neben der Gestaltung auch die Person widerspiegeln – schwierig, aber machbar. Also musste das Gericht etwas sein, das ich natürlich gerne esse, auch schon selbst gekocht habe, und das zu mir und meinen Werken passt. An dieser Stelle möchte ich allen die Illusion nehmen zu glauben, man hätte ständig die Zeit, das Gericht mittags zwischen Baustelle und Skizzenrolle zu genießen. Meine Mitarbeiter und Kollegen können das sicher bestätigen. Die Schlussfolgerung meines Gedankengangs: klar und einfach sollte das Rezept sein, jedoch neu durchdacht und schlüssig kombiniert.

So fiel meine Wahl auf den ersten Grundbaustein – Kohlenhydrate oder das **Element Erde:** Kartoffeln. Uns bekannt aus der Kindheit, immer heiß geliebt, irgendwann einmal als Fritten neu erdacht, zeigen die Kartoffelstreifen architektonische Ansätze: gerade, linear, mit Kanten und Ecken. Durch ihre klare gelbe Farbe und das schwarze Salz werden wir darüber hinaus visuell angesprochen.

Air: Lemon foam

Ingredients for a foam bath

1 g soya lecithin (from the pharmacy), 135 ml lemon juice
115 ml water, 2 tbsp. sugar, 1 pinch of salt

Stir all the ingredients until the sugar and salt have dissolved. Cover and put in the refrigerator for at least two hours. Using a hand blender mix the cold lemon water into a thick foam. Skim off some of the foam with a spoon and serve with the fish and the potatoes. Put the remaining liquid back into the refrigerator and whisk again if necessary.

Building blocks courageously combined

"When I heard about the competition I was very enthusiastic and two ideas occurred to me: Don't we already serve our customers a special menu every day and don't we try to meet their tastes with a combination of ideas, materials, calculations and countless sketches? And the other point I noticed was what interior architecture has in common with eating, which should be grasped with all the senses: seeing, feeling, tasting and smelling. Then I had to divert these first impressions, which forced themselves on me like a stamp, and put them into my composing language. At the same time my recipe suggestion was of course also supposed to reflect the person, as well as the composition – difficult but possible. Therefore the meal had to be something which of course I like eating, have already cooked before and which matches me and my work. At this point I would like to rob everybody of the illusion that we always have time to enjoy this meal at lunchtime between building site and rolls of drawings. My workers and colleagues can definitely confirm that. The conclusion to this train of thought: it should be clear and simple, yet newly thought out and conclusively combined.

So my choice fell to the first building block – carbohydrates or the **Element Earth:** Potatoes. Well known to us since childhood, always warmly popular, reinvented at some point as chips, potato strips show their architectonic approach: straight, linear, with hard edges. Moreover their yellow colour and the black salt appeal to us visually.

Die Verbindung durch das zweite **Element Wasser,** welches lebenswichtig für uns alle ist, wird durch die Forelle transportiert, die zugleich den zweiten Grundbaustein darstellt – Protein. Gestalterisch in erster Line glatt, stromlinienförmig, an den Lebensraum ideal angepasst und mit den Artischocken als Schuppenkleid wieder neu geschützt.

Nun fehlte noch das dritte **Element Luft,** das gewisse Etwas oder die Krönung, die Ergänzung: eventuell vitaminreich, leicht und luftig. Ich entschied mich für den Zitronenschaum, der das Gericht abrundet und alles geheimnisvoll umschließt. Hier spannt sich der Bogen zu meiner Gestaltungssprache: leicht, einfach und dabei doch besonders und erfrischend.

Ich hoffe, ich konnte Ihre Sinne begeistern – für leckeres Essen und geselliges Kochen – und Sie motivieren, mutig zu gestalten, neue Wege zu denken und im Miteinander ständig daran zu bauen.«
Heiko Gruber

The connection with the second **Element Water,** which is vital for us all, is transported by the trout, which also represents the second building block– protein. In design it is predominately smooth, streamlined, ideally adapted to its habitat and newly protected by its scaled dress of artichokes.

Now the third one is still missing the **Element Air,** that certain something or the crown, the complement: perhaps full of vitamins, light and airy. I decided on lemon foam, which rounds off the meal and encloses everything mysteriously. Here the bow is spanned to my composing language: light, simple and yet at the same time special and refreshing.

I hope I was able to inspire your senses – for delicious food and convivial cooking – and motivate you, to design courageously, to think of new roads and to keep building them together."
Heiko Gruber

Gegrillte Dorade
an gedünstetem Gemüse
mit gebackenen Kartoffel-
schiffchen und Zitronen-
Butter-Sauce

Jan Jaenecke, Dresden

Der Titel des Rezeptes beschreibt gleichzeitig auch seine Zubereitung: Sie grillen die Doraden, Sie dünsten das Gemüse und Sie backen die Kartoffeln! Mengenangaben in Gramm sind hier überflüssig. Vielmehr geht es um Stück oder Handvoll. So sind Sie nicht darauf angewiesen, eine entscheidende Zeile im Text des Kochbuches wieder finden zu müssen. Sie können sogar mit der Zubereitung beginnen, wenn Ihre Gäste schon da sind. Probieren Sie es aus, es ist ganz einfach. Entscheidend ist die Komposition.

Kartoffelschiffchen

Nehmen Sie große Kartoffeln, für jeden Gast eine. Weil diese ungekocht in den Ofen kommen, dauern sie am längsten. Auf das Schälen können Sie verzichten, wenn die Kartoffeln gut aussehen. Der Backofen kann schon einmal auf 200 Grad vorgeheizt werden (Umluft 180 Grad). Die Kartoffeln in Längsrichtung halbieren und die Hälften noch einmal längs vierteln, sodass kleine Kartoffelschiffchen entstehen. Diese werden mit Olivenöl bestrichen und kräftig gesalzen. Die Schiffchen nebeneinander auf ein Blech legen und in den Ofen schieben. Sie haben jetzt eine gute dreiviertel Stunde Zeit, um Fisch, Gemüse und die Sauce vorzubereiten.

Fisch

Nehmen Sie für jeden Gast einen Fisch. Doraden bekommt man in jedem besseren Supermarkt. Eventuell müssen Sie den Fisch mit dem Messerrücken noch »gegen den Strich« schuppen oder gar ausnehmen. In der Regel erledigt das jedoch der Fischverkäufer für Sie. Die Seiten der Doraden, diesmal mit der Messerschneide, mehrmals einschneiden. Waschen, trocken tupfen, beide Seiten mit Olivenöl

Grilled sea bream
and steamed vegetables
with baked potato wedges
and lemon-butter sauce

Jan Jaenecke, Dresden

The recipe's title also gives an indication of the method of preparation: You grill the sea bream, you steam the vegetables and you bake the potatoes! There is no need to state the quantities in grams. It is more a question of pieces or handfuls. That way you do not need to keep finding the right line in the cookery book. You can even start the preparation when your guests are already there. Just try it, it is very easy. What matters is the composition.

Potato wedges

Choose large potatoes and allow one for each guest. As the potatoes will be put into the oven uncooked, they will take the longest. If the potatoes look all right there is no need to peel them. The oven can already be pre-heated to 200 degrees (convection 180 degrees). Cut the potatoes in half, lengthwise and quarter the halves, lengthwise again. That way you get small potato wedges. Brush them with olive oil and salt them well. Place the wedges side by side on the baking tray and put them into the oven. Now you have a good three quarters of an hour to prepare the fish, vegetables and sauce.

Fish

Take one fish for each guest. You can buy sea bream in every good supermarket. You might have to scale the fish against the grain, using the back of a knife, or even gut them. However, usually the fishmonger will do this for you. Make several cuts into the sides of the sea bream, this time with the cutting edge of the knife. Wash the fish, dab them dry and brush both sides with olive oil. Salt and

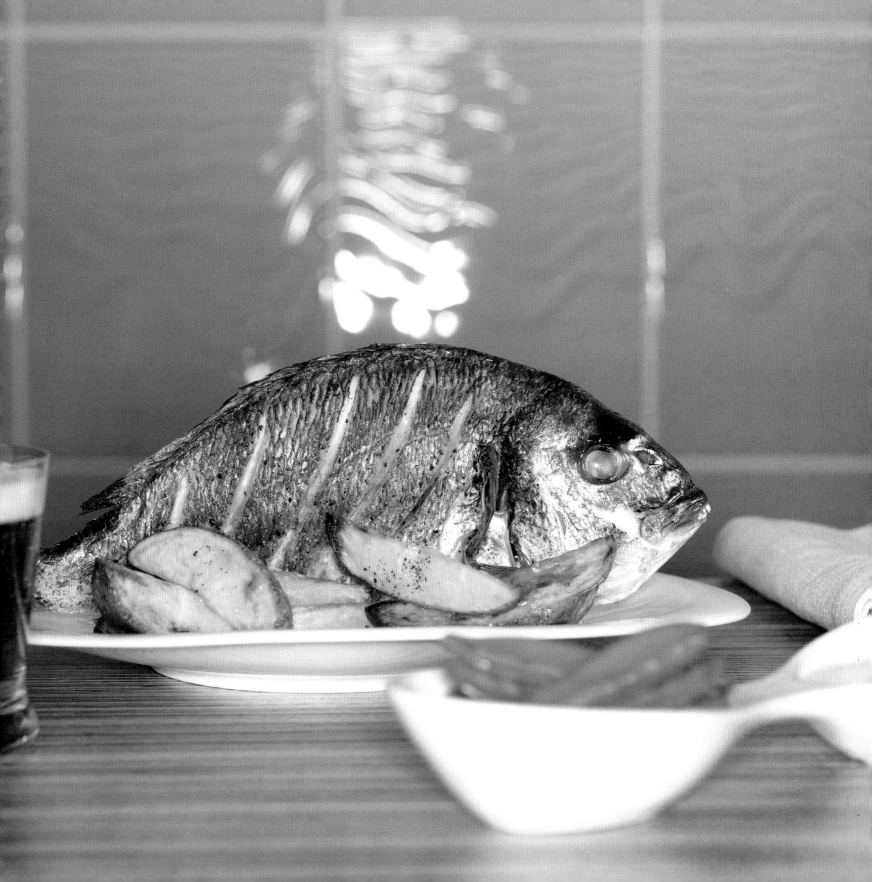

bestreichen. Innen und außen salzen, pfeffern. Damit die Fische eine zusätzliche Note bekommen, einen Zweig Rosmarin oder Thymian und eine unbehandelte Zitronenscheibe in die Bauchhöhle stecken. Sie können die Fische im Bräter liegend im Backofen grillen. Das dauert knapp zwanzig Minuten. Schieben Sie sie einfach über das Blech mit den Kartoffeln, die ja jetzt schon eine gewisse Zeit im Ofen sind. Damit die Fische von beiden Seiten gegrillt werden, kann man mit ein wenig Geschick die Bauchlappen der Fische so nach außen ziehen, dass die Doraden aufrecht, quasi in ihrer natürlichen Stellung, in den Ofen kommen. Es funktioniert wirklich – probieren Sie es einfach aus. Fertig sind die Doraden, wenn Sie die Rückenflossen herausziehen können.

Gemüse

Während die Fische im Ofen sind, kümmern Sie sich um das Gemüse. Bewährt haben sich Zuckererbsen, die Sie mit wenig Wasser und Salz im geschlossenen Topf dünsten. Überschüssiges Wasser vor dem Servieren einkochen. Zuckerschoten pfeffern und ein wenig Butter zugeben. Schön anzusehen ist auch frischer Mangold. Die Blätter grob schneiden oder zupfen und ebenfalls mit Wasser und Salz dünsten. Auch hier passt Butter, außerdem eine Spur Muskat. Falls Sie keinen Mangold bekommen, nehmen Sie frischen Blattspinat. Tiefgefrorener geht auch, aber das ist eine Entscheidung, als würden Sie zwischen Kunststofffenstern und Fenstern aus Holz auswählen. Was auch geht, sind Zucchini: In Scheiben, Sticks oder kleine Viertel schneiden. Mit wenig Öl im geschlossenen Topf bei schwacher Hitze dünsten, buttern, salzen und pfeffern. Wenn Sie möchten, können Sie eine fein geschnittene Knoblauchzehe mitdünsten. Richtig gut wird es, wenn Sie blanchierte Tomaten dazu geben, das heißt, Sie übergießen die Tomaten mit kochendem Wasser und lassen sie einige Sekunden ziehen, bevor Sie die Haut abziehen, die Tomaten vierteln und die Kerne entfernen. Die Tomaten kurz vor dem Servieren unter die Zucchini mischen. Angaben zu Kochzeit und Menge sind bei allen drei Vorschlägen überflüssig. Wenn Sie zwischendurch immer wieder probieren, achten Sie einfach darauf, dass das Gemüse am Ende noch Biss hat.

Zitronen-Butter-Sauce

Schmelzen Sie Butter und vermengen Sie sie mit Zitronensaft. Für das Verhältnis von Butter und Zitrone haben Sie nach ein paar Mal ein Gespür entwickelt. Falls sich im Fischbräter etwas Schmorfond

pepper them on the inside and on the outside. Place a sprig of rosemary or thyme and a slice of untreated lemon into the abdomen of the fish for that final touch. You can place the fish in a roasting pan and grill them in the oven. That will take almost twenty minutes. Just place the baking tray above the one with the potatoes, which have already been in the oven for some time. To make sure that the fish are grilled from both sides the trick is to pull the flanks of the fish outwards so that when you put the sea bream in the oven they are upright, in their natural posture so to speak. It really works, just give it a try. The sea bream are done when the dorsal fins can be pulled out.

Vegetables

While the fish is in the oven you can see to the vegetables. Mangetouts are a good idea. You just need to cook them in a little water with salt in a saucepan with a lid. Allow all the water to evaporate before serving the mange-touts, adding pepper and a little butter. Fresh chard also looks nice. Chop the leaves coarsely or pluck them and cook them too with water and salt. Butter goes well with this and a touch of nutmeg. If you cannot get chard, use fresh spinach. It is also possible to use frozen vegetables here but this is like choosing between PVC windows and wooden windows. Another possibility is courgettes: cut them into slices, sticks or small quarters. Cook them with a little oil in a covered saucepan on a low heat, add butter, salt and pepper. If you like you can also throw in a clove of garlic, finely chopped. It will all taste really good if you add blanched tomatoes, meaning that you pour boiling water over the tomatoes and leave them to soak for a few seconds before removing the skins, quartering the tomatoes and removing the pips. Stir the tomatoes in with the courgettes just before serving. Directions for the cooking times or the quantities are not necessary for any of these three suggestions. If you keep tasting the food in between you can make sure that the vegetables are still al dente at the end.

Lemon-butter sauce

Melt the butter and mix it with the lemon juice. After a couple of times you will develop a feeling for the proportions of butter and lemon. If any fond has formed in the roasting pan add this to the sauce too.

gebildet hat, gießen Sie ihn ebenfalls in die Sauce. Richten Sie dann Fisch und Beilagen auf einem weißen Teller so an, als ob Sie eine Materialcollage präsentieren wollen. Es soll einfach gut aussehen! Dazu passt ein Feldsalat mit einem Olivenöl-Balsamico-Dressing. Salzen und pfeffern nicht vergessen. Falls zur Hand, streuen Sie zerkleinerte Walnusskerne über den Salat.

Trinken

Vergessen Sie die Regel: zu hellem Fleisch weißer Wein. Die Dorade ist so kräftig im Geschmack, dass Sie unbesorgt einen Rotwein dazu wählen können. Statt Wein passt aber auch ausnahmsweise ein kühles Bier.

Tipp

Falls Sie sich nicht ganz sicher sind, ob Sie wirklich ohne genaue Zahlen arbeiten wollen, hier noch einige Mengenangaben: 4 große Kartoffeln je ca. 200 g, 4 geschuppte und ausgenommene Doraden mit je 400–500 g, 100 ml Olivenöl, 4 Zweige Rosmarin, 4 Zitronenscheiben, 400 g Zuckerschoten, 100 g Butter, 2–3 EL Zitronensaft.

Arrange the fish and the trimmings on a white plate as if you wanted to present a material collage. It should just look really good! Corn salad with a dressing of olive oil and balsamic vinegar goes well with this meal. Do not forget to season with salt and pepper. You may also sprinkle some finely chopped walnuts over the salad.

Drinks

Forget the rule: white wine with fish. The sea bream has such a strong flavour that you can choose to serve red wine here. Or by way of exception a cool beer would do very well instead of wine.

Tip

If you are not quite sure whether you really want to work without exact numbers, here are a few quantities: 4 large potatoes, approximately 200 g each, 4 scaled and gutted sea bream each weighing 400–500 g, 100 ml olive oil, 4 sprigs of rosemary, 4 slices of lemon, 400 g mange-touts 100 g butter und 2–3 tbsp. lemon juice.

Gratinierter Lachs
mit Koriander-Kruste

Nicola Bürk, Berlin

2 Chilischoten, 1 Knoblauchzehe, 2 cm Ingwerwurzel
150 ml Sojasauce, 2 EL Honig, 4 Stück Lachsfilet (je ca. 180 g)
1 Bund Koriander, 100 g Cornflakes, 4 EL weiche Butter
400 g junge Möhren, 2 TL Puderzucker, 150 ml Brühe
Salz, Pfeffer, 1 kg Blattspinat
2 EL weiße Sesamsamen, 1 TL schwarze Sesamsamen
4 EL Sesamöl

1. Chilischoten längs halbieren, entkernen und fein schneiden. Knoblauch und Ingwer schälen und ebenfalls fein hacken. Knoblauch, Ingwer und die Hälfte der Chilischoten mit Sojasauce und Honig verrühren. Die Lachsfilets trocken tupfen, in die Marinade legen und eine Stunde kühl stellen. Koriander waschen, trocken schütteln und hakken. Cornflakes etwas zerbröseln und mit der Hälfte des Korianders und 2 EL Butter verkneten.

2. Möhren schälen. 2 EL Butter mit den restlichen Chilistreifen und dem Puderzucker in einem Topf erhitzen, bis der Zucker schmilzt. Möhren und Brühe zugeben. Bei mittlerer Hitze 10 Minuten garen. Die Flüssigkeit sollte dann fast verkocht sein, sodass Sie die Möhren mit dem Rest schön glasieren können. Spinat putzen und waschen, in einem Sieb abtropfen lassen. Sesamsamen in einer Pfanne ohne Fett rösten, bis sie duften. 2 EL Sesamöl und den nassen Spinat dazu geben, würzen, zudecken und 5 Minuten dünsten. Dabei öfter umrühren.

3. Den Ofengrill auf höchste Stufe stellen. Lachsfilets aus der Marinade nehmen und mit 2 EL Sesamöl von beiden Seiten je 2 Minuten heiß anbraten. Den Fisch aus der Pfanne nehmen, die Cornflakes-Masse auf den Lachsfilets verteilen, zurück in die Pfanne legen und 2–3 Minuten unter dem Ofengrill gratinieren. Lachs, Spinat und Möhren anrichten, mit Koriander bestreuen und servieren.

Salmon au gratin
in a coriander crust

Nicola Bürk, Berlin

2 chilli peppers, 1 clove of garlic, 2 cm of ginger root
150 ml soya sauce, 2 tbsp. honey, 4 pieces of fileted salmon
(about 180 g each)
1 bunch of coriander, 100 g cornflakes, 4 tbsp. soft butter
400 g young carrots, 2 tsp. icing sugar, 150 ml stock
salt, pepper, 1 kg leaf spinach
2 tbsp. white sesame seeds, 1 tsp. black sesame seeds
4 tbsp. sesame oil

1. Cut the chilli peppers in half, lengthwise, core and chop finely. Peel garlic and ginger and chop finely as well. Mix garlic, ginger and half of the chilli peppers with soya sauce und honey. Dab the salmon filets dry, marinade them and chill for one hour. Wash, shake dry and chop the coriander. Crumble cornflakes a little and knead with half of the coriander and 2 tbsp. of butter.

2. Peel carrots. Heat 2 tbsp. of butter with the remaining strips of chilli and the icing sugar in a pot until the sugar melts. Add carrots and stock. Cook on medium heat for 10 minutes. The liquid should then have almost boiled away, so that the carrots can be glazed attractively with the rest. Clean and wash spinach, drain in a sieve. Roast the sesame seeds in a pan without fat until they can be smelt. Add 2 tbsp. of sesame oil and the wet spinach, season, cover and steam for 5 minutes. Stir often.

3. Switch oven-grill to highest setting. Take salmon filets out of the marinade and brown them quickly with 2 tbsp. of sesame oil for 2 minutes each side. Take the fish out of the pan, spread the salmon filets with the cornflake mixture, put them back into the pan and grill in the oven for 2–3 minutes. Arrange salmon, spinach and carrots, sprinkle with coriander and serve.

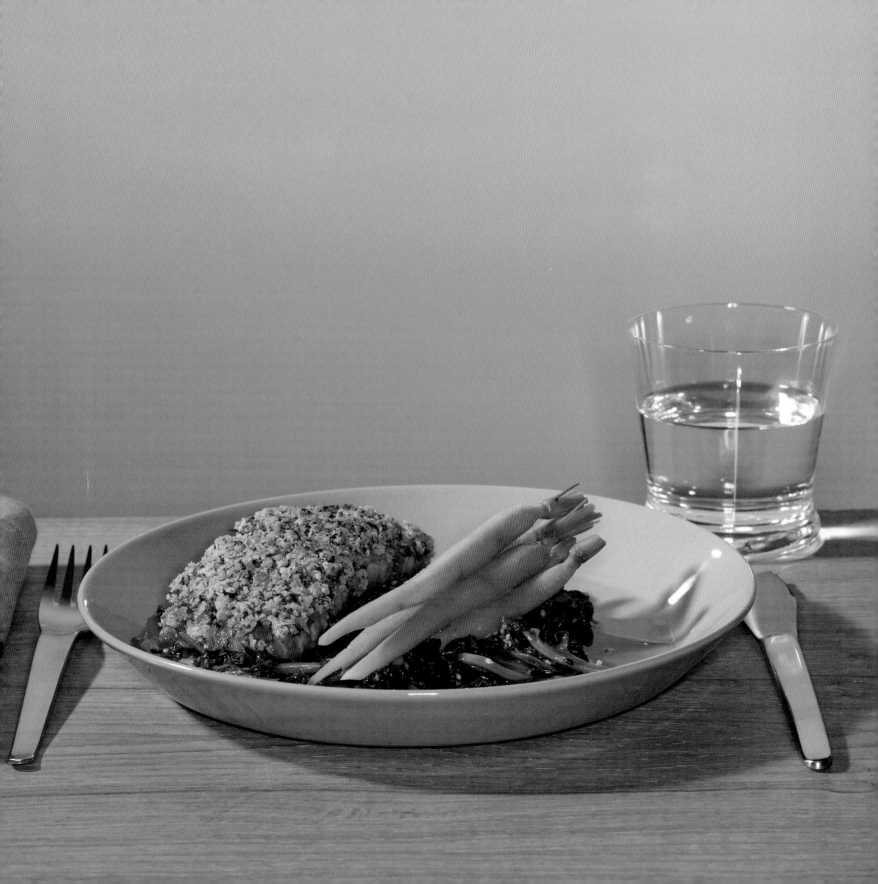

Kochen mit Gefühl

»Der moderne Mensch ist immer und überall von Architektur, Landschaft, anderen Menschen und Essen umgeben. Dieses ständig wechselnde Umfeld, in dem man sich bewegt, kann die Stimmung positiv wie negativ beeinflussen. Ich möchte bei den Menschen sowohl mit meiner Architektur als auch mit meinen Gerichten angenehme Empfindungen auslösen und sie zum Erkunden und Experimentieren einladen. Sie sollen nach dem ersten äußeren Eindruck neugierig werden und auch das Innere näher kennen lernen und entdecken wollen, sei es, indem sie ein Gebäude betreten und die Räume auf sich wirken lassen, oder indem sie ein ihnen unbekanntes Gericht probieren.

Diese positiven Essenzen versuche ich, auch bei meinen Rezepten und bei der Anordnung des jeweiligen Gerichts auf dem Teller zu erwecken. Die Speise, vielmehr der erste Gesamteindruck, soll die Gäste optisch ansprechen und sie dann weiter zu den Details des Menüs führen. Die einzelnen Geschmacksrichtungen und Zutaten sollen neu und überraschend erlebt werden und die Menschen in ein Wohlgefühl versetzen. Ich schicke sie sozusagen auf eine harmonische Entdeckungsreise.

Mit Gestaltung und kreativer Essenszubereitung habe ich mich immer schon gerne und intensiv beschäftigt. Meine Arbeiten sollten daher für sich sprechen und die Menschen und mich selbst glücklich machen. Wo sich mir eine Aufgabe stellt, nehme ich sie ernsthaft in Angriff und setze sie um. Meine Arbeitsweise könnte man als eher praxisorientiert beschreiben: Ich probiere Dinge lieber aus, als dass ich lange darüber rede. Ob beim Kochen oder Gestalten, am Anfang steht immer eine Idee, wie das Endergebnis aussehen soll, und dann setze ich die einzelnen Zutaten spontan, aber sehr gezielt zu einem Ganzen um.

Im Gegensatz zur Architektur bietet sich jedoch beim Kochen immer wieder die Gelegenheit, einzelne Elemente neu zu erfinden, wobei in der Architektur ein bereits realisiertes Projekt nicht leicht umzubauen oder nur bedingt veränderlich ist. So kann ich den gratinierten Lachs zum Beispiel einmal durch die Zutaten von bestimmten Gewürzen betonen, ein anderes Mal durch die Minimierung derselben im Geschmack neutralisieren. Das nächste Mal kann ich Fleisch anstatt Fisch verwenden oder einfach die Cornflakes weglassen.

Cooking with feeling

"Modern man is surrounded always and everywhere by architecture, landscape, other people and food. This constantly changing environment, in which people move, can influence their mood both positively and negatively. With both my architecture and my meals I would like to cause pleasant feelings for people and invite them to explore and experiment. The first outward impression should make you curious to find out and get to know more about the inside, whether you are entering a building and allowing the rooms to take effect or wether you are trying an unknown dish.

I try to awaken these positive essences in my recipes too and in the arrangement of the meal on the plate. The food, or rather the first overall impression, should appeal to the guests optically and then lead them further to the details of the menu. The individual flavours and ingredients should be experienced in a new and surprising way and give people a feeling of well-being. I send them so to speak on a harmonious voyage of discovery.

I have always enjoyed working intensively with design and the creative preparation of food. My work should then speak for itself and make other people and also myself happy. Wherever I have a task to fulfil I approach it seriously and carry it out. My way of working is best described as practice-oriented: I prefer to try something out than to talk about it for ages. Whether I am designing or cooking I always have an idea at the beginning of how the final result should look and then I turn the individual ingredients into a whole, spontaneously but purposefully.

However, unlike with architecture, cooking always offers you the opportunity to reinvent individual elements whereas in architecture a project which has been accomplished is not so easily rebuilt and can only be changed up to a point. For instance I can accentuate the salmon au gratin by adding certain spices and another time neutralise the flavour by minimising them. The next time I can use meat instead of fish or simply leave out the cornflakes.

Einer meiner ersten Kochversuche während meines Architektur-studiums, bei dem ich nicht nach einem Rezept kochte, sondern ein-fach meinen Ideen und Empfindungen freien Lauf ließ, war der grati-nierte Lachs. Durch die im Studium gewonnenen Erkenntnisse und Fähigkeiten, Konzepte umzusetzen und selbstständig oder in Zusam-menarbeit mit anderen etwas Neues aus einer kleinen Idee zu er-schaffen, konnte ich immer gezielter und bewusster meine Entwurfs-gedanken umsetzen. Das betrifft sowohl die Architektur als auch Rezepte. Immer eine bestimmte Vorstellung vor Augen, konnte ich meine Kreativität entwickeln.

Das Gericht des gratinierten Lachses wurde zu einem meiner Lieb-lingsrezepte, da es bei meinen Freunden, die ich als »Tester« einge-laden hatte, auf Anhieb Anklang fand – optisch ansprechend und lecker bis ins Detail. Nachdem ich es öfter für Freunde gekocht hatte, wurde ich von Bekannten gezielt danach gefragt. Natürlich gab ich es sehr gerne weiter. Beim gemeinsamen Kochen mit Freunden habe ich mit diesem Rezept schon sehr viele schöne Stunden erlebt, da man es immer wieder variieren kann.«
Nicola Bürk

One of my first attempts at cooking while I was an architecture stu-dent, where I did not follow a recipe but just allowed free rein to my ideas and feelings, was the salmon au gratin. Through the knowled-ge and skills I acquired during my studies concerning putting ideas into practice and working independently or together with others to develop something new out of a tiny idea I learnt how to put my ideas into practice more and more purposefully and deliberately, both in architecture and with recipes. With a mental picture always in my mind's eye I was able to develop my creativity.

The salmon au gratin dish has become one of my favourite recipes because it immediately went down well with the friends I had invited as 'testers' – optically attractive and delicious down to the last detail. After I had cooked it quite often for friends, people I knew asked spe-cifically about that dish. Of course I was only too happy to pass on the recipe. When cooking with friends I have already spent many very pleasant hours with this recipe, because there are so many ways to vary it."
Nicola Bürk

Trinken

Dazu passt ein Weißburgunder Kabinett trocken, Jahrgang 2005 Neuweier Mauerburg

To drink

Weißburgunder Kabinett dry, vintage 2005, Neuweier Mauerburg goes well with this.

Barsch mit Gemüse und Mungbohnen-Reis

Silja Tillner, Wien

100 g grüne Mungbohnen, 2 junge Artischocken
Je 4 EL Zitronensaft und Weißwein, Salz, Pfeffer
2 Radicchio Trevisano, 500 g gelbe Tomaten, 500 g Eiertomaten
500 g Blattspinat, 100 g Datteln, 250 g Basmatireis
1 EL arabisches Reisgewürz (oder Kardamom und Kreuzkümmel)
4 cm Ingwerwurzel, 2 Knoblauchzehen, 6 Rosmarinzweige
6 EL Olivenöl, 4 EL Kapern
1 Wolfs- oder Zackenbarsch (ca. 1,5 kg) geschuppt und ausgenommen

1. Mungbohnen mindestens 3 Stunden in Wasser einweichen. Spitzen und Stielenden von den Artischocken abschneiden, mit Zitronensaft, Weißwein und Salz in 2 l Wasser etwa 30 Minuten kochen. Danach abgießen und halbieren. Restliches Gemüse waschen. Radicchio und Tomaten halbieren. Dicke Spinatstiele entfernen, die Blätter 1 Minute in reichlich Wasser kochen, kalt abschrecken, abtropfen. Datteln entsteinen und würfeln.

2. Mungbohnen ca. 30 Minuten bissfest kochen. Reis mit Reisgewürz nach Packungsanweisung kochen. In der Zwischenzeit den Ofen auf 180 Grad (160 Grad Umluft) vorheizen. Ingwer und Knoblauch schälen. Rosmarinnadeln von zwei Zweigen abstreifen, mit Ingwer und Knoblauch hacken. Anschließend mit Salz und 4 EL Olivenöl in einem Mörser oder Blitzhacker pürieren. Den Fisch waschen und mit einem Küchenpapier trocknen, innen und außen mit der Würzpaste einreiben. Ein Backblech mit dem restlichen Olivenöl bestreichen. Rosmarinzweige auf dem Blech verteilen, mit Kapern bestreuen. Den Fisch in die Mitte legen, das Gemüse um den Fisch herum arrangieren. Salzen und pfeffern, ca. 30 Minuten im Ofen garen. Fünf Minuten vor Schluss den Spinat würzen und mit aufs Blech geben.

3. Datteln, Reis und Mungbohnen mischen, abschmecken. Den Reis mit Fisch und Gemüse servieren.

Perch with vegetables and mung bean rice

Silja Tillner, Vienna

100 g green mung beans, 2 young artichokes
4 tbsp. each of lemon juice and white wine, salt, pepper
2 Treviso radicchio, 500 g yellow tomatoes, 500 g plum tomatoes
500 g leaf spinach, 100 g dates, 250 g Basmati rice
1 tbsp. Arabian rice spices (or cardamom and cumin)
4 cm of ginger root, 2 cloves of garlic, 6 sprigs of rosemary
6 tbsp. olive oil, 4 tbsp. capers
1 sea bass (about 1.5 kilos) scaled and gutted

1. Soak mung beans in water for at least 3 hours. Cut the tips off the artichokes and shorten the stalks. Then cook artichokes for about 30 minutes in 2 l water with lemon juice, white wine and salt. Pour off the water and halve the artichokes. Wash the remaining vegetables. Cut the radicchio and the tomatoes in half. Remove thick spinach stalks, boil the leaves in plenty of water for 1 minute. Rinse with cold water, drain. Stone and dice dates.

2. Cook mung beans al dente for about 30 minutes. Cook the rice with the rice spices according to the directions on the packet. In the meantime preheat oven to 180 degrees (convection 160 degrees). Peel ginger and garlic. Pull the rosemary needles off two sprigs and chop together with ginger and garlic. Then purée with salt and 4 tbsp. olive oil in a mortar or chopper. Wash the fish, dry it with a kitchen towel and brush the inside and the outside of the fish with the paste. Brush a baking tray with the remaining olive oil. Set out the rosemary sprigs on the tray and sprinkle with capers. Place the fish in the middle and arrange the vegetables around it. Season with salt and pepper, then bake in the oven for about 30 minutes. Season the spinach 5 minutes before the end of this period and place it on the baking tray as well.

3. Mix dates, rice and mung beans and season to taste. Serve the rice with fish and vegetables.

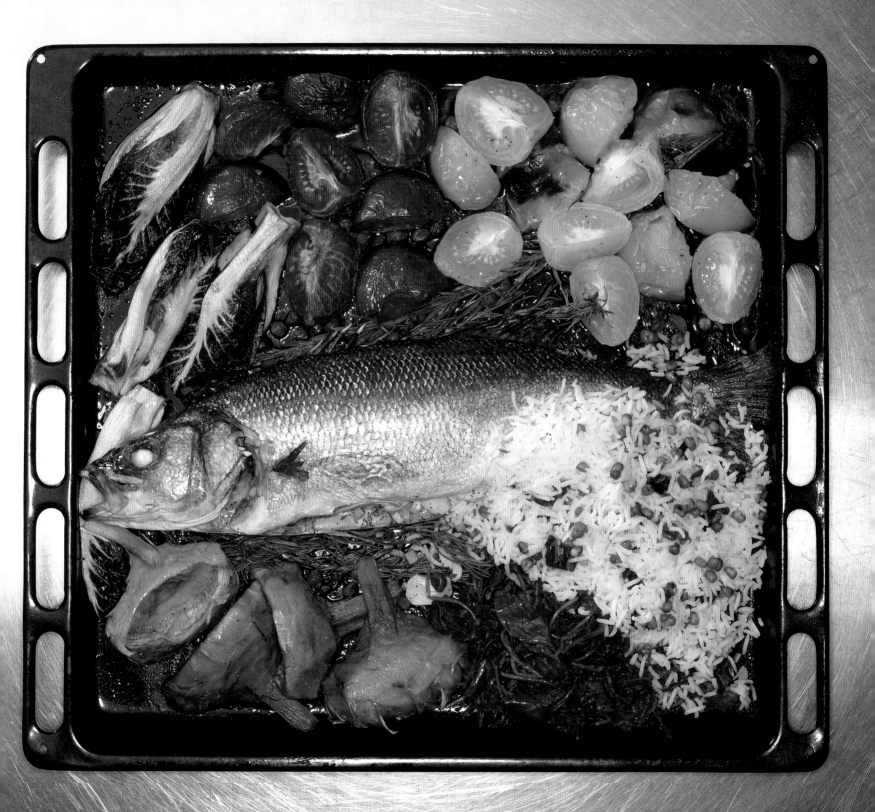

Geschmortes Huhn in 4 Variationen

Wolfgang Schwarz, Stuttgart

1 großes Brathähnchen oder Poularde
Salz, Pfeffer, 2 EL Öl

Außerdem: ein Schmortopf oder Bräter

Den Ofen auf 180 Grad vorheizen (Umluft 160 Grad). Die Hähnchenflügel abschneiden. Das Hähnchen mit einem schweren Messer oder einer Geflügelschere entlang des Rückgrats teilen. Die Keulen abschneiden und halbieren. Die Hähnchenbrüste voneinander trennen und ebenfalls halbieren. Alle Teile mit Salz und Pfeffer würzen. Öl im Bräter erhitzen. Die Geflügelteile auf der Hautseite 5 Minuten anbraten. Speck, Zwiebeln, Gemüse mit langen Garzeiten oder hartlaubige Kräuter (Rosmarin, Thymian, Salbei, Lorbeer, Verbene) zugeben und weitere 5 Minuten braten. Geflügelteile umdrehen, mit Wein oder Zitronensaft ablöschen und mit Wasser oder Brühe auffüllen. Ungefähr 45 Minuten im Ofen garen und mit Weißbrot, Ofenkartoffeln, Knödeln oder Polenta servieren.

Regionale Variationen

1. Für die spanische Variation **»pollo estofado«** (Abb. links) keinen Speck verwenden, dafür aber 4 Knoblauchzehen. Zusammen mit je 2 Zwiebeln und Paprikaschoten klein schneiden und mit den Hähnchenteilen anbraten. Mit einem kräftigen Schluck Sherry ablöschen, eine kleine Handvoll Oliven zugeben, mit 200 g passierten Tomaten und etwas Wasser schmoren.

2. Ein französischer **»Coq au vin«** (Abb. unten) lebt von Speck, Schalotten, Champignons und Rotwein. Die Hähnchenteile vor dem Anbraten mit Mehl bestäuben. 100 g Speck würfeln und mit einigen Thymianzweigen und je 200 g Schalotten und Pilzen zum Hähnchen geben. Mit Rotwein ablöschen, immer wieder einkochen und ablöschen, bis 500 ml Wein verbraucht sind. Wenig Wasser oder Brühe zugeben und nur noch eine halbe Stunde garen.

Braised chicken in 4 variations

Wolfgang Schwarz, Stuttgart

1 large roasting chicken
salt, pepper, 2 tbsp. oil

In addition: a stewpot or roasting pan

Preheat the oven to 180 degrees (convection 160 degrees). Cut off the chicken wings. Split the chicken along the backbone with a strong knife or with poultry shears. Cut off the legs and halve them. Separate the chicken breasts and cut in half as well. Season all the pieces with salt and pepper. Heat oil in the roasting pan. Brown the poultry parts with the skin side downwards for 5 minutes. Add bacon, onions, and vegetables that require long cooking times or hard-leafed herbs (rosemary, thyme, sage, bay leaf, verbena) and fry for another 5 minutes. Turn poultry, add wine or lemon juice and top up with water or stock. Braise in oven for about 45 minutes and serve with white bread, baked potatoes, dumplings or polenta.

Regional variations

1. For the Spanish variation **"pollo estofado"** (fig. left) use 4 cloves of garlic instead of bacon. Chop together with 2 onions and 2 peppers and brown with the chicken parts. Add a good swig of sherry and a small handful of olives, braise with 200 g strained tomatoes and some water.

2. A French **"Coq au vin"** (fig. bottom) needs bacon, shallots, mushrooms and red wine. Sprinkle the poultry with flour before browning. Dice 100 g bacon and add a few sprigs of thyme, 200 g shallots and 200 g mushrooms to the chicken. Add red wine. Keep on boiling down and adding more wine until 500 ml have been used up. Add a little water or stock and cook for another half hour only.

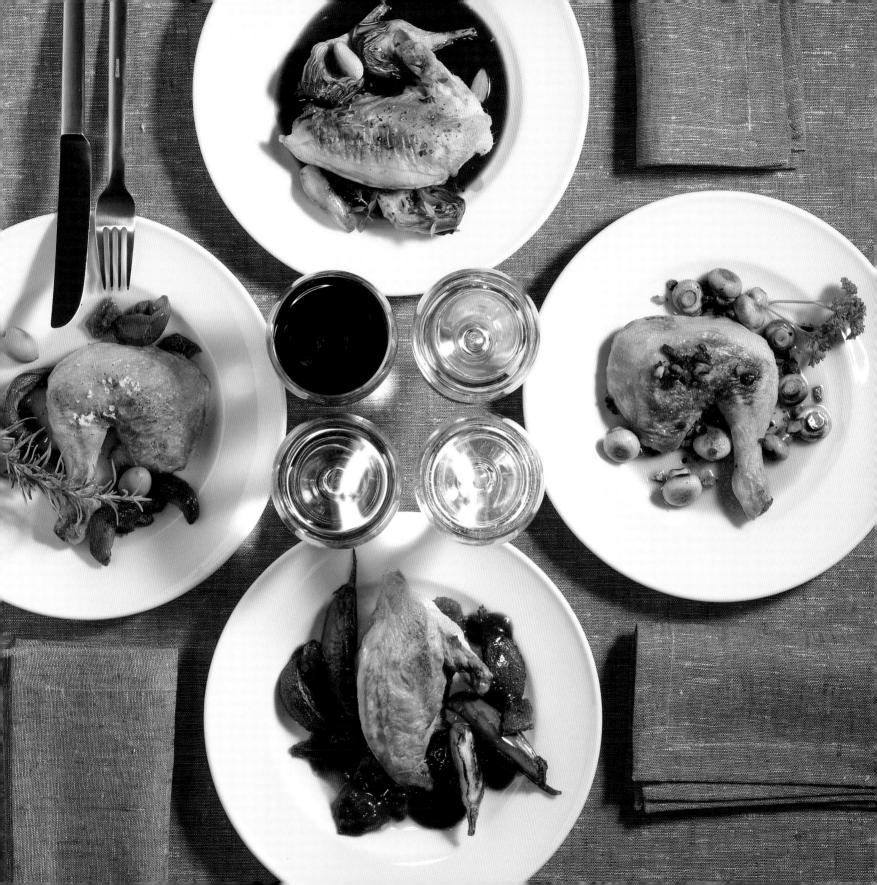

3. Auch beim **»badischen Schmorhähnchen«** (Abb. Seite 103 rechts) finden Sie Thymian, Champignons und Speck. Abgelöscht wird das Hähnchen aber mit einem großen Schluck Weißburgunder oder Gewürztraminer. Sobald der eingekocht ist, kommt ein Viertel Liter Brühe dazu und zum Schluss noch ein Becher Sahne – in allerletzter Minute vielleicht noch ein Löffelchen Senf, der dann aber nicht mehr kochen darf.

4. Für einen italienischen **»Pollo con carciofi«** (Abb. Seite 103 oben) 2–3 Knoblauchzehen und einen Rosmarinzweig zusammen mit 4 jungen Artischocken zum Hähnchen geben, das natürlich mit Olivenöl angebraten wird. Dafür die oberen zwei Fünftel von 4 Artischocken mit einem Sägemesser abschneiden. Zähe äußere Blätter mit einem kleinen Messer entfernen. Die Stiele auf etwa 10 cm kürzen und schälen. Artischocken der Länge nach vierteln, das »Heu« mit einem Teelöffel entfernen. Hähnchen und Gemüse mit dem Saft einer Zitrone ablöschen und mit 500 g Tomatenwürfeln schmoren.

Kochen, entwerfen, konstruieren, wenig Zeit haben ...

»Woher meine Lust am Kochen kommt, ist nicht leicht herzuleiten. Die Großmütter konnten noch kochen, hatten Bezug zum kosmopolitischen Kulturraum Österreichs, das die Rezepte aus allen assimilierten Völkern zusammentrug. Als kleiner Junge habe ich viel und gern gegessen, hing bisweilen den kochenden Hausfrauen an der Schürze und lernte so einiges über Handarbeit, Materialien und Zubereitung. Stimmung und Vorfreude sind wichtige Elemente beim Essen.

Zwei Generationen später sind wir eine 'Architektenfamilie'. Mutter und Vater sind Architekten, Sohn und Tochter gehen noch zur Schule. Urlaub machen wir im Süden, Weihnachten wird im selbst geplanten und umgebauten Heim gefeiert. Dabei fing ich an, Experimente am Kochtopf zu wagen. In den bereisten Ländern stellten meine Familie und ich oft Gemeinsamkeiten bei kulinarischen Zubereitungen fest. Huhn und Wein etwa waren wiederkehrende Bestandteile der nach Regionen unterschiedlich formulierten Rezepte. Die Variationen scheinen unendlich, halten sich letztlich aber doch an das, was gut schmeckt.

Wie ein Rezept setzt sich auch die Architektur immer wieder aufs Neue zusammen. Beim gemeinsamen Essen unter mediterraner Sonne ist bei uns die Architektur immer gegenwärtig – zumindest im Unterbewusstsein.«
Wolfgang Schwarz

3. Braised **chicken as it is prepared in Baden** (fig. page 103 right) contains thyme, mushrooms and bacon as well. Add a good swig of white Burgundy or Gewürztraminer wine to the chicken. As soon as the liquid is evaporated add 250 ml of stock and finally a cup of cream – maybe at the last minute a small spoonful of mustard, which is not allowed to boil.

4. For an Italian "Pollo con carciofi" (fig. page 103 top) add 2-3 cloves of garlic, a sprig of rosemary and 4 young artichokes to the chicken which, of course should be browned in olive oil. Cut off the top two fifths of the artichokes using a serrated knife. Remove the tough outer leaves with a serrated knife. Shorten the stalks to 10 cm and peel them. Quarter the artichokes, lengthwise and remove the choke with a teaspoon. Add the juice of one lemon to the chicken and the vegetables and braise with 500 g diced tomatoes.

Cooking, designing, constructing, having a little time ...

"It is not easy to deduce where the joy of cooking comes from. My grandmothers were good cooks and were in touch with the cosmopolitan cultural area of Austria, which brought together the recipes from all of the assimilated nations. When I was a little boy I used to eat a lot and to enjoy eating. Sometimes I clung to the cooking housewives' apron strings and this way I learned quite a bit about handicraft, materials and preparation. The atmosphere and the anticipation are important elements when it comes to eating.

Two generations later we are an 'architect family'. Mother and father are architects; son and daughter still go to school. We spend our holidays in the south, Christmas is celebrated in the home we ourselves designed and converted. That's where I started to risk a few cooking experiments. My family and I often discovered things we had in common in culinary preparations with the countries we visited. Chicken and wine for instance were recurring elements of the recipes formulated differently from region to region. There seem to be endless variations; yet they stick to what tastes good.

Just like a recipe, architecture is made up in a new way again and again. And so, when we are eating together under the Mediterranean sun, architecture is always present – at least subconsciously."
Wolfgang Schwarz

Ferien (auch Zuhause)	Küchenlandkarte	Architekturlandkarte
Holidays, (at home too)	Region/Weinempfehlung	Architecture map
	Culinary map	
	Region/Wine recommendation	

sacristain
Coq au vin

port de tarn

Frankreich
Languedoc
Daumas Gassac
France
Languedoc
Daumas Gassac

Castello di trebbio
fricassea

Italien
Toscana
Vernaccia
Italy
Tuscany
Vernaccia

Toscana Florenz

atlantera
pollo jerez

Spanien
Cadiz
Jerez/Fino
Spain
Cadiz
Jerez/Fino

Cordoba Mesquita

Wormhaus
coq au riesling

Deutschland/Elsass
Pfalz
Fitz Riesling Classic
Germany/Alsace
The Palatinate
Fitz Riesling Classic

Weihnachten zu Hause

Lammkarree mit Zucchiniplätzchen

Bert Kühnöhl, München

1 Lammkarree (ca. 800 g), Salz, Pfeffer, 4 EL Olivenöl
2 Schalotten, 2 Knoblauchzehen, 1/2 Bund Petersilie
4 Zweige Rosmarin, 4 Zweige Thymian
1 Scheibe Vollkornbrot, 50 g Gorgonzola, 1 Eiweiß
400 g Zucchini, 2 EL gehackte Mandeln
2 EL Paniermehl, 1 Ei, 250 ml Lammfond oder Bratensaft

1. Ofen auf 160 Grad vorheizen (Umluft 140 Grad). Lammkarree mit Küchenpapier trocken tupfen und würzen. In einer ofenfesten Pfanne mit 2 EL Olivenöl von allen Seiten anbraten, insgesamt 2–3 Minuten. Danach das Fleisch für ca. 20 Minuten in den Ofen schieben.

2. In der Zwischenzeit Schalotten und Knoblauch schälen und in kleine Würfel schneiden. Kräuter waschen, trocken schütteln, die Blätter abzupfen und mit dem Vollkornbrot fein hacken. Gorgonzola in kleine Stücke zerbröseln. Alle Zutaten mit dem Eiweiß vermischen, mit Salz und Pfeffer abschmecken. Die Zucchini waschen und grob raspeln. Zucchinistreifen mit Mandeln, Paniermehl und Ei vermischen. Den Zucchiniteig mit Pfeffer und Salz würzen.

3. Lammkarree aus dem Ofen nehmen und die Temperatur auf 240 Grad erhöhen (Umluft 220 Grad). Die Schalotten-Kräuter-Masse auf dem Lamm verteilen und 10 Minuten im Ofen gratinieren. Währenddessen etwas Olivenöl in einer großen beschichteten Pfanne erhitzen. Mit einem Esslöffel kleine Zucchiniplätzchen in die Pfanne setzen und von beiden Seiten goldbraun braten. Den Lammfond aufkochen, eventuell mit frischen Kräutern, Knoblauch und einem Butterflöckchen verfeinern. Lammkarree aus dem Ofen nehmen, entlang der Rippen in einzelne Koteletts schneiden und mit Zucchiniplätzchen und Lammfond servieren.

Trinken

Dazu passt ein Barolo, zum Beispiel der von Enrico Serafino. Der Jahrgang 2001 ist zu empfehlen.

Rack of lamb with courgette biscuits

Bert Kühnöhl, Munich

1 rack of lamb (about 800 g), salt, pepper, 4 tbsp. olive oil
2 shallots, 2 cloves of garlic, 1/2 bunch of parsley
4 sprigs of rosemary, 4 sprigs of thyme
1 slice of wholegrain bread, 50 g Gorgonzola (cheese), 1 egg white
400 g courgettes, 2 tbsp. chopped almonds
2 tbsp. breadcrumbs, 1 egg, 250 ml lamb fond or meat juice

1. Preheat oven to 160 degrees (convection 140 degrees). Dab lamb dry with kitchen paper and season. Brown on all sides with 2 tbsp. olive oil in an ovenproof pan, for 2–3 minutes altogether. Then put the meat in the oven for about 20 minutes.

2. In the meantime peel, cut and dice shallots and garlic. Wash herbs, shake them dry, pluck off the leaves and chop finely with the wholegrain bread. Crumble Gorgonzola into small pieces. Mix all of the ingredients with the egg white, season with salt and pepper. Wash courgettes and grate coarsely. Mix courgette strips with almonds, breadcrumbs and egg. Season the courgette mixture with pepper and salt.

3. Take the lamb out of the oven and turn the temperature up to 240 degrees (convection 220 degrees). Spread the shallot and herb mixture over the lamb and brown in the oven for 10 minutes. In the meantime heat some olive oil in a large coated frying pan. Using a tablespoon put small amounts of courgette mixture into the pan and fry on both sides until golden brown. Bring the lamb fond to the boil, and maybe refine with fresh herbs, garlic and a knob of butter. Take lamb out of the oven, cut along the ribs into single cutlets and serve with courgette biscuits und lamb fond.

To drink

A good choice here is Barolo, for example from Enrico Serafino. The 2001 vintage is recommendable.

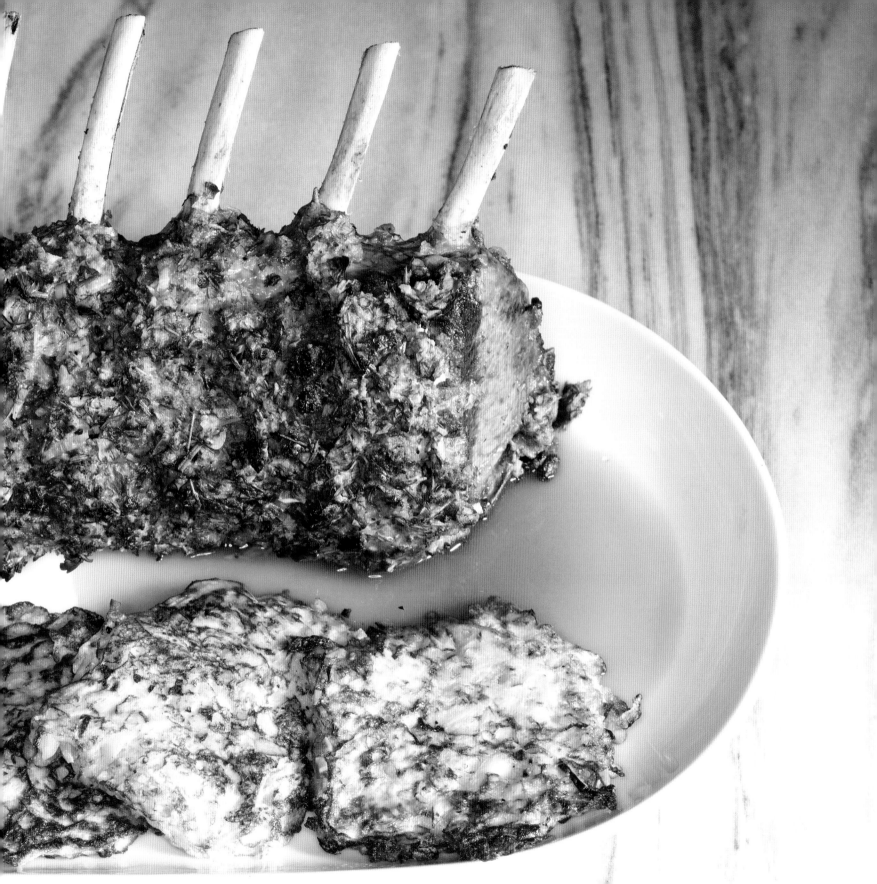

Dekonstruierte Schlachtschüssel

Christa Baumgartner, Nürnberg

Beim Schlachten entstehen alle Teile für die folgenden Gerichte. Man kann sie zusammen, aber auch einzeln zubereiten und genießen.

Sauerkrautsuppe

Lorbeerblätter, Wacholderbeeren, Kümmel
2 Zweige Thymian, 2 Zweige Majoran
1 Zwiebel, 2 Knoblauchzehen, 1/2 Apfel
4 EL Butter, 1 EL Zucker
1 mehlige Kartoffel (ca. 100 g), 250 g Sauerkraut
250 ml Weißwein, 800 ml Brühe
Salz, Pfeffer, Paprikapulver
2 Zweige Rosmarin
4 dünne Scheiben Bauernbrot, 100 g Schmand

Außerdem: 1 Stück Küchentuch und etwas Bindfaden oder ein Teeei

1. Zuerst das Kräutersäckchen binden: Kräuter und Gewürze auf den Stoff legen und mit dem Bindfaden verschließen oder in das Teeei geben. Zwiebel, Apfel und Knoblauch schälen und klein würfeln. 2 EL Butter in einem Topf erhitzen, das Gemüse 3 Minuten darin dünsten. Zucker zugeben und 5 Minuten karamellisieren. Kartoffel schälen und grob reiben. Sauerkraut und Kartoffel weitere 5 Minuten mit dem Gemüse dünsten. Den Weißwein angießen, 5 Minuten kochen und mit Brühe auffüllen. Das Kräutersäckchen in die Suppe legen, salzen und 15 Minuten bei geringer Hitze kochen.

2. Restliche Butter in einer Pfanne erhitzen. Knoblauch quetschen und mit Rosmarin und den Brotscheiben in der Pfanne rösten. Das Gewürzsäckchen aus der Suppe entfernen, den Schmand unterrühren. Die Suppe mit Pfeffer und Paprika würzen und mit einem Pürierstab schaumig mixen. Die Sauerkrautsuppe mit gerösteten Brotscheiben anrichten.

Deconstructed "Schlachtschüssel"

Christa Baumgartner, Nuremberg

All the parts for the following dishes result from slaughtering. They can be prepared and enjoyed either together or separately.

Sauerkraut soup

Bay leaves, juniper berries, caraway seeds
2 sprigs of thyme, 2 sprigs of marjoram
1 onion, 2 cloves of garlic, 1/2 apple
4 tbsp. butter, 1 tbsp. sugar
1 floury potato (about 100 g), 250 g sauerkraut
250 ml white wine, 800 ml stock
salt, pepper, paprika
2 sprigs of rosemary
4 thin slices of coarse rye bread, 100 g thick soured cream

In addition: 1 piece of muslin (or similar material) and some string or a tea ball

1. First prepare a bouquet garni: Place herbs and spices on the material and tie up with the string or put them into the tea ball. Peel and dice onion, apple and garlic. Heat up 2 tbsp. of butter in a pan and sauté the vegetables in it for 3 minutes. Add sugar and caramelise for 5 minutes. Peel potatoes and grate them coarsely. Cook the sauerkraut and the potatoes with the vegetables for another 5 minutes. Pour in the white wine, boil for 5 minutes and top up with the stock. Add the bouquet garni and salt to the soup and then simmer for 15 minutes on a low heat.

2. Heat the remaining butter in a pan. Crush the garlic and fry with the rosemary and the slices of bread. Remove the bouquet garni from the soup and stir in the soured cream. Season the soup with pepper and paprika and puree it with a hand blender until it is frothy. Garnish the sauerkraut soup with the slices of fried bread.

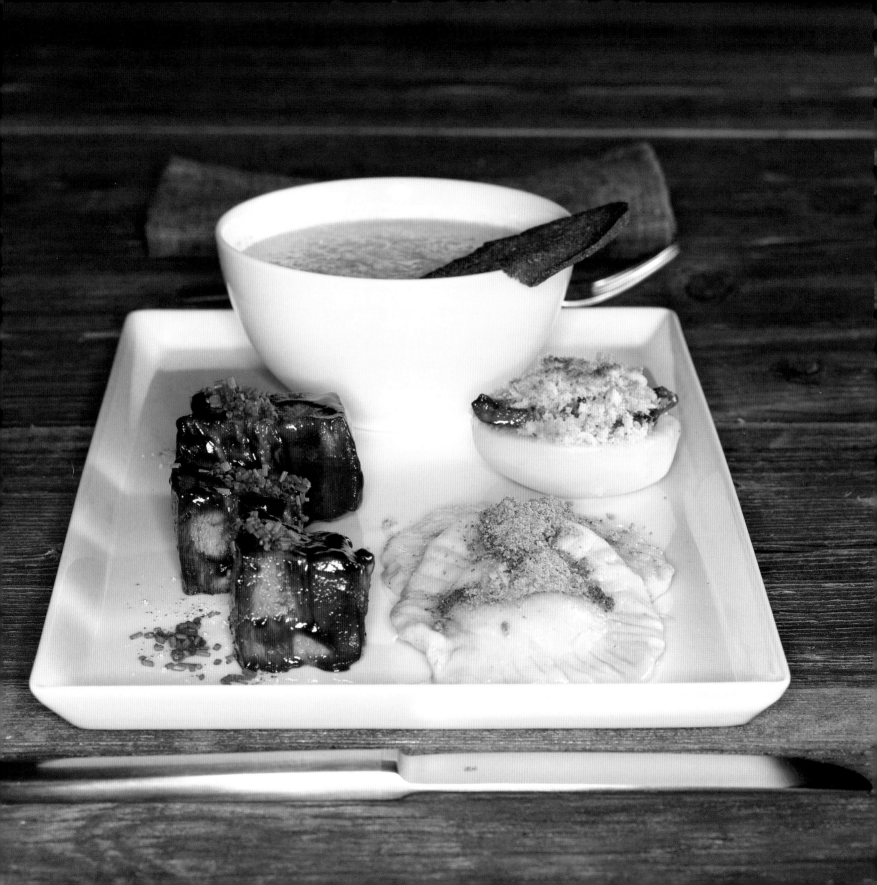

Glasierter Schweinebauch

500 g Schweinebauch, 1 l Brühe, 2 Zweige Thymian
2 Zweige Rosmarin, 1/2 Bund Schnittlauch
2 EL Butter, 150 ml Bratensauce (Tipp)

Brühe aufkochen, den Schweinebauch mit den Kräutern einlegen und 35–40 Minuten bei schwacher Hitze kochen. Den Schweinebauch aus der Brühe nehmen, abkühlen und in 3 cm große Würfel schneiden. Schnittlauch waschen, trocken schütteln und in dünne Röllchen schneiden. Die Fleischwürfel mit der Butter goldbraun braten. Bratensauce über die Würfel gießen und unter Rühren einkochen bis die Bratensauce fast vollständig eingekocht ist. Glasierten Schweinebauch auf Teller verteilen und mit Schnittlauch bestreut servieren.

Tipp

Der Geschmack hängt von der Bratensauce ab. Verzichten Sie auf Produkte aus dem Supermarkt und holen Sie sich etwas Bratensaft vom Metzger oder Restaurant Ihres Vertrauens.

Glazed pork belly

500 g pork belly, 1 l stock, 2 sprigs of thyme
2 sprigs of rosemary, 1/2 bunch of chives
2 tbsp. butter, 150 ml gravy (tip)

Bring stock to the boil, simmer the pork belly and the herbs in the stock on a low heat for 35–40 minutes. Take the pork belly out of the stock, allow to cool then cut it into 3 cm cubes. Wash the chives, shake dry and cut into thin rolls. Fry the diced meat until golden. Pour gravy over the meat and reduce the gravy until it is almost completely evaporated. Arrange the glazed pork belly on the plates and sprinkle with chives.

Tip

The taste depends on the gravy. Instead of buying from a supermarket get some meat juice from your butcher or from a restaurant you can trust.

Blutwursttaler

600 g Kartoffeln, Salz, 4 Eier, 1 EL Öl, Muskat gerieben
300 g Mehl, 50 g Stärke, 1 Zwiebel, 1/2 Apfel
4 Zweige Majoran, 1 TL Wacholderbeeren
150 g Blutwurst, 6 EL Butter, Pfeffer
1 Scheibe Schwarzbrot, 1 unbehandelte Orange

1. Kartoffeln schälen, kochen und abgießen. Die Kartoffeln im Topf ohne Flüssigkeit 5 Minuten ausdampfen lassen. Kartoffeln durch eine Presse drücken und auf Zimmertemperatur abkühlen. Die Eier trennen. Drei Eigelbe mit Kartoffeln, Öl, Mehl und Stärke und einer Prise Salz verkneten.

2. Für die Füllung Zwiebel und Apfel schälen. Den Apfel vierteln und entkernen. Zwiebel, Apfel und Blutwurst in kleine Würfel schneiden und mit 2 EL Butter in einer beschichteten Pfanne 6–8 Minuten braten, dabei öfter umrühren. Die Füllung abkühlen lassen. Majoran waschen, trocken schütteln und fein schneiden. Majoran und das letzte Eigelb mit der Füllung mischen und abschmecken.

Blood sausage medaillons

600 g potatoes, salt, 4 eggs, 1 tbsp. oil, grated nutmeg
300 g flour, 50 g cornflour, 1 onion, 1/2 apple
4 sprigs of marjoram, 1 tsp. juniper berries
150 g blood sausage, 6 tbsp. butter, pepper
1 slice of pumpernickel, 1 untreated orange

1. Peel potatoes, cook them and drain off the water. Leave the potatoes in the pot without water for 5 minutes to steam off. Put the potatoes through a press and allow them to cool off to room temperature. Separate the egg yolks from the white. Mix three of the yolks with the potatoes, oil, flour, cornflour and a pinch of salt.

2. Peel the onion and the apple for the filling. Core and quarter the apple. Dice the onion, apple and blood sausage and fry with 2 tbsp. butter in a coated pan for 6–8 minutes, stirring often. Allow the filling to cool down. Wash and shake dry the marjoram and chop it finely. Mix marjoram and the remaining egg yolk with the filling, then season.

3. Schwarzbrot in kleine Stücke schneiden. Orange waschen, abtrocknen und die Schale abreiben. Wacholderbeeren, Brot und Orangenschale in einer Pfanne ohne Fett rösten. Anschließend in einem Blitzhacker zu Bröseln mixen.

4. Den Teig auf einer mit Mehl bestäubten Arbeitsfläche 5 mm dick ausrollen. 32 Kreise mit je 6 cm Durchmesser ausstechen. Auf die Hälfte der Teigkreise jeweils 1 TL Füllung geben. Die Ränder mit Eiweiß bestreichen, die restlichen Teigkreise auflegen und an den Rändern leicht andrücken. Blutwursttaler 3–5 Minuten in kochendem Salzwasser garen. Restliche Butter erhitzen, die Taler in der Butter schwenken, auf Teller anrichten und mit den Gewürzbröseln bestreut servieren.

3. Cut the pumpernickel into small pieces. Wash and dry the orange and grate the peel. Fry the juniper berries, the pumpernickel and the orange zest in a pan without fat. Then chop finely into crumbs.

4. Sprinkle flour onto a pastry board and roll out the pastry to a thickness of 5 mm. Cut out 32 circles 6 cm in diameter. Place 1 tsp. of the filling on one half of each circle. Brush the edges with egg white, place the remaining pastry circles on top and press the edges lightly together. Cook the blood sausage medaillons in boiling salt water for 3–5 minutes. Heat the remaining butter, toss the medaillons in the butter and arrange on plates. Sprinkle with the spiced crumbs before serving.

Gratinierte Leberwurst

2 mittelgroße Kartoffeln, 100 g Schweineleber, 1 Schalotte
2 Zweige Zitronenthymian, 2 EL Öl
1 EL Quittengelee, 2 EL Calvados
100 g gekochte Leberwurst, 1 Eigelb, Salz, Pfeffer
3 EL Butter, 4 EL Weißbrotbrösel

1. Kartoffeln schälen und kochen. Die Leber in dünne Streifen schneiden. Die Schalotte schälen und klein würfeln. Thymian waschen, trocken schütteln und die Blätter abstreifen. Die Kartoffeln halbieren und mit einem Teelöffel aushöhlen.

2. Die Leber mit Öl und den Schalottenwürfeln 3 Minuten anbraten. Zitronenthymian und Quittengelee unterrühren, und mit Calvados ablöschen, 3 Minuten einkochen. Die Leber mit den Kartoffelresten, Leberwurst und Eigelb gut vermengen, mit Salz und Pfeffer würzen.

3. Den Ofengrill vorheizen. Butter in einer Pfanne erhitzen und die Weißbrotbrösel darin goldbraun rösten. Die Lebermasse mit einem Esslöffel in die Kartoffelhälften füllen und mit den Brotbröseln bestreuen. Im Ofen 2–3 Minuten gratinieren, dabei die Kartoffeln ständig beobachten.

Christa Baumgartner: »Das traditionelle Rezept wurde von mir zu einer leichten, überschaubaren und modernen Variante 'überplant'.«

Liver sausage au gratin

2 medium-sized potatoes, 100 g pig's liver, 1 shallot
2 sprigs of lemon thyme, 2 tbsp. oil
1 tbsp. quince jelly, 2 tbsp. Calvados
100 g boiled liver sausage, 1 egg yolk, salt, pepper
3 tbsp. butter, 4 tbsp. white breadcrumbs

1. Peel the potatoes and boil them. Cut the liver into small strips. Peel and dice the shallot. Wash the thyme, shake it dry and strip the leaves. Cut the potatoes in half and scoop them out with a teaspoon.

2. Brown the shallots and the liver in oil for 3 minutes. Stir in the lemon thyme and the quince jelly, add the Calvados, reduce for 3 minutes. Mix the liver with the scooped out potato, liver sausage and egg yolk, season with salt and pepper.

3. Preheat the oven-grill. Heat butter in a pan and fry the white breadcrumbs until golden. Spoon the liver mixture into the potato halves and sprinkle them with the breadcrumbs. Brown them in the oven for 2–3 minutes, while watching the potatoes constantly.

Christa Baumgartner: "The traditional recipe was newly drawn up by myself to form a light, easy, comprehensible and modern version."

Beijing ya waiguo –
Peking Ente europäisch

Barbara Brembs, Röthlein

2 Flugentenbrustfilets (je 250 g), 4 EL Sesamöl, 4 cm Ingwerwurzel
100 g kandierter Ingwer in Zuckersirup, 4 EL Sojasauce
160 g Mehl, 1 Bund Frühlingszwiebeln, 1 kleine Salatgurke
200 g Sojasprossen, 200 g Zuckerschoten
2 EL Sonnenblumenöl, Salz, 100 ml Hoisin-Sauce

1. Ofen auf 180 Grad vorheizen (Umluft 160 Grad). Die Entenbrüste mit einem Küchenpapier trocken tupfen. 2 EL Sesamöl in einer beschichteten Pfanne erhitzen und die Brustfilets von beiden Seiten 2–3 Minuten anbraten. Ingwer schälen und mit dem eingelegten Ingwer in kleine Würfel schneiden. Beides in eine ofenfeste Form geben und die Entenbrüste mit der Hautseite nach oben auf den Ingwer legen. Sojasauce auf die Brüste gießen, 16–18 Minuten im Ofen garen.

2. 100 ml Wasser aufkochen und mit dem Mehl zu einem glatten Teig verkneten. Den Teig auf einer mit Mehl bestäubten Arbeitsfläche sehr dünn ausrollen. Kreise mit 7 cm Durchmesser ausstechen. Die Hälfte der Teigkreise mit dem restlichen Sesamöl bestreichen. Übrige Teigkreise auflegen und auf die doppelte Größe ausrollen. Eine schwere Pfanne erhitzen, einen Teigfladen hinein legen. Mit einem Küchentuch auf den Pfannkuchen drücken, bis die ersten Blasen entstehen. Pfannkuchen wenden, 1 Minute fertig backen, auf einen Teller legen und mit einem Tuch zudecken. Die restlichen Pfannkuchen auf dieselbe Weise backen.

3. Gurke schälen, längs halbieren. Mit einem Teelöffel die Kerne herauskratzen. Die Gurkenhälften in dünne Stifte schneiden. Frühlingszwiebeln putzen, waschen und in feine Ringe schneiden. Sprossen und Zuckerschoten waschen, in einem Sieb abtropfen lassen. Öl in einer beschichteten Pfanne oder in einem Wok erhitzen. Das Gemüse 5 Minuten braten, salzen. Die Entenbrüste aus dem Ofen nehmen und kurz ruhen lassen. Ingwer und den entstandenen Bratensaft mit Hoisin-Sauce vermischen. Die Entenbrüste in Scheiben schneiden, mit Gemüse, Sauce, Gurkenstreifen und den Pfannkuchen anrichten.

Beijing ya waiguo –
Peking duck the European way

Barbara Brembs, Röthlein

2 Muscovy duck breast filets (250 g each), 4 tbsp. sesame oil, 4 cm ginger root, 100 g candied ginger in syrup, 4 tbsp. soya sauce
160 g flour, 1 bunch of spring onions, 1 small cucumber
200 g soya sprouts, 200 g mangetouts
2 tbsp. sunflower oil, salt, 100 ml hoisin sauce

1. Preheat oven to 180 degrees (convection 160 degrees). Dab the duck breasts dry with kitchen paper. Heat up 2 tbsp. sesame oil in a coated pan and brown the breast fillets from both sides for 2–3 minutes. Peel ginger root and cut into small dices with the candied ginger. Place both in an ovenproof pan and place the duck breasts with the skin side upwards on top of the ginger. Pour soya sauce over the duck and cook in the oven for 16–18 minutes.

2. Bring 100 ml water to the boil and knead this with the flour until the dough is smooth. Roll out the dough very thinly on a work surface sprinkled with flour. Cut out 7 cm circles. Brush half of the dough circles with the remaining sesame oil. Put the remaining dough circles on top of them and roll out until twice the size. Heat up a heavy pan and place one of the pancakes in it. Press the pancake with a kitchen towel until the first bubbles appear. Turn the pancake over, fry for 1 minute until it is done, put it on a plate and cover it with a cloth. Make the remaining pancakes in the same way.

3. Peel cucumber, cut it in half, lengthwise. Scrape out the seeds with a teaspoon. Cut the cucumber halves into thin strips. Clean spring onions, wash them and cut into thin rolls. Wash sprouts and mangetouts and drain them in a sieve. Heat oil in a coated pan or a wok. Fry the vegetables for 5 minutes, then salt. Take the duck breasts out of the oven and leave to stand for a short time. Mix the ginger and the hoisin sauce with the juice from the meat. Cut the duck breasts into slices, arrange with vegetables, sauce, cucumber strips and the pancakes.

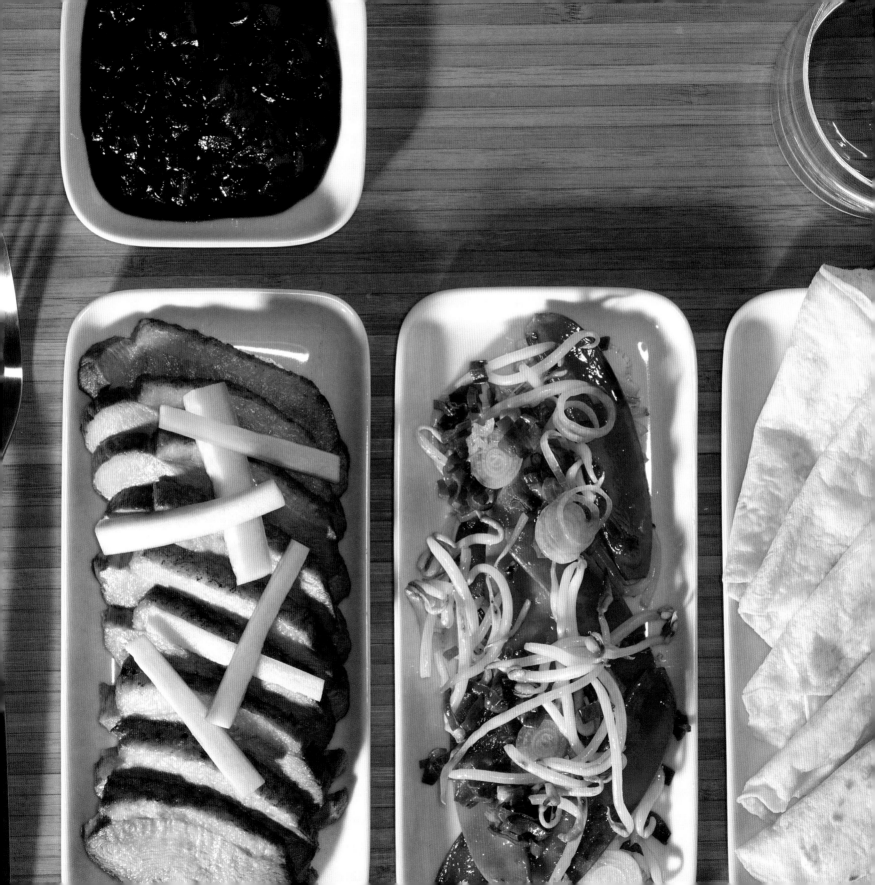

Martin Fröhlich mit/with Tim Raue

Wachteln über Berlin
Quails over Berlin

■ Mit Modellbaugeschick und der Architekten innewohnenden Portion von Detailbesessenheit basteln Martin Fröhlich und sein Kollegenteam von AFF Architekten im Swissôtel Berlin einigen Wachteln ein neues Schinkenkleid. Tim Raue, von Gault Millau als Koch des Jahres 2007 ausgezeichnet, rundet mit einer meisterhaften Vor- und Nachspeise das Geschmackserlebnis ab.

■ With their skills as model-builders and their architects' inherent portion of obsession for detail Martin Fröhlich und his team of colleagues from AFF Architekten in the Swissôtel in Berlin have made a new ham dress for some quails. Tim Raue, acclaimed by Gault Millau as chef of the year 2007, rounds off the gourmet experience with both a masterly starter and a dessert.

Die Akteure: Martin Fröhlich von AFF Architekten, Berlin, und Tim Raue, Chef de Cuisine im Restaurant 44 des Swissôtel Berlin

Der Ort: Siemens lifeKochschule im Swissôtel Berlin

Das Menü: Wachtel im Schinkenkleid

Die Zubereitung eines Gerichts als Vergleich zu einem gestalterischen Prozess, der das Ausgangsobjekt neu interpretiert.

Der Kernsatz: »Ich greife vorhandene Dinge auf und versuche, auf unterschiedlichste Weise deren spezifische Eigenarten und Traditionen herauszufiltern, setze mich dabei jedoch über bestehende Konventionen hinweg.«

The actors: Martin Fröhlich from AFF Architekten, Berlin, and Tim Raue, Chef de Cuisine at Restaurant 44 of the Swissôtel, Berlin

Place: Siemens lifeKochschule (school of cooking) at Swissôtel in Berlin

The menu: Quail dressed in ham

The preparation of a dish as a comparison with a creative process, which reinterprets the starting point.

The core sentence: "I take up whatever things are available and try to extract their specific characteristics and traditions in all sorts of ways, but at the same time ignoring existing conventions."

Vergleiche zwischen Architektur und Kochkunst

Ob Architekt oder Chef de Cuisine – Erfolg verlangt in beiden Berufen die Leidenschaft zur Materie: Der Architekt erarbeitet zu architektonischen Fragestellungen die geeigneten Lösungsansätze, der Profikoch entwickelt unkonventionelle Foodkonzepte zu kulinarischen Aufgaben. Kreativität, Offenheit für Neues und Flexibilität sind für ein positives Endergebnis in beiden Berufen unerlässlich. So sieht das auch Tim Raue, Executive Chef des Restaurants 44 im Swissôtel Berlin. Als Alternative zu seinem steilen Aufstieg an die internationale kulinarische Spitze hätte er sich durchaus auch einen Werdegang in der Architektur vorstellen können. Deshalb der humorvolle Vorschlag an den Architekten Martin Fröhlich, doch einmal für einen Tag den Arbeitsplatz zu tauschen – um auszuprobieren, ob gewisse Herangehensweisen an die Kochkunst und die Entstehungsprozesse in der Architektur durchaus ähnlich oder auch übertragbar sind. Die Parallele zwischen den beiden Professionen wird deutlich, als Tim

Comparisons between architecture and the art of cooking

Whether for an architect or a chef de cuisine – success in both professions requires passion for the materials: The architect works out suitable solution approaches to architectonic questions, the professional chef develops unconventional food concepts for culinary tasks. Creativity, openness for new things and flexibility are indispensable for a positive final result in both professions. That's how Tim Raue, executive chef at Restaurant 44 at Swissôtel in Berlin, sees it too. As an alternative to his rapid rise to the top in the international culinary field he could equally well have imagined making a career in architecture. This led to the humorous suggestion to the architect Martin Fröhlich, that they should swap jobs for a day – in order to try out whether certain ways of approaching the art of cooking and the development processes in architecture were to all extents and purposes similar or even transferable. The parallels between both professions are seen clearly as Tim Raue talks enthusiastically, clearly unconventionally and refreshingly about his daily work, his work

Lachsfilet mit Wassermelonensalat

4 Wildlachsfilets ohne Haut und Gräten (je 100 g)
Zitronenöl (Tipp unten)
Maldon Sea Salt (oder ein anderes Meersalz, Seite 20)
100 g Ingwerwurzel
200 g Lauch
2 EL Zucker, Salz
600 g Wassermelone
2 EL Zitronensaft
4 Zweige Reiskraut (Thailändisch: Kayang/Vietnamesisch: Rau Ngo om)
100 g Sojasprossen

1. Backofen auf 80 Grad vorheizen (keine Umluft). Lachsfilets mit Zitronenöl bestreichen und mit Maldon Sea Salt würzen. Die Filets in eine ofenfeste Form legen und 15 Minuten im Ofen garen.

2. Währenddessen den Ingwer schälen und in dünne Scheiben schneiden. Lauch waschen und in Streifen schneiden. Beide Zutaten mit Zucker und Salz in einem Blitzhacker fein pürieren. Die Melone schälen, das Fruchtfleisch in 3 cm große Würfel schneiden. Die Wassermelonenwürfel mit etwas Salz und Zitronensaft marinieren.

3. Das Reiskraut waschen und trocken schütteln, die Blätter abzupfen. Je 2–3 EL Ingwer-Lauch-Püree auf die Teller verteilen, den Lachs darauf anrichten. Die Wassermelonenwürfel verteilen, mit Sojasprossen und Reiskraut garnieren und mit Maldon Sea Salt bestreuen.

Tipp
Zitronenöl können Sie leicht selber ansetzen: Einfach eine Biozitrone waschen und sehr dünn schälen. Die Schalen in eine Flasche mit Olivenöl stecken und mindestens eine Woche ziehen lassen.

Salmon filet with watermelon salad

4 wild salmon filets, skinned and boned (100 g each)
lemon oil (tip below)
Maldon sea salt (or any other sea salt, page 20)
100 g of ginger root
200 g leek
2 tbsp. sugar, salt
600 g watermelon
2 tbsp. lemon juice
4 sprigs of rice paddy herb (Thai: Kayang/Vietnamese: Rau Ngo om)
100 g soya sprouts

1. Preheat oven to 80 degrees, not convection. Brush salmon filet with lemon oil and season with Maldon sea salt. Place the filets in an ovenproof pan and cook them in the oven for 15 minutes.

2. In the meantime peel the ginger and cut it into thin slices. Wash leek and cut into strips. Purée both ingredients finely in a chopper with salt and sugar. Peel the melon and cut the flesh into 3 cm cubes. Marinate the watermelon with some salt and lemon juice.

3. Wash the rice paddy herb and shake it dry, pluck off the leaves. Arrange 2–3 tbsp. of the ginger-leek-puree on each plate, place the salmon on top. Portion out the watermelon, garnish with soya sprouts and rice paddy herb, sprinkle with Maldon sea salt.

Tip
You can prepare the lemon oil easily yourself: wash an organic lemon and peel very thinly. Put the peel into a bottle with olive oil and marinate for at least one week.

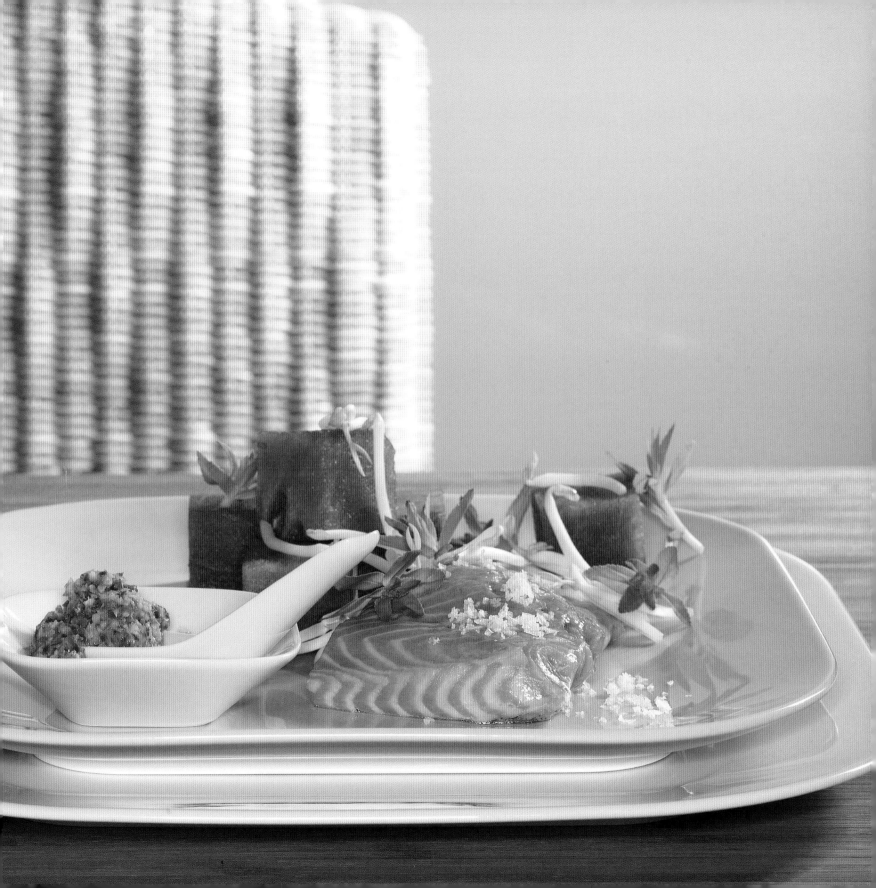

Raue bereitwillig, auffallend unkonventionell und erfrischend von seinem Berufsalltag, seiner Arbeitsphilosophie und dem hochprofessionellen und langwierigen Entstehungsprozess eines Rezepts berichtet: Der analytische und komplexe Vorgang, in dem optimale Garzeiten bestimmt werden, die wissenschaftliche Forschung im Bereich der Gewürze und die Inspiration durch exotische kulinarische

philosophy and about the highly professional and long drawn out process of developing a recipe: The analytical and complex procedure whereby the optimal cooking times are fixed, the scientific research as far as spices are concerned, and the inspiration from exotic culinary interpretations remind you of fundamental research, material studies and analyses of international trends in architecture.

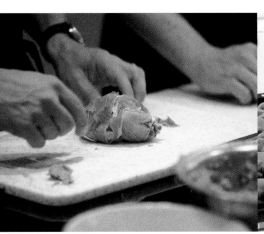

Interpretationen erinnern an Grundlagenforschung, Materialstudien und Analysen internationaler Strömungen in der Architektur. So gibt es im Bereich des Kochens wie auch in der Architektur Herausforderungen und Themenbereiche unterschiedlicher Schwierigkeitsgrade. Eine Gewissenhaftigkeit und Genauigkeit bei der Bearbeitung jeder Aufgabe ist allerdings erforderlich.

Einige Projektvorbereitungen

»Die Zubereitung einer Wachtel wäre vom Schwierigkeitsgrad her eher mit dem architektonischen Entwurf einer Bushaltestelle vergleichbar als mit dem eines Wohnturms«, so sagt Architekt Martin Fröhlich. »Ohne Umschweife sei dennoch auf die Vielfalt der Anforderungen und Nuancen der Geschmacksvariationen verwiesen. Natürlich kann man den Vogel gut gekühlt im Delikatessenladen erstehen, die freie Jagd ist aber vorzuziehen. Eine selbst gefangene Mahlzeit schmeckt nämlich besser als eine gekaufte. Da das kleinste

Thus both in the field of cookery and in architecture too there are challenges and themes of varying degrees of difficulty. Meticulousness and precision are nonetheless essential, whichever work is being carried out.

Some project preparations

"Preparing a quail, seen from the degree of difficulty, would be more comparable with the architectonic design of a bus-shelter than with that of a tower block ", says architect Martin Fröhlich." To put it plainly, attention should be drawn to the multiplicity of demands and nuances of the variations in flavour. Naturally you can purchase the bird well-refrigerated in a delicatessen, but a bird fresh from the hunt is preferable. This is because a meal you have caught yourself is better than one you have bought. Since however this smallest of partridges from the order of galliformes has become seldom you need considerable local knowledge to catch one. One precondition, which must

Feldhuhn aus der Ordnung der Hühnervögel selten geworden ist, benötigt man jedoch eine gehörige Portion von Ortskenntnis für den Fang. Eine Voraussetzung, die den Berufskollegen aus der Baubranche sicher bekannt vorkommt, gerne wird diese Pirsch auch mit Akquise umschrieben. Wer nicht zum Gewehr greifen möchte, dem sei zur Jagd die Umnutzung eines abgelegten Tennisschlägers

seem familiar to the colleagues from the construction sector, this hunting is often renamed acquisition. For those who don't wish to use a gun, we recommend using a discarded tennis racket for the hunt instead. After the first long unsuccessful waiting around you start to feel a bit uneasy because in open hunting territory the birdies as rare as are understanding property hunters who are willing to experiment."

empfohlen. Bereits nach dem ersten langen erfolglosen Abwarten stellt sich etwas Unmut ein, da der Vogel in freier Wildbahn ebenso rar ist wie verständnisvolle und experimentierfreudige Bauherren.«

Entwurfsstrategien für eine Wachtel

Wer so an die Zubereitung einer Delikatesse herangeht, ist es gewohnt, abseits ausgetretener Pfade zu denken. Tatsächlich haben die drei Kollegen Martin und Sven Fröhlich mit Torsten Lockl bereits während des Studiums AFF Architekten 1996 nach dem Atelierprinzip gegründet, das durch wechselseitigen Austausch ein kreatives Podium bildet. Sie nennen es ein architektonisches Labor, in dem die Netzwerkpartner mit ihrer unterschiedlichen professionellen Kompetenz eigenverantwortlich für einen Teil des Erfolges stehen. »Die inhaltliche Orientierung unseres Büros definieren wir über eine Entwurfsstrategie der Interpretation und Verwendung von Metaphern. Gebräuchliche Typologien und Formen stellen wir dabei ständig

Design strategies for a quail

Whoever approaches preparing a special delicacy is used to thinking off the beaten track. In fact, as far back as during their studies in 1996 the three colleagues Martin and Sven Fröhlich with Torsten Lockl founded AFF Architekten based on the studio principle, which forms a creative podium through the reciprocal exchange of ideas. They call it an architectonic laboratory, in which the network partners, with their varying professional competences, are each responsible independently for part of the success. "We define the contents orientation of our office by means of a design strategy which interprets and uses metaphors. We constantly question typical typologies and forms and we confront these with modern ways of looking at things", says Martin Fröhlich explaining his office's approach. "Our work is based on an understanding of architecture as something tangible. We try to explore which relationship an object has to its surroundings and to the characteristics of its task." In doing so over the

Wachtel im Schinkenkleid

4 Wachteln, 1/2 Apfel, 150 g Geflügelleberpastete, 1 Ei
1 EL Paniermehl, 1 TL grob gemahlener Pfeffer, Salz
4 Scheiben roher Schinken, 4 kleine Zweige Rosmarin
200 g Sauerkirschen, 250 ml Weißwein
3 EL Zucker, 1 Zimtstange, 1 TL Stärke

1. Ofen auf 180 Grad vorheizen (Umluft 160 Grad). Apfel schälen, entkernen und in kleine Würfel schneiden. Geflügelleberpastete, Ei, Paniermehl, Pfeffer und Apfelwürfel vermischen. Die Füllung salzen und in die Wachteln füllen. Je eine Scheibe Schinken und einen Rosmarinzweig auf die Brust der Wachteln legen und mit Bratenschnur festbinden. Die Wachteln ca. 25 Minuten im Ofen garen.

2. In der Zwischenzeit die Sauerkirschen waschen, in einem Sieb abtropfen und entsteinen. Kirschen mit Weißwein, Zucker und Zimtstange 5 Minuten einkochen. Die Stärke mit 2 EL Weißwein oder Wasser verrühren. Die Kirschen vom Herd nehmen, die Stärke unterrühren. Zurück auf den Herd stellen und noch einmal 5 Minuten kochen, leicht salzen.

3. Wachteln aus dem Ofen nehmen, Bratenschnur entfernen. Die Wachteln mit der Sauce anrichten. Dazu passt frisches Baguette.

Tipp

Noch luxuriöser wird das Gericht, wenn Sie die Vögel vor dem Füllen entbeinen. Der Profi bezeichnet diese Fingerübung für angehende Meisterköche als »hohl auslösen«: Dafür die Haut der Wachtel am Rücken einritzen und mit einem kleinen scharfen Ausbeinmesser das Fleisch vorsichtig entlang des Brustkorbs von den Knochen lösen. Bald müssen Sie Schulter- und Hüftgelenk durchschneiden, denn die Flügel- und Keulenknochen bleiben in der Wachtel. Die nächste Hürde ist das Brustbein. Hier liegt kein Fleisch zwischen Haut und Knochen, Sie müssen an dieser Stelle also besonders vorsichtig vorgehen, um die Haut nicht zu verletzen. Den ausgelösten Vogel füllen, in seine ursprüngliche Form bringen und mit zwei Zahnstochern verschließen.

Quail dressed in ham

4 quails, 1/2 apple, 150 g poultry liver pâté, 1 egg
1 tbsp. breadcrumbs, 1 tsp. coarsely ground pepper, salt
4 slices of raw ham, 4 small sprigs of rosemary
200 g cherries, 250 ml white wine
3 tbsp. sugar, 1 stick of cinnamon, 1 tsp. cornflour

1. Preheat oven to 180 degrees (convection 160 degrees). Peel apples, core them and cut them into small cubes. Mix poultry liver pâté, egg, breadcrumbs, pepper and apple cubes. Salt the filling and stuff the quails. Put one slice of ham and one rosemary sprig over each quail's breast and tie shut with string. Roast quails in the oven for about 25 minutes.

2. In the meantime wash the sour cherries, drain them in a sieve and stone them. Stew the cherries in white wine, sugar and the cinnamon stick for 5 minutes. Mix the cornflour with 2 tbsp. of white wine or water. Remove cherries from stove and stir in the cornflour. Return cherries to stove and cook for another 5 minutes, salt lightly.

3. Take the quails out of the oven, remove string. Arrange the quails with the sauce. Fresh baguettes go well with this dish.

Tip

This dish will be even more luxurious if you bone the birds before stuffing them. The professional calls this finger-exercise for budding master chefs "hollowing out": Slit the skin at the back of the quail and using a small sharp boning knife cut along the rib cage and carefully remove the meat.
Soon you will have to cut through the shoulder and hip joints, because the wing bones and leg bones will stay in the quail. The next obstacle is the breastbone. There is no meat between the skin and the bone. You have to be especially careful here not to harm the skin. Stuff the filleted bird, form it back into its original shape and close it with two toothpicks.

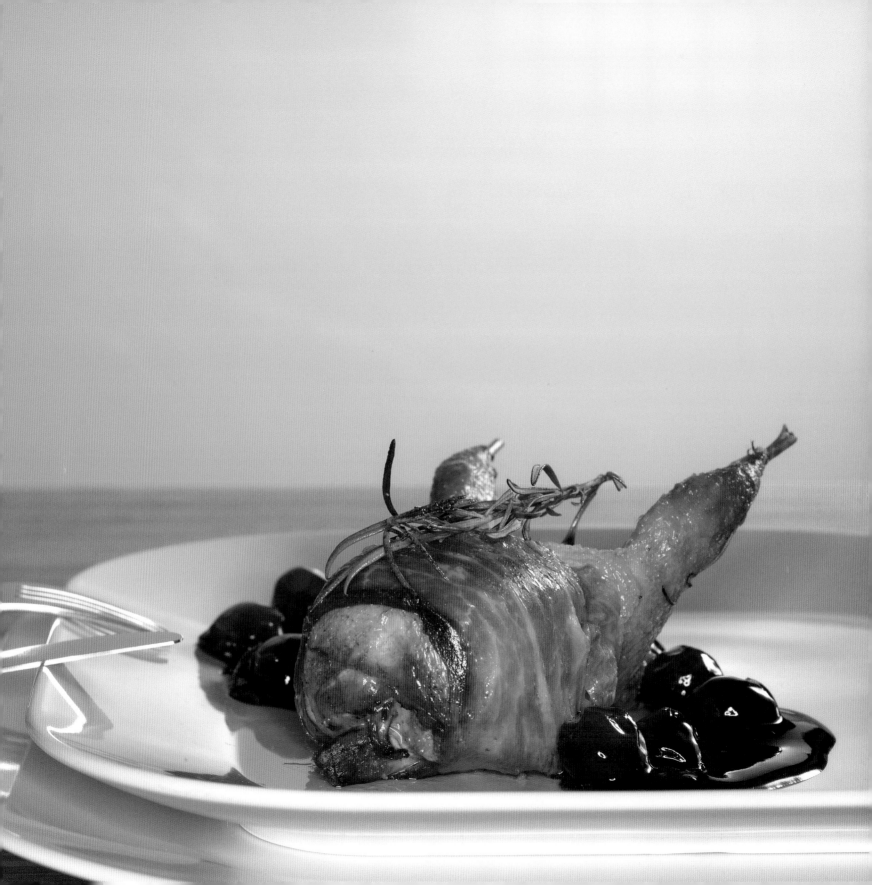

infrage und konfrontieren sie mit modernen Sichtweisen«, legt Martin Fröhlich den Ansatz des Büros dar. »Unsere Arbeit basiert auf dem Verständnis von Architektur als etwas Gegenständlichem. Wir versuchen zu ergründen, in welchem Verhältnis ein Objekt zu seinem Ort und zum Charakter seiner Aufgabe steht.« Dabei hat sich die Bürogemeinschaft in den letzten Jahren nicht nur auf rein architektonische Fragen fokussiert. Anstelle individueller Arbeiten werden Erzeugnisse produziert, die miteinander agieren und eine interdisziplinäre Arbeitsweise propagieren. Diskussionen und Gedankenexperimente tragen zur Verfeinerung des Netzwerkes bei.

the last few years the office team has not only focussed on purely architectonic questions. Rather than producing individual works they create what complements each other well and propagates an interdisciplinary working method. Discussions and experiments of thought contribute to refining the network.

Der Vogel als zarte Bausubstanz

»Mit flinker Hand wird nun der Vogel ausgepackt und auf die für uns wesentlichen Bestandteile reduziert. Dabei bitte ein wenig Vorsicht walten lassen, da wir es mit einer sehr zarten Bausubstanz zu tun haben. Am Ende der Arbeit sollte sich uns hier ein hohler Vogel präsentieren. Nun empfiehlt es sich, für den weiteren Entwurf den Vogel mit einer sanften Massage allseitig einzusalzen. Dazu bitte nur etwas Olivenöl verwenden. Die Wachtel bietet uns, wie alle ganzen Federtiere, einen hervorragenden Hohlraum zum kulinarischen Verdichten. Dabei wird die neue Innenausstattung beim späteren Verzehr den letzten Platz einnehmen. Hier bestimmt der Koch den Abgang des Gerichts«, führt Martin Fröhlich weiter aus. Für den Geschmack der Füllung ist in diesem Fall Tim Raue zuständig, in der Welt der Gourmets bekannt für seine markanten Aromen und den provozierenden Einsatz von Gewürzen. Er unterstützt den Wettbewerbsgewinner bei der Bewirtung seiner Gäste in der Siemens life

The bird as a delicate building substance

"With a deft hand the bird is unpacked and for our intents and purposes reduced to its essential parts. A certain amount of care is called for here please since we are dealing with a delicate building substance. At the end of our work we should be left with a hollow bird. To continue with the design giving the bird a gentle massage rubbing salt in on all sides is highly recommended. Please only use a little olive oil here. As with all poultry the quail offers us a marvellous cavity for culinary packing. When it is eaten later the new 'interior fitting' will occupy the last place. It is the chef who puts the finishing touch to the meal", Martin Fröhlich adds. On this occasion Tim Raue is responsible for the flavour of the stuffing. He is known in the gourmet world for his striking aromatic flavours and the provocative use of spices. In addition he supports the competition winner when hosting guests at the Siemens lifeKochschule (school of cooking) at Swissôtel in Berlin by providing a delicious starter and dessert. For

Kochschule im Swissôtel Berlin zudem mit einer köstlichen Vor- und Nachspeise. Für den Koch des Jahres 2007 ein Heimspiel, betreut er doch als Küchenchef das Restaurant 44 im selben Haus. Dort kommen Liebhaber der klassischen Küche ebenso auf ihre Kosten wie Bewunderer seiner avantgardistischen Kochkunst, denn der kreative Kochprofi lässt sich bevorzugt von den spanischen Küchenstars des letzten Jahrzehnts inspirieren. Heute wird er dafür sorgen, dass die Wachtel schließlich ein wohlschmeckendes Inneres offenbart. »Gut sortiert wird die gefüllte Wachtel zunächst in eine bequeme Ausgangslage gelegt«, fährt Martin Fröhlich fort. »Als Vorbereitung des nächsten Schrittes dient ein Aufmaß zur Bestimmung der Oberfläche, gefolgt von einer gedanklichen Entwurfsskizze für das neue Kleid. Mit zehn Fingern, dem bekannten Modellbaugeschick und der Architekten innewohnenden Portion von Detailbesessenheit wird der Wachtel nun ein neues Outfit gebastelt. Dabei sei ausnahmsweise auch ein leichter Hang zum Ornament nicht verboten. Nun folgt die Translozierung, die Umbettung des Vogels in eine neue Umgebung. Da das Tier zu Lebzeiten ein ausgesprochenes Gespür für seinen Lebensraum besaß, sollte man bei der Wahl des neuen Aufenthaltsortes mit gleicher Sorgfalt vorgehen.«

Perfekt zubereitet

Fünf Handvoll nackte Wachteln liegen kopflos nebeneinander auf der Arbeitsplatte. Sie sehen in ihrer Hühnerhaut aus als frören sie und deshalb rückt ihnen das Gästeteam mit Schnur und Schinken zu Leibe. Vorher jedoch werden ihnen die letzten Federkiele mit einer kleinen Zange ausgerupft. Hier bedarf es etwas Fingerspitzengefühl seitens des Kochteams, damit das zierliche Knochengerüst der Vögel nicht zerbricht. Tim Raue demonstriert mit einem scharfen Messer das fachgerechte Ausweiden des kleinen Körpers, während an anderer Stelle schon die Füllung aus Leberpastete mit Ei und Semmelbrösel in einer Schüssel gewissenhaft zusammengeknetet wird. Wenig später liegen die Wachteln mit Leberpaste gefüllt und liebevoll in ihre neuen Schinkengewänder verschnürt auf dem Blech zum Garen bereit. Während sich der Vogel in der neuen Umgebung entfaltet, geht es an das Rühren der Sauce. Sie wird beim Anrichten die Rolle des Fundaments und beim Verzehr die Erweiterung des Geschmacksraumes übernehmen. Nach Vollendung aller kreativen Tätigkeiten kann das Projekt zur kulinarischen Prüfung den geladenen Gästen übergeben werden. Und wer weiß – vielleicht entwickelt sich aus dem Abnahmeprotokoll sogar eine neue Bauaufgabe.

the Chef of the Year 2007 it is a home game since he is the chef de cuisine of Restaurant 44 in the same building. There both lovers of classical cuisine as well as admirers of the avant-garde art of cooking have their money's worth because the creative professional chef is particularly inspired by the Spanish cooking stars of the last decade. Today he will make sure that in the end the quail will reveal tasty inners. "When it has been well arranged the stuffed quail is first laid out in a comfortable starting position", Martin Fröhlich continues. "In preparation for the next step measuring up must be carried out to determine the surface, followed by a mental sketch design of the new dress. Using ten fingers, the architects' known skills as model-builders and their inherent portion of obsession for detail, a new outfit is produced for the quail. By way of exception this time a slight inclination for ornament is not forbidden. There now follows the translocation, re-bedding the bird in a new setting. As the animal had a distinct feeling for its habitat whilst alive the same care should be applied to choosing its new abode."

Perfectly prepared

Five handfuls of naked quails are lying next to each other headless on the work surface. In their fowls' skin they look as if they were freezing cold and so our team of guests will move in on them with thread and ham. Before that the quails' last quills will be plucked using small pliers. This requires careful handiwork on the part of the cooking team to make sure that the birds' delicate skeleton does not snap. Using a sharp knife Tim Raue demonstrates the expert way of disembowelling the tiny body while elsewhere the stuffing of liver pâté with egg and breadcrumbs is being painstakingly kneaded in a bowl. A short time later the quails, stuffed with liver pâté and lovingly laced up in their ham garments, are lying on a baking tray and are ready for cooking. As the bird unfolds in its new surroundings it is time to prepare the sauce. This plays a fundamental role when serving the dish and will take on the task of expanding the gustatory dimension whilst eating. After the completion of all the creative jobs the project can be handed over to the invited guests for the culinary testing. And who knows – while the acceptance certificate is being discussed maybe a new construction job will emerge.

Mandelmilch-Granité

600 ml Milch
300 g Mandeln ohne Haut
3 EL Muscovado-Zucker (brauner Zucker)
1 cl Amaretto
200 g Himbeeren
1 TL Himbeeressig

1. Milch mit den Mandeln 10 Minuten lang im Mixer fein pürieren. Das Püree durch ein Küchentuch auspressen, die Mandelmilch auffangen. Muscovado-Zucker mit 3 EL Wasser aufkochen. Mandelmilch mit Zuckersirup und Amaretto mischen und in ein flaches Gefäß füllen. Mindestens 3 Stunden gefrieren.

2. Himbeeren mit Himbeeressig marinieren. Mit einem Löffel Eisflocken von der gefrorenen Mandelmasse abschaben und mit den Himbeeren sofort servieren.

Tipp
Tim Raue empfiehlt zum Mandelgranité seine Version des halbflüssigen Schokoladenkuchens: Je 65 g Vollmilch- und Zartbitterkuvertüre schmelzen, 125 g handwarme Butter unterrühren. 2 Eier und 2 Eigelbe mit 20 g Muscovado-Zucker über einem kochenden Wasserbad cremig schlagen. Eiermasse und Schokoladenmasse mischen, 35 g Mehl unterziehen. Je 60 g gehackte weiße Kuvertüre, Vollmilchkuvertüre und gehobelte Mandeln unterrühren. Die Schokomasse in gebutterte Kaffeetassen oder in kleine Weckgläser füllen und bei 175 Grad (Umluft 160 Grad) 10–12 Minuten im Ofen backen.

Almond milk granité

600 ml milk
300 g blanched almonds
3 tbsp. Demerara sugar (brown sugar)
1 cl. Amaretto
200 g raspberries
1 tsp. raspberry vinegar

1. Purée milk and almonds finely in a blender for 10 minutes. Pass the puree through a kitchen towel saving the almond milk. Bring the Demerara sugar to the boil in 3 tbsp. of water. Mix almond milk with sugar syrup and Amaretto and fill into a flat receptacle. Freeze for at least 3 hours.

2. Marinate raspberries in raspberry vinegar. Scrape the ice flakes off with a spoon then serve the frozen almond mass immediately with the raspberries.

Tip
Tim Raue recommends his version of the semi-fluid chocolate cake with almond granité: Melt 65 g each of milk chocolate and plain chocolate coating, stir in 125 g hand-warm butter. Whisk up 2 eggs and 2 yolks with 20 g Demerara sugar in a double boiler over boiling water. Mix these with the melted chocolate butter, fold in 35 g flour. Stir in 60 g each of chopped white chocolate coating, milk chocolate coating and sliced almonds. Fill chocolate mixture into greased coffee cups or small bottling jars and bake in the oven at 175 degrees (convection 160 degrees) for 10–12 minutes.

NACHSPEISEN
Desserts

Pfirsichblätter-Eis

Jan Reuter, München

1 Hand voll unbehandelter Pfirsichblätter
80 g Zucker
250 ml Milch
250 g Crème fraîche d'Isigny
1 EL Zitronensaft (von Zitronen aus Menton bei Nizza)
2 reife Platt-Pfirsiche

1. Pfirsichblätter einige Stunden trocknen lassen. 4 Pfirsichblätter beiseite legen, den Rest zusammen mit dem Zucker und der Milch aufkochen. Die heiße Milch vom Herd nehmen und 20 Minuten ziehen lassen.

2. In der Zwischenzeit die Pfirsiche einmal im Kreis herum bis zum Kern einschneiden. Die Pfirsiche 10–30 Sekunden in kochendes Wasser legen, bis die Haut beginnt sich zu lösen, dann kalt abschrecken. Die Haut der Früchte abziehen und die Hälften vorsichtig vom Stein lösen.

3. Die Pfirsichmilch durch ein Sieb gießen, Crème fraîche unterrühren und mit Zitronensaft abschmecken. Die Masse in einer Eismaschine gefrieren. Jeweils eine Pfirsichhälfte mit einer Kugel Eis und einem frischen Pfirsichblatt anrichten.

Tipp
Pfirsichblätter ernten Sie am besten vom eigenen Baum. Die Platt-Pfirsiche der Sorte »Galaxia« wachsen auch in unseren Breiten. Junge Bäume können Sie bei Südflora Baumschulen, Peter Klock, in Hamburg bestellen.

Peach leaf ice cream

Jan Reuter, Munich

1 handful of untreated peach leaves
80 g sugar
250 ml milk
250 g crème fraîche d'Isigny
1 tbsp. lemon juice (from lemons from Menton, near Nice)
2 ripe flat peaches

1. Allow peach leaves to dry for several hours. Put aside 4 of the leaves and bring the rest of them to the boil with sugar and milk. Take the hot milk off the stove and allow to steep for 20 minutes.

2. In the meantime cut right round the peaches through to the stone. Place the peaches in boiling water for 10–30 seconds until the skin starts to come off, then rinse with cold water. Remove the skin from the peaches and carefully remove the stones.

3. Sieve the peach milk, stir in crème fraîche and season with lemon juice. Freeze the mixture in an ice cream machine. Serve one scoop of ice cream and a fresh peach leaf with each half peach.

Tip
Best would be to pick the peach leaves from your own tree. "Galaxia" flat peaches even grow in our latitudes. Young trees can be ordered at specialized tree nurseries, e.g. at "Südflora Baumschulen", Peter Klock, in Hamburg.

Kürbis-Biskuitrolle

Melanie Porcella, Steven Morgan, Berlin

Für 1 Rolle (ca. 12 Stück)

300 g Hokkaidokürbis
3 Eier, 200 g Zucker, 1 TL Salz
Je 1 TL Ingwer-, Zimt- und Muskatpulver
150 g Mehl, 400 g Frischkäse, 2 EL weiche Butter
1 TL Vanillezucker, 100 g Puderzucker
100 g Pekannüsse
1 EL Butter, 3 EL Zucker

1. Ofen auf 180 Grad vorheizen (Umluft 160 Grad). Ein Ofenblech mit Backpapier auslegen. Kürbis schälen und die Kerne entfernen, das Fruchtfleisch in große Stücke schneiden und ca. 30 Minuten im Ofen garen. Den weichen Kürbis in einem Blitzhacker pürieren.

2. Die Eier trennen. Eigelb mit Zucker, Salz und den Gewürzen schaumig schlagen. Das Kürbispüree mit der Eigelbmasse verrühren. Eiweiß steif schlagen. Mehl und Eiweiß unter die Kürbis-Ei-Masse heben. Den Teig gleichmäßig auf ein mit Backpapier ausgelegtes Blech streichen und 10–15 Minuten backen. Ein Küchentuch mit Zucker bestreuen und den Teig auf das Küchentuch stürzen. Das Backpapier mit kaltem Wasser befeuchten, kurz warten und dann das Papier vom Biskuit abziehen. Den Biskuit mit dem Küchentuch einrollen und abkühlen lassen.

3. Für die Füllung Frischkäse, Butter, Vanillezucker und Puderzucker cremig verrühren. Für den Krokant Pekannüsse hacken. Butter und Zucker in einer Pfanne schmelzen. Die Nüsse zugeben und hellbraun karamellisieren – dabei ständig rühren. Den Nusskrokant auf ein Stück Backpapier gießen und abkühlen. Krokant im Blitzhacker zerbröseln. Biskuit ausbreiten, mit der Frischkäsecreme bestreichen und mit Krokant bestreuen. Einrollen und mit Puderzucker bestäuben. Die Kürbisrolle in Stücke schneiden und servieren.

Trinken

Dazu passt ein Orange Muscat.

Pumpkin Swiss roll

Melanie Porcella, Steven Morgan, Berlin

For 1 roll (about 12 slices)

300 g Hokkaido pumpkin
3 eggs, 200 g sugar, 1 tsp. salt
3 tsp. mixed spices (ginger, cinnamon and nutmeg)
150 g flour, 400 g cream cheese, 2 tbsp. soft butter
1 tsp. vanilla sugar or a few drops of vanilla essence
100 g icing sugar, 100 g pecan nuts
1 tbsp. butter, 3 tbsp. sugar

1. Preheat oven to 180 degrees (convection 160 degrees). Line a baking tray with greaseproof paper. Peel pumpkin, remove the core and cut the flesh into big slices. Bake it in the oven for about 30 minutes. Then purée the soft pumpkin in a chopper.

2. Separate the egg yolks from the whites. Beat yolks, sugar, salt and the spices until frothy, then stir this mixture into the pumpkin puree. Beat egg whites until stiff. Fold flour and egg whites into the pumpkin puree. Spread the mixture out evenly on a baking tray lined with greaseproof paper and bake for 10–15 minutes. Turn the sponge out onto a kitchen towel sprinkled with sugar. Moisten the greaseproof paper with cold water, wait for a minute and then pull the paper off the sponge. Roll the sponge up in the kitchen towel and allow to cool.

3. For the filling mix cream cheese, butter, vanilla essence and icing sugar until creamy. Chop pecan nuts for the cracknel. Melt butter and sugar in a pan. Add nuts and caramelise them lightly, stirring often. Pour the nut brittle onto a piece of greaseproof paper and allow to cool. Crumble brittle in a chopper. Spread sponge out and spread with the cheese cream, sprinkle with cracknel. Roll up and sprinkle with icing sugar. Slice the pumpkin roll and serve.

To drink

Orange Muscat goes well with this.

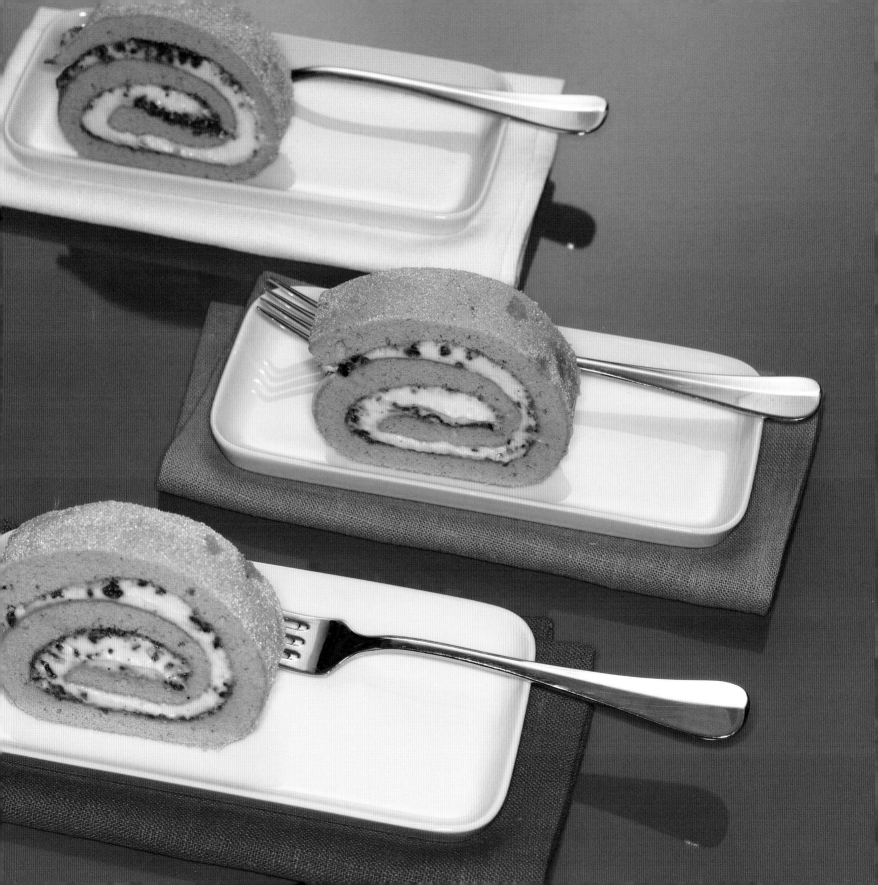

Grundbausteine des Designs

Melanie Porcella: »Seit meiner Kindheit hat diese Nachspeise Tradition in meiner Familie. Ich habe sie vor zwölf Jahren aus Ohio mit nach Berlin gebracht. Jedes Jahr veranstalten wir für Freunde und Kollegen eine große Thanksgiving Party, bei der die Kürbisrolle genauso wenig fehlen darf wie der 15 Kilo schwere Truthahn.

Die Kürbisrolle steht außerdem für unsere architektonische Sprache. Sie ist einfach, aber doch visuell interessant. Die Zutaten sind optisch klar abgegrenzt und weisen eine eindeutige Schichtung von Farbe und Textur auf. Diese Nachspeise ist deshalb optimal dazu geeignet, verschiedene Grundbausteine des Designs wie Form, Farbe, Textur und Struktur vor Augen zu führen. Sie stellt eine perfekte Verbindung von Essen und Design dar.«

Die Form beschreibt die Erscheinung oder das Äußere eines Objekts. Bei der Kürbisrolle handelt es sich dabei um eine elliptische Spirale. Die Spirale ist eine Form, die häufig in der Natur vorkommt: in den Kurven einer Muschel, in Wasserstrudeln oder den Wolkenwirbeln eines Unwetters – eine wichtige Form, die sich in jeder Kultur der Welt findet und die einen hohen Symbolgehalt hat. Unter anderem ist es die Spirale, die am meisten Bewegung durch die damit verbundene Rotation in sich hat, und die den immer wiederkehrenden Zyklus von Leben und Tod versinnbildlicht.

Die Farben eines Objekts stehen häufig für seine symbolischen Eigenschaften. Die Kürbisrolle hat drei klar definierte Farben, eine für jede Schicht. Orange, Weiß und Braun versprechen Spannung und Kontrast. Braun und Orange sind noch dazu die Farben, die für das amerikanische Thanksgiving stehen.

Die Textur macht die sinnlichen Eigenschaften erfahrbar, die einem Objekt innewohnen. Verschiedene Texturen verfeinern Geschmack zu Genuss. Alle drei Schichten der Kürbisrolle unterscheiden sich in ihrer Textur, sind aber doch kompatibel. Die Kürbislage ist weich und schwammig, die Creme dagegen eine samtene Verführung. Als Krönung wird der krosse Krokant darübergestreuselt.

Die Strukturen beschreiben die Wiederholung der Formen und Inhalte eines Objektes. Sie können auch benutzt werden, um die »Spielregeln« bei den Variationen eines Objektes festzulegen. Die Zutaten in der Kürbisrolle sind für die verschiedenen Geschmäcker variierbar, zum Beispiel kann die Füllung mit einem Teelöffel Orangensaft und etwas Orangenschale anstelle der Vanille zu einer Orangencreme umgewandelt werden.

Design foundation stones

Melanie Porcella: "This dessert is a tradition in my family, dating back to my childhood. I brought it from Ohio twelve years ago when we moved to Berlin. Every year we throw a huge Thanksgiving party for our friends and colleagues, and pumpkin roll is as much a staple of the evening as the 15 kg turkey. Everyone loves it. Pumpkin roll is also representative of our architectural and design language. It is simple, yet visually interesting. The materials are clearly delineated and offer a successful layering of colours and textures. When analysed according to several common elements of design including shape, colour, texture, and pattern, pumpkin roll clearly represents the perfect synthesis of food and design."

Shape describes the appearance, or outline, of an object. The shape of a pumpkin roll is an elliptic spiral. The spiral is a shape found frequently in nature, in the curves of seashells, water funnels, or the whorl of weather events. It is an important shape that is found in every world culture and which is rife with symbolic meaning. Among many things, the spiral implies movement through the appearance of rotational motion and represents cyclical continuity such as that of life and death.

The colours of an object are representative of the physical attributes of its material contents or mass. Pumpkin roll has 3 clearly defined colours that are associated with each individual layer. Orange, white, and brown colours provide visual excitement and contrast. Additionally, brown and orange are considered colours that represent the American holiday of Thanksgiving.

Texture describes the sensual properties of an object's material contents. Contrasting textures within the (edible) object increase gustatory pleasure. Each of the 3 layers of pumpkin roll offers entirely different yet compatible textural elements. The pumpkin layer has a soft and spongy texture while the cream cheese layer has a creamy, velvety texture. Both of these textures are highlighted by the crumbly, crunchy texture of the pecan brittle.

Pattern describes the repetition of shapes or contents of an object. It can also be used to describe the template or "set of rules" that are used to generate variations of an object. The ingredients in pumpkin roll are flexible depending on personal taste. For example, the filling can be modified with a teaspoon of orange juice and some orange zest instead of the vanilla to make an orange cream.

Schnitt Maßstab 1:1

Gesamtlänge: 360 mm
1 Stück: 80 mm x 60 mm x 15 mm
Gesamtstückzahl: 12

1 Verkleidung:
Puderzucker,
Pulverbeschichtung, 5 mm
Farbe RAL 9003, Signalweiß

2 Außenwand:
Kürbisteig, ca. 10 mm
Farbe RAL 1028, Melonengelb

3 Dämmung:
Krokant, ca. 2–3 mm
Farbe RAL 8011, Nussbraun

4 Innenwand:
Creme, variable Stärke
Farbe RAL 9001, Cremeweiß

Section Scale 1:1

Total Length: 360 mm
1 Serving: 80 mm x 60 mm x 15 mm
Total Servings: 12

1 Cladding:
Powdersugar,
Coating 5 mm
Colour RAL 9003, signal white

2 Exterior Wall:
Pumpkin Cake, approx. 10 mm
Colour RAL 1028, melon yellow

3 Insulation:
Pecan Prittle, approx. 2–3 mm
Colour RAL 8011, nut brown

4 Interior Wall:
Filling, variable thickness
Colour RAL 9001, cream white

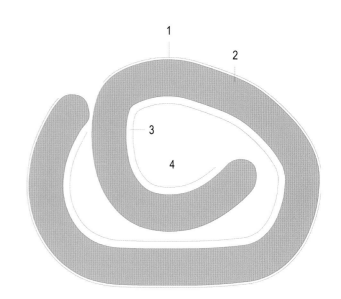

SCHEIBE

TEIL 1

SCHNITTLINIE

TEIL 2

Rotwein-Birnen-Strudel

Bert Kühnöhl, München

600 g Birnen, 0,5 l Rotwein, 4 EL Zucker, 1 Anisstern, 1 Zimtstange, 4 EL Butter, 1 Packung Strudelteig, 4 EL Sauerrahm, 3–4 EL Paniermehl, 4 EL Rosinen, 1 EL Zimtzucker, 1–2 EL Birnengeist 200 ml Sahne, Puderzucker

1. Birnen schälen, achteln, Kerngehäuse herausschneiden. Die Birnenstücke mit Rotwein, Zucker und den Gewürzen aufkochen, vom Herd nehmen, abkühlen und mindestens 3 Stunden im Rotwein ziehen lassen.

2. Backofen auf 180 Grad Umluft vorheizen. Ein Tuch auf der Arbeitsfläche ausbreiten. Ein Backblech mit Backpapier auslegen. Butter schmelzen. Strudelteig auf dem Tuch ausbreiten und mit Butter bestreichen. Sauerrahm auf dem Teig verteilen, mit Paniermehl bestreuen. Die Birnen gut abtropfen lassen oder mit Küchenpapier trocken tupfen. Den Rotwein sirupartig einkochen. Birnen auf einem Drittel des Teiges verteilen, mit Rosinen und Zimtzucker bestreuen. Den Strudel einrollen und auf das Blech legen. Mit Butter bestreichen und ca. 20 Minuten im Ofen goldbraun backen. Dabei noch ein- oder zweimal mit zerlassener Butter einpinseln.

3. Sahne steif schlagen und mit 3–4 EL vom eingekochten Sirup und etwas Birnengeist abschmecken. Den Strudel aus dem Ofen nehmen und kurz ruhen lassen, mit Puderzucker bestäuben und mit der Birnen-Sahne servieren. Dazu passt ein arabischer Kaffee sehr gut.

Tipp

Strudelteig kann man auch selber machen: 1 Prise Salz, 2 EL Öl, 1 Eigelb und 100 ml lauwarmes Wasser verquirlen, mit 200 g Mehl mindestens 5 Minuten kräftig durchkneten, dann zu einer Kugel formen. Die Teigkugel zwischen den Handflächen rollen, bis die Oberfläche samtig glatt ist. Mit wenig Öl bestreichen und mindestens 30 Minuten ruhen lassen. Den Teig erst mit einem Nudelholz ausrollen, dann auf einem mit Mehl bestäubten Tuch nach allen Seiten dünn ausziehen. Dazu mit den bemehlten Handrücken unter den Teig greifen und vorsichtig Richtung Tischkante ziehen.

Red wine pear strudel

Bert Kühnöhl, Munich

600 g pears, 500 ml red wine, 4 tbsp. sugar, 1 star-anise, 1 stick of cinnamon, 4 tbsp. butter, 1 packet of strudel dough, 4 tbsp. thick soured cream, 3–4 tbsp. breadcrumbs, 4 tbsp. sultanas, 1 tbsp. cinnamon sugar, 1–2 tbsp. pear brandy, 200 ml cream, icing sugar

1. Peel pears, core them and cut into eighths. Bring the pears to the boil with red wine, sugar and the spices remove from stove, allow to cool and leave to steep in the red wine for at least 3 hours.

2. Preheat oven to 180 degrees (convection). Spread out a cloth on the work surface. Line a baking tray with greaseproof paper. Melt butter, spread out strudel dough on the cloth and brush with butter. Spread the dough with thick soured cream, sprinkle with breadcrumbs. Drain the pears well or dab them dry with kitchen paper. Reduce the red wine to syrup. Spread out pears on one third of the dough, sprinkle with sultanas and cinnamon sugar. Roll up the strudel and place it on the baking tray. Brush strudel with butter and bake for about 20 minutes in the oven until golden brown. Baste once or twice with melted butter.

3. Whip cream until it is stiff and flavour with 3–4 tbsp. of the syrup and a little pear brandy. Take the strudel out of the oven and leave to stand for a while, sprinkle with icing sugar and serve with the pear-cream. Arabian coffee goes especially well with this dish.

Tip

You can prepare the strudel dough yourself as well: whisk 2 tbsp. oil, 1 egg yolk 100 ml lukewarm water and a pinch of salt, knead well with 200 g flour for at least 5 minutes, then shape the dough into a ball. Roll it around in your hands with even, circular movements until the surface of the dough is velvety smooth. Brush with a little oil and leave to stand for at least 30 minutes. First roll out the dough with a rolling pin, then place on a cloth sprinkled with flour and pull the pastry on each side until it is very thin. To do this sprinkle the backs of your hands with flour and put them underneath the pastry. Now pull carefully towards the edge of the table.

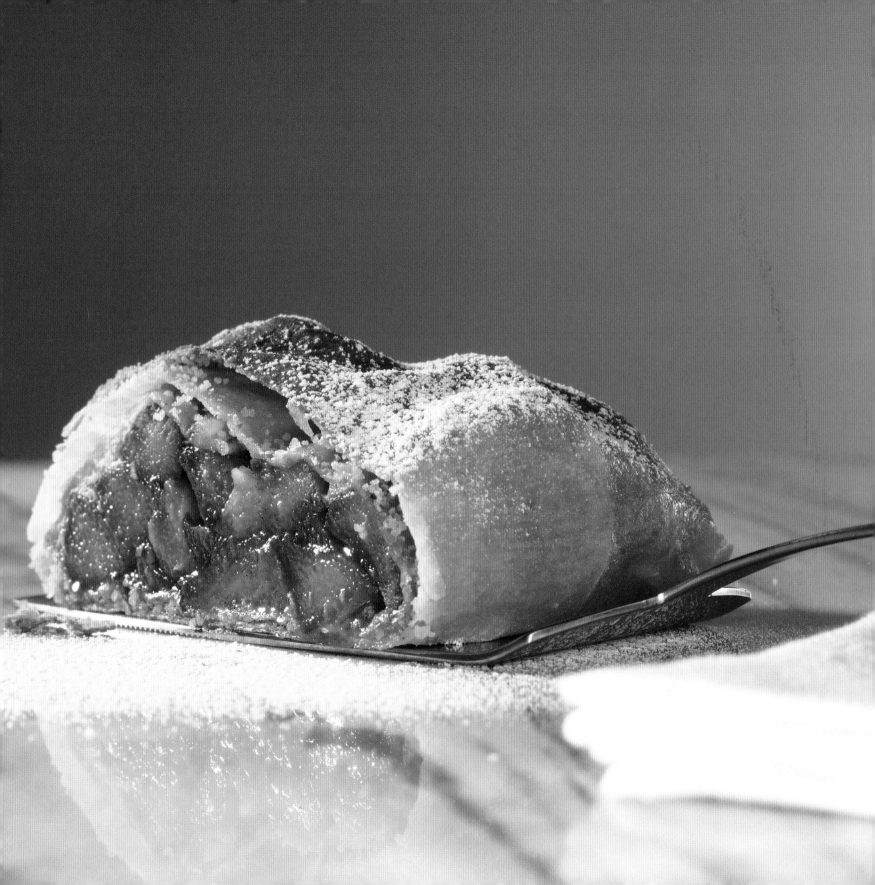

Simone Heckmann, Norbert Fischbach mit/with Michael Fell

Im Rhabarber-Labor
In the Rhubarb Laboratory

■ Als experimentellen Versuch inszenieren Norbert Fischbach und Simone Heckmann in Traunreut ihre Rhabarber-Studien im Showroom der Siemens-Electrogeräte GmbH. Zusammen mit Sternekoch Michael Fell, Küchenchef der Restaurants im Park-Hotel Egerner Höfe, testen sie das Gemüse auf seine Tauglichkeit als Süßspeise.

■ As a test experiment Norbert Fischbach and Simone Heckmann stage their rhubarb studies in Traunreut in Siemens-Electrogeräte GmbH's showroom. In cooperation with star chef Michael Fell, chef de cuisine in the Park Hotel Restaurant Egerner Höfe, they test the vegetable to see whether it is suitable for a sweet dish.

Die Akteure: Norbert Fischbach und Simone Heckmann von pmg profile marketing group, Wiesbaden, und Michael Fell, Küchenchef der Restaurants im Park-Hotel Egerner Höfe in Rottach-Egern

Der Ort: Showroom der Siemens-Electrogeräte GmbH, Traunreut

Das Menü: Rhabarber-Stangen – Rhabarber-Streifen – Rhabarber-Gelee – Rhabarber-Eis – Rhabarber-Creme – Rhabarber-Schaum Aus den Materialstudien mit Rhabarber entstehen im Versuchslabor Großküche eine Reihe Süßspeisen von unterschiedlicher Konsistenz.

Der Kernsatz: »Um einen Werkstoff richtig einsetzen zu können, muss man wissen, wie er sich unter verschiedenen Bedingungen verhält.«

The actors: Norbert Fischbach and Simone Heckmann from pmg profile marketing group, Wiesbaden, and Michael Fell, chef de cuisine at the Park Hotel Restaurants Egerner Höfe in Rottach-Egern

Place: Siemens-Electrogeräte GmbH's showroom, Traunreut

The menu: Rhubarb sticks – rhubarb strips– rhubarb jelly – rhubarb ice cream – rhubarb cream – rhubarb whip. In the material studies on rhubarb in the canteen kitchen testing-laboratory a series of sweet dishes of varying consistencies are produced.

The core sentence: "To be able to use a tool correctly one has to know how it reacts under varying conditions."

Eine Küche wird zum Kochlabor

Ein großer Raum mit hohen Sprossenfenstern – weiße Stützen, weiße Wände, weiße Bodenfliesen. Darin acht freistehende Küchenzeilen, vier in jeder Reihe, ebenfalls weiß und penibel sauber. Flächenbündige Induktionskochfelder fügen sich als dunkle Rechtecke in die makellos hellen Arbeitsplatten. Griffbereit hängen an einer Stahlreling über den Kochinseln Instrumente wie Schöpfer, Schwingbesen und Sieb. In den Schubladen wartet Profigerät vom Elektromixer bis zur Schneidemaschine auf seinen Einsatz. Mannshohe Kühlschränke stehen entlang der Wände bereit. Der Showroom der Bosch Siemens Hausgeräte GmbH in Traunreut kommt dem wohl am nächsten, was man ein Kochlabor nennen könnte. Die beiden Wettbewerbsgewinner Norbert Fischbach und Simone Heckmann werden hier mit Unterstützung ihrer Gäste und mit Hilfe von Profikoch Michael Fell an diesem Nachmittag den Werkstoff Rhabarber auf seine Eigenschaften hin testen. Sie werden ihn in Stücke hacken, in dünne Scheiben

A kitchen becomes a cooking laboratory

A large room with high lattice windows – white supports, white walls, white floor tiles. Inside there are eight freestanding kitchen units, four in each row, also white and scrupulously clean. Flush induction hobs fit into the immaculate white working surfaces as dark rectangles. Hanging ready at hand on a steel railing over the island suites there are instruments such as a ladle, a whisk and a sieve. In the drawers professional tools from an electric mixer to a cutting machine are waiting to be used. Man-sized refrigerators line the walls ready. The Bosch Siemens Hausgeräte GmbH's showroom in Traunreut is probably as close as they come to what could be called a cooking laboratory. This afternoon the two competition winners Norbert Fischbach and Simone Heckmann supported by their guests and with the help of professional chef Michael Fell will test the properties of the material rhubarb. They will hack it into pieces, cut it into thin slices, plait it into a mat, whip it and cook it and boil it away to mash. The team

Rhabarbermatte

500 g Rhabarber, 175 g Zucker, 60 g Himbeeren
Je 1/4 Vanille- und Zimtstange, 1 TL Vanille-Puddingpulver

1. Rhabarber waschen, die Enden abschneiden. Anschließend auf der Aufschnittmaschine in 2–3 mm dicke Streifen schneiden. Die Abschnitte in einen Topf geben, mit Wasser knapp bedecken. Zucker, Himbeeren und Gewürze zugeben, 10 Minuten kochen. Den Sud durch ein Sieb gießen.

2. Die Rhabarberscheiben 10 Sekunden kochen, vorsichtig aus dem Sud heben, abschrecken. Die Streifen kurz auf einem Küchentuch ausbreiten, trocken tupfen und zu einem schönen Muster legen. Den Sud mit dem Puddingpulver zu einer Sauce abbinden und den Rhabarber mit dem Sirup beträufeln.

Rhabarbercharlotte

250 g Rhabarber, 100 g Zucker, je 1/2 Vanille- und Zimtstange
50 g Himbeeren, 1 EL Zitronensaft, 4 Blatt Gelatine
1/2 Rezept Rhabarbermatte, 100 ml Sahne, 3 Eiweiß

Außerdem: 4 Souffléeformen, Plätzchen-Ausstecher oder Kaffeetassen

1. Rhabarber waschen, klein schneiden. Mit 50 g Zucker und den Gewürzen bei schwacher Hitze 10–15 Minuten zugedeckt dünsten. Gelatine in kaltem Wasser einweichen. Die Gewürze entfernen, Himbeeren, Gelatine und Zitronensaft zugeben, pürieren und durch ein Sieb streichen.

2. Die Formen mit kaltem Wasser ausspülen, jeweils ein Stück Klarsichtfolie hinein legen. Die Formen mit den Rhabarberstreifen der Rhabarbermatte auskleiden. Sahne schlagen, Eiweiß mit dem restlichen Zucker ebenfalls steif schlagen. Sahne und Eiweiß unter das Rhababerpüree ziehen, wenn die Masse gerade eben beginnt, fest zu werden. Die Creme in die vorbereiteten Formen füllen. Etwa 2 Stunden kühl stellen. Vor dem Anrichten stürzen.

Rhubarb mat

500 g rhubarb, 175 g sugar, 60 g raspberries
1/4 vanilla pod, 1/4 cinnamon stick, 1 tsp. custard powder

1. Wash the rhubarb, cut off the ends. Then, using an electric slicer, cut rhubarb into 2–3 mm thin strips. Put the chopped off ends of rhubarb in a pan, barely cover with water. Add sugar, raspberries and spices, simmer for 10 minutes. Strain.

2. Boil the rhubarb strips for 10 seconds, remove carefully from pan and rinse strips in cold water. Dry rhubarb strips on a kitchen towel for a short time, dab dry and arrange them in an attractive pattern. Bind the juice from the cooking with custard powder to make a sauce and then drip the syrup over the rhubarb.

Rhubarb charlotte

250 g rhubarb, 100 g sugar, 1/2 vanilla pod, 1/2 cinnamon stick
50 g raspberries, 1 tbsp. lemon juice, 4 sheets gelatine
1/2 of the rhubarb mat recipe, 100 ml cream, 3 egg whites

In addition: 4 soufflé forms, biscuit cutters or teacups

1. Wash rhubarb, cut it small. Simmer with 50 g sugar and the spices on a low heat 10–15 minutes in covered saucepan. Leave gelatine in cold water to soak. Remove spices, add raspberries, gelatine and lemon juice; purée and strain through a sieve.

2. Rinse forms in cold water and place a piece of cling foil in each. Line the forms with the rhubarb strips of the rhubarb mat. Whip the cream, also whisk the egg whites and remaining sugar stiff. Fold the cream and the egg white into the rhubarb purée, just as the mixture is beginning to thicken. Fill the cream into the prepared forms. Cool for about 2 hours. Turn out of forms before serving.

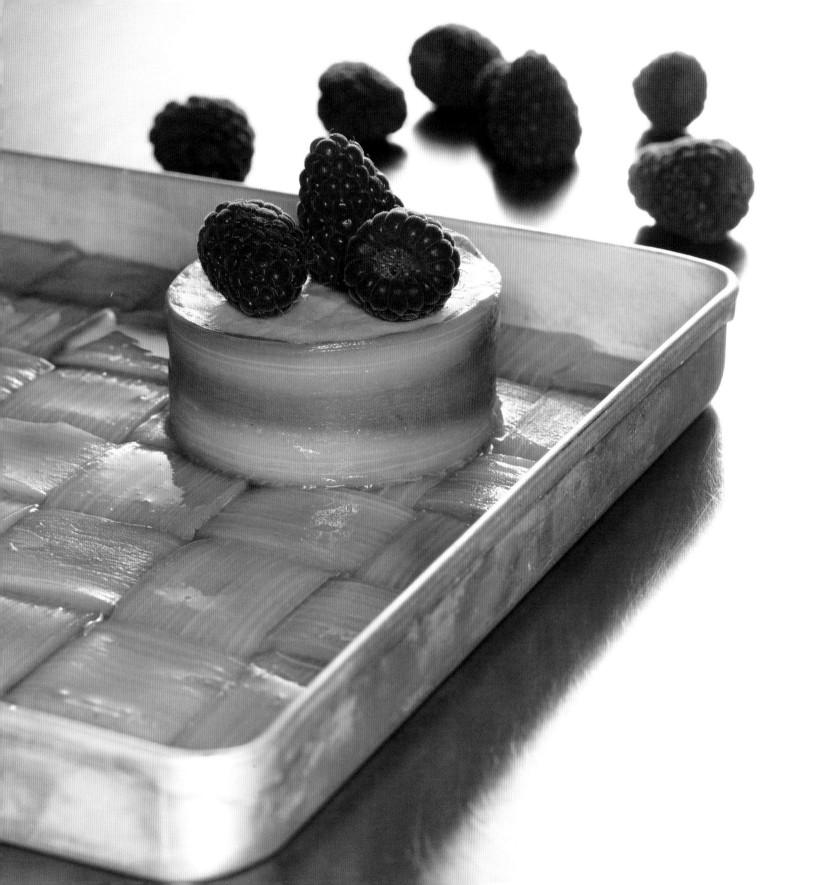

schneiden, zu einer Matte flechten, zu Schaum schlagen und zu Mus verkochen. Das Team möchte herausfinden, ob das Knöterichgewächs abseits des altbekannten Kompotts noch andere Qualitäten hat, sowohl in seiner Materialität und Struktur als auch in verschiedenen physikalischen Aggregatszuständen. Damit greifen die beiden Rezepterfinder, die ansonsten Arbeitskollegen sind, auf eine Vorgehensweise zurück, die sie als Planer und Gestalter auch bei ihren Projekten für die pmg profile marketing group im Rahmen der Event-Architektur einsetzen, sei es für temporäre Bauten oder Rauminszenierungen. Bei der Entwicklung freier Formen untersuchen sie

would like to investigate whether, apart from the well-known stewed rhubarb, this member of the polygonaceae family also has other qualities, both in its materiality and structure as well as in different physical states of aggregation. In doing so the two recipe inventors, who are normally working colleagues, fall back on a procedure which they also apply as planners and designers for their projects for the pmg profile marketing group within the framework of event-architecture, whether it be for temporary buildings or room productions. When developing free forms they examine, often playfully, which uses a material can allow both in construction and design and which forms

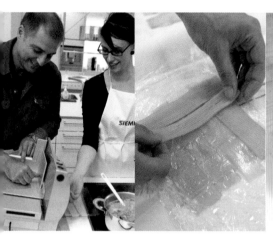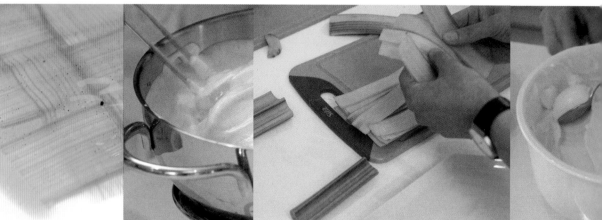

oft spielerisch, welchen Einsatz ein Material konstruktiv wie auch gestalterisch zulässt und welche Formen durch die Merkmale des Werkstoffes an Ausdruck gewinnen. »Es ist uns wichtig, ehrlich mit den Materialien umzugehen, also das Maximale herauszuholen, ohne den Grundcharakter der Stoffe zu zerstören«, sagt Simone Heckmann. »Aber wenn ich nicht weiß, wie sich ein Werkstoff verhält, kann ich ihn nicht richtig einsetzen, weder in der Architektur noch in der Küche«, fügt Norbert Fischbach hinzu und erklärt damit gleich Sinn und Zweck der anstehenden Rhabarber-Studie.

find expression through the characteristics of the material. "It is important to us that we deal honestly with the materials, that means getting the maximum out of them without destroying the basic nature of the materials", says Simone Heckmann. "But if I don't know how a material behaves I cannot use it properly, whether it be in architecture or in the kitchen", adds Norbert Fischbach thereby explaining the sense and purpose of the impending rhubarb study.

Rhabarber im Geschmackstest

Zu Beginn der Testreihe versammelt der Versuchsleiter seine Gäste um sich und verteilt an jeden ein rohes Stück Rhabarber. »Wenn man ein Nahrungsmittel untersucht, gilt es zuerst einmal herauszufinden, wie es schmeckt, denn es wird später darum gehen, den Eigengeschmack zu intensivieren.« Alle probieren gerne. Die Meinung ist

Rhubarb in the gustatory test

At the beginning of this test series the leader of the experiment gathers his guests around him and gives each of them a piece of raw rhubarb. "When examining food, the first task is to find out how it tastes, because later it will be a question of intensifying its intrinsic taste." All like tasting it. Their opinion is unanimous:

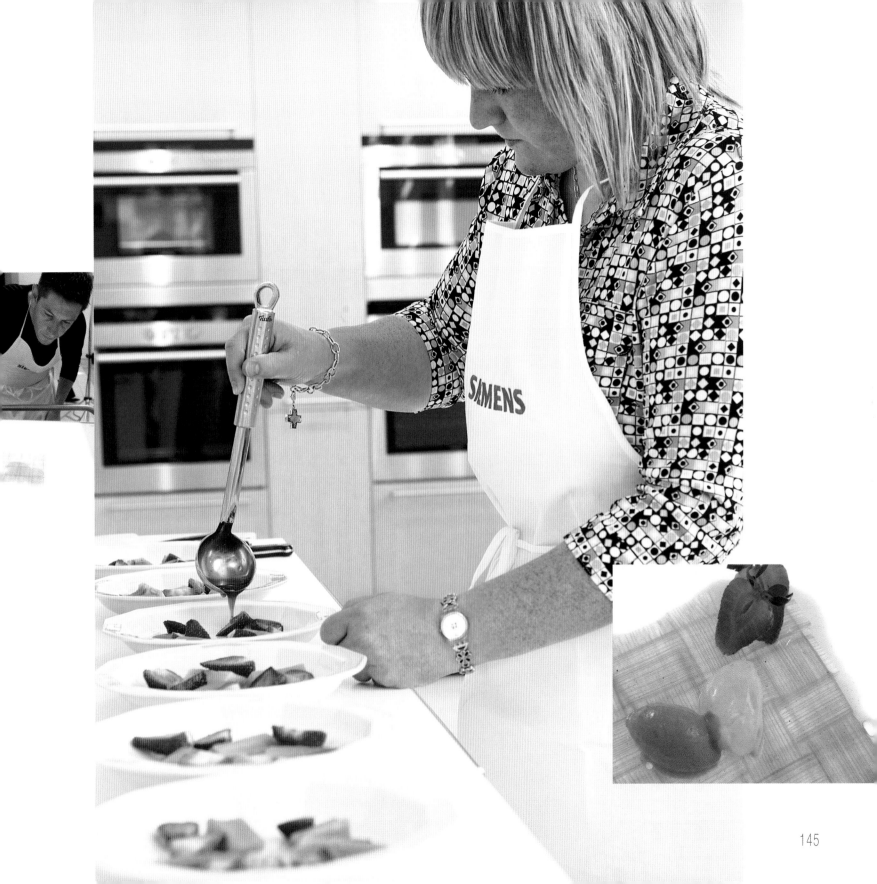

Rhabarberbündel

1/2 Rezept Rhabarbermatte (Seite 142)
500 g Rhabarber
200 g Zucker
50 g Himbeeren
Je 1/2 Vanille- und Zimtstange

1. Backofen auf 200 Grad vorheizen (Umluft 180 Grad). Rhabarber waschen, in 4 cm lange Stücke schneiden. Zucker mit 5 EL Wasser kurz aufkochen. Rhabarber, Himbeeren und Gewürze eng in eine passende Auflaufform legen. Den heißen Zuckersirup darüber gießen, mit Alufolie abdecken und 20 Minuten im Ofen garen, abkühlen.

2. Jeweils 8–10 Rhabarberstücke mit je zwei Rhabarberstreifen zu einem Bündel wickeln. Den restlichen Sud durch ein Sieb gießen und für Rezepte wie das lauwarme Rhabarber-Baiser aufbewahren.

Lauwarmes Rhabarber-Baiser

100 ml Rhabarbersud (oben)
2 Eiweiß
40 g Zucker

Rhabarbersud in einer Metallschüssel mit dem Eiweiß verquirlen. Die Masse über einem passenden Topf mit kochendem Wasser schaumig schlagen. Dabei den Zucker nach und nach einstreuen. Rhabarberschaum sofort servieren.

Rhubarb bundles

1/2 of the rhubarb mat recipe (page 142)
500 g rhubarb
200 g sugar
50 g raspberries
1/2 vanilla pod, 1/2 cinnamon stick

1. Preheat oven to 200 degrees (convection 180 degrees). Wash rhubarb, cut it into 4 cm long pieces. Briefly boil sugar with 5 tbsp. of water. Put rhubarb, raspberries and spices close together in the right sized soufflé form. Pour the hot sugar syrup over the top, cover with tinfoil and bake in the oven for 20 minutes, leave to cool.

2. Wrap two rhubarb strips round 8–10 rhubarb pieces to form bundles. Pour the rest of the juice through a sieve and keep it for recipes like the lukewarm rhubarb meringue.

Lukewarm rhubarb meringue

100 ml rhubarb juice (above)
2 egg whites
40 g sugar

Whisk rhubarb juice with the egg whites in a metal bowl. Stand the bowl in a suitable saucepan of boiling water and beat the rhubarb mixture frothy. While doing so gradually add the sugar. Serve immediately.

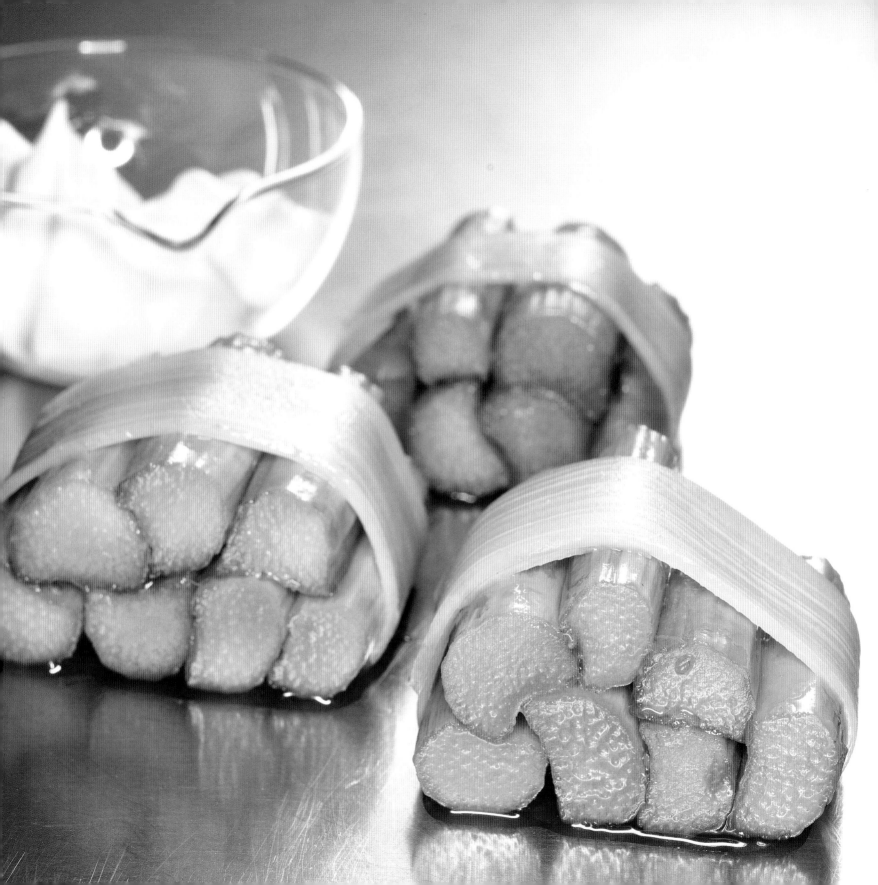

einhellig: sauer. Aber sauer ist nicht gleich sauer. Die Färbungen des Stiels geben Aufschluss über das Aroma. Sind Fruchtfleisch und Stängel gleichermaßen grün, können sich die Zungenrezeptoren auf ein sehr saures Erlebnis gefasst machen. Ein roter Stiel mit grünem Fruchtfleisch schmeckt leicht herb, und ein rotstieliges Exemplar mit weiß-rotem Fruchtfleisch ist eher mild mit leichtem Himbeeraroma.

Neuer Bezug zu Altbekanntem

Schon 2 700 v. Chr. war Rhabarber in China als Heilpflanze bekannt. Seine Wurzeln wurden zur Förderung der Verdauung und als mildes

sour. But there is sour and sour. The colour of the stem gives information about the aroma. If the pulp and the stem are equally green the tongue's receptors should be prepared for a very sour result. A red stem with green pulp tastes slightly acid, and a red stemmed variety with whitish red pulp is rather mild with a slightly raspberry aroma.

New relationship to something long known

As long ago as 2700 BC rhubarb was known in China as a medicinal plant Its roots were used to aid digestion and as a mild laxative. In

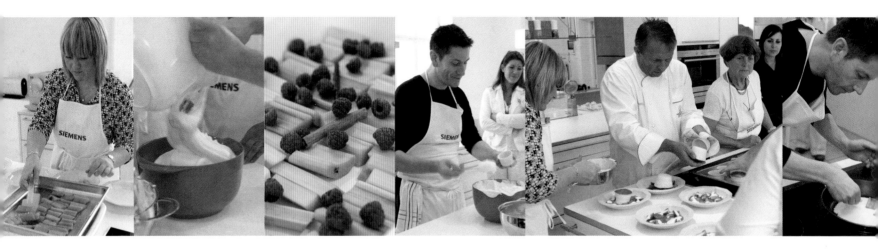

Abführmittel eingesetzt. Über Russland kam die Pflanze im 16. Jahrhundert nach Europa. Aber erst vor 250 Jahren hat man in England ihren kulinarischen Wert entdeckt. Bis in die 1960er Jahre war Rhabarber auch in Deutschland sehr beliebt, bis ihn südländische Früchte von den Marktständen verdrängten. Heute ist er wieder im Trend, genau wie andere heimische Gemüsesorten, die nicht erst auf langen Transportwegen in die Läden gebracht werden müssen. »Die Gesellschaft ist im Begriff, ihren Lebensstil zu ändern, Gesundheit und Nachhaltigkeit sind aktuelle Themen, das beeinflusst auch den Bezug der Leute zu den Nahrungsmitteln«, führt Norbert Fischbach an, »deshalb haben wir uns für Rhabarber als typisches Frühlingsgemüse entschieden.«

Vom Kochen zur Architektur und umgekehrt

In Gruppen zu drei bis vier Leuten begeben sich die Gastlaboranten an die Teststationen. Die Aufgaben sind verteilt und jede Gruppe

the 16th century the plant found its way to Europe via Russia. But it was not until 250 years ago that its culinary value was discovered in England. Up until the 1960s rhubarb was also very popular in Germany until it was replaced on the market stalls by fruits from southern lands. Today it is the trend again, just like other domestic vegetable sorts, which do not have to be transported over long distances to reach the shops. "Society is just about to change its lifestyle, health and sustainability are current topics and this influences people's relationship to food", Norbert Fischbach claims, "that's the reason we chose rhubarb as a typical spring vegetable."

From cooking to architecture and vice versa

The guest laboratory assistants go to the test stations in groups of three or four people. The tasks are assigned and each group works

bearbeitet ein Rezept. Doch am Anfang sind alle mit derselben Tätigkeit beschäftigt: Rhabarber schälen. Profikoch Michael Fell hat das heimische Gemüse aus lokalem Anbau besorgt. Jetzt stapeln sich die roten Stangen auf den Tischen. Gut gelaunt durchstöbert er die Schubladen nach Schälern und geeigneten Messern und sorgt dafür, dass alle mit Schneidebrettern versorgt sind. Wenig später baden Stängelstücke im Zuckersud, Gelatine löst sich in einer Schale voll kaltem Wasser auf, Rhabarberpüree friert zusammen mit Zitronensaft und Weißwein in der Eismaschine. Michael Fell geht von einer Gruppe zur nächsten, beantwortet Fragen, gibt Kochtipps. Er ist es gewohnt, sich schnell auf verschiedene Kochsituationen und wechselnde Anforderungen einzustellen. Schließlich betreut er als Chef de Cuisine des Park-Hotels Egerner Höfe so unterschiedliche gastronomische Einrichtungen wie das Hotel-Restaurant St. Florian, das rustikale Hubertusstüberl mit bayerischer Traditionsküche und die Dichterstub'n, das Gourmetrestaurant, für dessen lukullische Gerichte viele Münchner Kenner abends noch an den Tegernsee fahren. Norbert Fischbach ist der berufliche Umgang mit Nahrungsmitteln auch nicht fremd. In seinem ersten Berufsabschnitt führte er die Familientradition als Patissier weiter, wird mit zwei Michelin-Sternen ausgezeichnet, entdeckt die Event-Gastronomie für sich und wechselt 1993 als Quereinsteiger ganz in die Event-Konzeption. Nach zwei Lehrjahren in einer Agentur macht er sich selbstständig und gründet 2003 die pmg profile marketing group. Im selben Jahr stößt Architektin Simone Heckmann dazu, die ihre solide Grundausbildung zur Bauzeichnerin und ihre Erfahrung als Projektleiterin einbringt. Heute zählen die Event-Architektur und die Raumplanung zu den Kernkompetenzen der Agentur.

Kreative Experimente

Mit derselben Kreativität, die die beiden Gestalter im Berufsalltag einsetzen, haben sie die Rezepturen der Studie neu- oder weiterentwickelt. Zum Beispiel die Rhabarber-Matte, die gerade an der Kochstation etwas Schwierigkeiten macht. Es ist nämlich gar nicht so einfach, die hauchdünnen Längsstreifen so zu blanchieren, dass man sie flechten kann. Eine Sekunde zu lang im Topf und der Streifen wird matschig, zu kurz und er wird nicht transluzent. Doch nach einigen unbrauchbaren Versuchen bringen die Gruppenmitglieder ein gelungenes Ergebnis zustande: Die gleichmäßig geflochtene Anordnung ist stabil und weist eine optisch interessante Längs- und Quermaserung auf. Das Experiment war erfolgreich.

on one recipe. But at the beginning they are all busy with the same work: peeling rhubarb. Professional chef Michael Fell bought the domestic vegetable from a local grower. Now there are piles of red sticks on the tables. Good temperedly he rummages through drawers looking for peelers and suitable knives and he makes sure that everyone has a chopping board. Soon afterwards stem pieces are soaking in a sugary brew, gelatine is dissolving in a bowl full of cold water, rhubarb purée is being frozen together with lemon juice and white wine in the ice cream machine. Michael Fell goes from one group to the next answering questions, giving cooking tips. He is used to adapting quickly to different cooking situations and changing demands. After all as chef de cuisine at the Park Hotel Egerner Höfe he is in charge of such widely differing gastronomic establishments as the St. Florian hotel restaurant, the rustic Hubertusstüberl with its traditional Bavarian cuisine and the Dichterstub'n, the gourmet restaurant, for whose epicurean specialities many Munich connoisseurs travel out to Lake Tegernsee of an evening. Norbert Fischbach is no stranger either to dealing with food professionally. In his early career he continued the family tradition as a pastry cook, was awarded two Michelin stars, discovered event-gastronomy for himself and changed direction in 1993 to go into event design. After learning the job for two years with an agency he went self-employed and in 2003 founded the pmg profile marketing group. In the same year he was joined by the architect Simone Heckmann, who brings in her well founded training as a technical draughtsman and her experience as a project leader. Today event-architecture and room planning count as the agency's core competences.

Creative experiments

With the same creativity which the two designers use in their everyday working life they have redeveloped or further developed the recipes for the study. For example the rhubarb mat which is causing some difficulty at the cooking station right now. In fact it is not so easy to blanch the wafer-thin strips so that they can be plaited. A second too much in the pan and the strip becomes mushy, too little and it won't become translucent. But after a few hopeless attempts the group members produce a successful result: the evenly plaited arrangement is stable and displays an optically interesting grain pattern lengthwise and crosswise. The experiment was successful.

Rhabarberpfannkuchen

250 g Rhabarber, 300 g Mehl
4 Eier, 400 ml Milch, 50 g flüssige Butter
50 g Zucker und Zucker zum Bestreuen
1 Prise Salz, 2 EL Öl

1. Rhabarber schälen, in kleine Stücke schneiden. Übrige Zutaten (bis auf das Öl) in einer Schüssel zu einem glatten Teig verrühren.

2. Die Pfanne auf dem Herd ca. 3 Minuten vorheizen. Etwas Öl und einen kleinen Schöpflöffel voll Pfannkuchenteig gleichmäßig in der Pfanne verteilen. Rhabarberstücke auf den flüssigen Teig streuen. Die Pfanne sofort mit einem Deckel abdecken. Sobald die Unterseite goldbraun gebacken und die Oberseite nicht mehr flüssig ist, den Pfannkuchen wenden. Einige Minuten von der zweiten Seite goldbraun backen, auf einen Teller stürzen, sodass der Rhabarber oben ist. Wiederholen, bis der Teig verbraucht ist. Die fertigen Pfannkuchen nach Geschmack mit Zucker bestreuen.

Rhubarb pancakes

250 g rhubarb, 300 g flour
4 eggs, 400 ml milk, 50 g soft butter
50 g sugar and sugar to sprinkle
1 pinch salt, 2 tbsp. oil

1. Peel rhubarb, cut into small pieces. Mix all other ingredients (except the oil) smoothly in a bowl.

2. Preheat the pan on the stove for about 3 minutes. Spread a little oil and a small ladle of pancake mixture evenly in the frying pan. Spread the rhubarb pieces over the runny mixture. Cover frying pan with a lid immediately. As soon as the bottom is golden brown and the top is no longer runny, turn the pancake. Fry for a few minutes until the second side is golden brown, turn out onto a plate, with the rhubarb side facing upwards. Repeat until all the pancake mixture has been used up. Sprinkle the finished pancakes with sugar to taste.

Quark-Ingwer-Soufflée

Zucker und Butter für die Förmchen
250 g Magerquark, 3 Eigelbe, 1 TL Vanille-Puddingpulver
Je 1 Msp. geriebene Orangenschale und Vanillemark
1 gehäufter TL frischer Ingwer, gerieben
6 Eiweiße, 90 g Zucker, 1 Prise Salz

Außerdem: 6 Souffléeformen, je 150 ml

Auflaufform 3 cm hoch mit Wasser füllen, im Backofen auf 210 Grad vorheizen (keine Umluft). Die Souffléeformen sorgfältig buttern und mit Zucker ausstreuen. Quark, Eigelbe, Puddingpulver und Gewürze zu einer glatten Masse verrühren. Eiweiß mit Zucker und einer Prise Salz steif schlagen, unter die Quarkmasse heben, in die vorbereiteten Formen füllen. Souffléeformen in das Wasserbad stellen und ca. 20 Minuten backen. Gestürzt oder in der Form mit Gerichten aus unseren Rhabarbervariationen in Sekundenschnelle servieren.

Quark and ginger soufflé

sugar and butter to grease the forms
250 g low-fat quark, 3 egg yolks, 1 tsp. custard powder
1 pinch grated orange zest and 1 pinch vanilla
1 heaped tsp. fresh ginger, grated
6 egg whites, 90 g sugar, 1 pinch salt

In addition: 6 soufflé forms, each for 150 ml

Preheat a 3 cm tall soufflé dish filled with water in the oven at 210 degrees (not convection). Grease the soufflé forms carefully and sprinkle with sugar. Mix quark, egg yolks, custard powder and spices to a smooth mixture. Beat egg whites stiff with sugar and a pinch of salt. Fold egg white into the quark mixture, fill into the prepared forms. Stand soufflé forms in the bain-marie and bake for about 20 minutes. Serve instantly and very fast, either turned out, or still in the form with one or several of the dishes from our rhubarb variations.

ANHANG
Appendix

Nachwort

Steinarchitektur ist mit Muße, Tiefgang und Ruhe verbunden – die Inspiration lässt zuweilen auf sich warten und der konzeptuelle Prozess ist ein asketischer. »Das Einfachste ist nicht das Leichteste«, wusste auch Le Corbusier. Tief in unserer kulturellen Herkunft sind die Ursprünge unserer Kreativität verwurzelt. Montesquieu sagte: »Um Universalität zu erreichen, könnte man mit dem Lokalen beginnen.«

Auch die Kochkunst muss ein Gleichgewicht finden zwischen vollendeter Schlichtheit und Kulturreichhaltigkeit.
Mein Lieblingsrezept stammt aus einer Region Südfrankreichs, der Camargue, wo die berühmten schwarzen Stiere in freier Wildbahn leben: es heißt »daube camarguaise«, Rinderragout der Camargue, und ist ein sehr reichhaltiges Gericht, gewürzt mit vielerlei Kräutern der Provence. Ich mag die Kombination einer bodenständigen Mahlzeit mit einem dezenten Geschmack. Dazu wird Rotwein aus »costières de Nîmes« gereicht. Dieses Gericht benötigt eine lange Zubereitungszeit, das Kochen dauert viele Stunden.
Zu dieser Mahlzeit braucht man nichts weiter als reines Wasser, das man am besten direkt aus einem Erdloch schöpft. Aber vorweg – glücklich darüber, mit seinen Freunden im Schatten eines Feigenbaums zu sitzen – muss man einen »Domaine Perraudin«, diesen großartigen Weißwein, als Aperitif genießen.

Die zur Zubereitung eines guten Essens benötigte Zeit entspricht in etwa der Zeit, die man für Architektur benötigt. Als Architekt träume ich davon, mein Büro in meiner Küche zu haben ...

Feiern Sie schön!
Gilles Perraudin

Epilogue

Stone architecture is connected with time, depth and calmness. It takes a long time to be inspired and the conceptual process is an ascetic one. "The simplest is not the easiest", said Le Corbusier. Inspiration's origins are deeply rooted in one's cultural background. "In order to achieve universality you could start with ultra local", said Montesquieu.

Cooking must find a balance and underline these options: minimalism and richness of culture.
My favourite recipe is rooted in the culture of the South of France, in the Camargue region, where bulls run freely in the wilds: this is "daube camarguaise" (Camargue beef stew). It's a very rich dish, seasoned with many herbes de Provence. A mixture of a rich meal together with a light flavour, this dish requires a long time to prepare, using red wine from "costières de Nîmes" and it takes many hours to cook.
Whilst eating this meal all you need is pure water dug from a hole in the ground. But first, together with your friends, happy to be beneath the shade of the fig tree, you must take a "Domaine Perraudin", the great white wine, as an aperitif.

The time needed to prepare good food relates to the time for archtecture. My dream as an architect is to have my office in my kitchen ...

Have a good party!
Gilles Perraudin

Büroprofile | Office profiles

sigeko-Ingenieure
Andreas Aug

Nach einer Ausbildung zum Koch und Betriebswirt sowie Tätigkeit als selbstständiger Gastronom Studium an der FH Hamburg, Fachbereich Architektur; Diplom 1995; Mitarbeit in verschiedenen Büros in Hamburg, Los Angeles und Taipeh; 1998 Gründung des Büros Arc-Serv; Fortbildung zum Sicherheits-Ingenieur; 1999 Gründung der sigeko GbR in Hamburg; seit 2002 sigeko-Ingenieure www.si-ge-ko.de

After training as a chef and business administrator as well as working as a self-employed gourmet chef studied Architecture at Hamburg University of Applied Sciences; degree 1995; worked at various offices in Hamburg, Los Angeles and Taipei; founded ArcServ office in 1998; training as a safety engineer; 1999 founded sigeko GbR, Hamburg; since 2002 sigeko-Ingenieure www.si-ge-ko.de

Christa Baumgartner

Architekturstudium an der FH Nürnberg; Diplom 1972; Mitarbeit in verschiedenen Büros; seit 1975 eigenes Architekturbüro in Nürnberg mit Schwerpunkt Denkmalpflege und Bauen im Bestand; diverse Lehraufträge; 1995–2007 Vorstandsmitglied der Bayerischen Architektenkammer; seit 1991 Mitglied der Gastrosophinnen Schweiz; seit 2001 für den VFB im Landesplanungsbeirat

Studied Architecture at University of Applied Sciences in Nuremberg; degree 1972; worked in various offices; since 1975 own architect's office with main focus on monument preservation and building in existing fabric; various teaching assignments; 1995–2007 member of the board of the Bavarian Chamber of Architects; since 1991 member of the Women Gastrosophers Club in Switzerland; since 2001 member in town and country planning advisory board for the VFB association of freelance architects

gaumenlaune
Julia Beer, Verena Weikinger

Architekturstudium an der TU Wien; Diplom 2007; Mitarbeit in diversen Architekturbüros in Innsbruck und bei ARTEC Architekten, Wien; Gründung von gaumenlaune 2000 mit Verena Weikinger; Projekte mit gaumenlaune u. a. 2004 Wonnemonat Mai – Subbotnik Architektur, 2005 Fest für Kultur und Gewerbe – Volkert-/Alliiertenviertel Wien; Verena Weikinger studierte an der TU Wien; Diplom 1999; Mitarbeit in Architekturbüros in Wien und Oberösterreich

Studied Architecture at University of Technology in Vienna (TU); degree 2007; worked for various architect's offices in Innsbruck and with ARTEC Architekten, Vienna; founded gaumenlaune 2000 with Verena Weikinger; projects with gaumenlaune included 2004 "Wonnemonat Mai" (merry month of May) – Subbotnik Architektur", 2005 Fest für Kultur und Gewerbe (festival for culture and trade) – Volkert-/Alliiertenviertel Vienna; Verena Weikinger studied at TU Vienna; degree 1999; worked at architectural offices in Vienna and Upper Austria

Brembs Architekten
Barbara Brembs

Abschluss zur Kauffrau im Einzelhandel und Dipl.-Ing. Innenarchitektur an der FH Kaiserslautern; 1979 Eröffnung eines eigenen Ladens für Wohnaccessoires in Schweinfurt, der bis heute besteht; 1986 Bürogründung in Röthlein bei Schweinfurt zusammen mit Ehemann Dipl.-Ing. Architekt BDA Winfried Brembs; diverse Wettbewerbserfolge, u. a. Feuerwache Monsheim, Kindergarten Kürnach www.architechnic.de

Degree in Retail Business and Dipl.-Ing engineering degree in Interior Design at University of Applied Sciences in Kaiserslautern; 1979 opened own store for home accessories in Schweinfurt; the store is still in existence today; 1986 together with husband, Dipl.-Ing. architect Winfried Brembs BDA (Association German Architects), founded own office; various successes in competitions including the fire station in Monsheim and the kindergarten in Kürnach www.architechnic.de

J.S.K. Dipl.-Ing. Architekten
Nicola Bürk

Architekturstudium an der TU Darmstadt und der TU Berlin; Diplom 2006; Praktika bei J.S.K. Dipl.-Ing. Architekten, Berlin, Drees und Sommer Projektmanagement und bautechnische Beratung, Berlin, Perkins Eastman Architects, New York, gmp Architekten, Berlin, Cresco Capital Real Estate Investment and Development, London; seit 2006 Mitarbeit bei J.S.K. Dipl.-Ing. Architekten, Berlin

Architectural studies at Technical University of Darmstadt and Technical University of Berlin; degree 2006; internships at J.S.K. Dipl.-Ing. Architekten, Berlin, Drees & Sommer Project Management and Real Estate Consulting, Berlin, Perkins Eastman Architects, New York, gmp Architekten, Berlin, Cresco Capital Real Estate Investment and Development, London; since 2006 in cooperation with J.S.K. Dipl.-Ing. Architekten, Berlin

Mario Cucinella Architects
Mario Cucinella

Architekturstudium an der Università di Genova; Diplom 1987; seit 1992 eigenes Büro in Paris; seit 1999 Bürogemeinschaft mit Elizabeth Francis in Bologna; Gastprofessor an der Nottingham University; diverse Vorlesungen in Europa; seit 1998 Lehrauftrag an der Universität Ferrara; 1999 Förderungspreis Baukunst der Akademie der Künste, Berlin
www.mcarchitects.it

Studied Architecture at University of Genoa; degree 1987; since 1992 own office in Paris; since 1999 office partnership with Elizabeth Francis in Bologna; visiting professor at Nottingham University; various lectures in Europe; since 1998 teaching post at the University of Ferrara; 1999 received the Förderungspreis award from the Academy of Arts in Berlin
www.mcarchitects.it

pmg profile marketing group
Norbert Fischbach,
Simone Inge Heckmann

Ausbildung zum Chef-Patissier; mit zwei Michelin-Sternen ausgezeichnet; Wechsel in den Eventbereich; 1993–1995 Lernphase bei Agentur Kaufmann & Partner, Frankfurt; 1997 Gründung der Profile Events & PR GmbH; Aufteilung 2003 in MEC2 GmbH (Produktion) und pmg profile marketing group, Wiesbaden (Konzeption); seit 2003 mit Unterstützung von Dipl.-Ing. (FH) Architektin Simone Inge Heckmann verstärkt im Bereich Event-Architektur und Messebaukozeption tätig
www.profile-mg.com

Trained to be a chef-patissier; awarded two Michelin stars; changed to events sector; 1993–1995 learning phase at Kaufmann & Partner's agency, Frankfurt; 1997 founded Profile Events & PR GmbH; 2003 split into MEC2 GmbH (Production) und pmg profile marketing group (Planning); since 2003 working mainly in the event-architecture and fairs-planning fields, supported by Dipl.-Ing. (FH) architect Simone Heckmann
www.profile-mg.com

Franken Architekten
Bernhard Franken

Architekturstudium an der TU Braunschweig und TU Darmstadt; Diplom 1996; bis 2000 Freier Mitarbeiter bei ABB Architekten, Frankfurt; in Arbeitsgemeinschaft bis 2002; im selben Jahr Gründung von Franken Architekten in Frankfurt am Main; diverse Lehraufträge, zuletzt als Dozent am Zollverein School for Management and Design, Essen; Gastprofessor am Southern California Institute of Architecture, L.A.
www.franken-architekten.de

Studied Architecture at Universities of Applied Sciences in Brunswick and in Darmstadt; degree 1996; until 2000 freelancer at ABB Architekten, Frankfurt; part of a joint team until 2002; in the same year founded Franken Architekten; various teaching assignments, the latest lecturing at Zollverein School for Management and Design, Essen; visiting professor at the Southern California Institute of Architecture, Los Angeles
www.franken-architekten.de

AFF Architekten
Martin Fröhlich

Berufsausbildung zum Elektromonteur und Maurer; 1994 Diplom an der Bauhaus-Universität Weimar; bis 2005 wiss. Mitarbeiter bei Prof. Rudolf; 1996 Gründung des Büros AFF Architekten, Berlin/Magdeburg, als offenes Atelier mit Netzwerkpartnern unterschiedlicher professioneller Kompetenzen; verantwortlich: Martin und Sven Fröhlich, Alexander Georgi, Torsten Lockl
www.aff-architekten.com

Trained as an electrician and bricklayer; 1994 degree at Bauhaus University Weimar; until 2005 research assistant to Professor Rudolf; 1996 founded AFF Architekten office, Berlin, as an open studio with network partners with different professional competencies; responsible: Martin and Sven Fröhlich, Alexander Georgi, Torsten Lockl
www.aff-architekten.com

Ensamble Studio
Antón García-Abril

Studiengang Architektur und Städtebau an der E.T.S.A. Madrid; Diplom 1995 und Doktorat 2000; Professor an der E.T.S.A. Madrid; Veröffentlichungen in EL CULTURAL; Vorlesungen und Vorträge an verschiedenen Universitäten; Gründung von Ensamble Studio im Jahr 2000 in Madrid als heterogene Gruppe mit Mitgliedern aus diversen professionellen Sparten und Ländern; Projektbereich: Architektur und öffentliche Kunst
www.ensamble.info

Studied Architecture and Town Planning at E.T.S.A. Madrid; degree 1995 and doctorate 2000; professor at E.T.S.A. Madrid; publications in EL CULTURAL; lectures and talks at various universities; founded Ensamble Studio in 2000 as a heterogeneous group of members from diverse professional sectors and countries; project area: architecture and public art
www.ensamble.info

planungsbüro i21
Heiko Gruber

planungsbüro mehring + heuser
Edith Heuser

Jan Jaenecke

HVB Immobilien
Bert Kühnöhl

Kengo Kuma & Associates
Kengo Kuma

Studiengang Innenarchitektur an der FH Mainz; Diplom 2000; freiberufliche Tätigkeit 2000–2002; Gründung planungsbüro i21 in Rüdesheim im Jahr 2002 mit Konzentration der Arbeitsfelder auf vorhandene Bausubstanz; Publikationen: Fachzeitschrift AIT (2002), Jahrbuch BDIA Innenarchitekten (2002), WHO's WHO Deutscher Innenarchitekten German Interior Designers (2003) www.innenarchitektur21.de

Studied Interior Design at the University of Applied Sciences in Mainz; degree 2000; freelance work 2000–2002; founded planungsbüro i21 in 2002 concentrating on the field of working with existing building substance; publications: Trade journal AIT (2002), the BDIA interior designer's handbook (2002), WHO's WHO German Interior Designers (2003) www.innenarchitektur21.de

Ausbildung zur Innenarchitektin an der FH Rosenheim und FH Darmstadt mit Diplom; Büro seit 1996 zusammen mit Anne Mehring; Niederlassungen in Darmstadt und Frankfurt am Main; Schwerpunkt auf dem Umgang mit vorhandener Bausubstanz mittels ausgewählter Materialien sowie gezieltem Einsatz von Licht und Farbe; Veröffentlichungen u. a. in der Fachzeitschrift AIT (2003 und 2006) und im BDIA Handbuch Innenarchitektur (2006/2007) www.mehring-heuser.de

Studied Interior Design at the Universities of Applied Sciences in Rosenheim and Darmstadt, degree; since 1996 office together with Anne Mehring; special focus on the use of available building substance by the means of selected materials and planned use of light and colour; publications amongst other things in the AIT trade journal (2003 and 2006) and in the BDIA interior designer's handbook (2006/2007) www.mehring-heuser.de

Studium der Architektur und Denkmalpflege; Bauforschungsstudien in Namibia; ab 1995 in Dresden für verschiedene Architekturbüros tätig; seit 1998 eigenes Büro in Dresden; Projektbereich: überwiegend Umbauten und Sanierungen; Arbeitsweise: sowohll Substanz schonende Eingriffe als auch solche, die ohne Dogmatik eine neue Ordnung schaffen

Studied Architecture and Monument Preservation; construction research studies in Namibia; from 1995 worked for various architects in Dresden; since 1998 own office in Dresden; project area: mainly conversion and renovation work; method of working: interventions to protect substance as well as those creating a new order without dogmatism

Architekturstudium in München und Berlin; Mitarbeit in Architekturbüros in München und Berlin; seit 1981 als Projektarchitekt, später als Abteilungsdirektor in der Bauabteilung der Bayerischen Vereinsbank bzw. ab 1997 der HypoVereinsbank, danach in der HVB Immobilien AG tätig; Projektleitung u. a. für die Konzernzentrale in München, als Generalplaner für die Planung der Allianz Arena bei München

Studied Architecture in Munich and Berlin; worked at architectural offices in Munich and Berlin; from 1981 as a project architect, later as head of the construction department at the Bayerische Vereinsbank and from 1997 at the Hypo-Vereinsbank, later worked at HVB Immobilien AG; project management for corporate headquarters in Munich, as chief designer for the planning of the Allianz Arena, near Munich

1979 Diplom an der School of Engineering, University of Tokyo; 1985–1986 Columbia University, New York; 1987 Gründung Spatial Design Studio; 1990 Gründung des eigenen Architekturbüros Kengo Kuma & Associates, Tokio; 1999–2001 Professor an der Keio Universität, Tokio; zahlreiche Preise, Auszeichnungen und Veröffentlichungen www.kkaa.co.jp

1979 degree at the School of Engineering, University of Tokyo; 1985–1986 Columbia University, New York; 1987 founded the Spatial Design Studio; 1990 founded own architectural office Kengo Kuma & Associates, Tokyo; 1999–2001 professor at Keio University, Tokyo; numerous prizes, awards and publications www.kkaa.co.jp

Kraemer Partner Architekten
Ralf Malter

Maler- und Lackiererlehre; Studium Innenarchitektur an der FH des Saarlandes; 1991 Diplom; 1991–1995 Studium der Architektur an der FH Düsseldorf; 1995 Diplom; 1995–1997 Mitarbeiter im Büro Prof. Kleihues, Berlin; 1998 Eintragung in die Architektenkammer Berlin als freischaffender Architekt; seit 1998 Partner im Büro Kraemer Partner Architekten, Niederlassung Berlin
www.kraemerpartner.de

Apprenticeship as a painter and varnisher; studied Interior Design at the Saarland University of Applied Sciences; 1991 degree; 1991–1995 studied architecture at the University of Applied Sciences in Düsseldorf; 1995 degree; 1995–1997 worked at Prof. Kleihues' office, Berlin; 1998 enrolled in the Chamber of Architects Berlin as a freelance architect; since 1998 partner at Kraemer Partner architects' office, Berlin branch
www.kraemerpartner.de

Patkau Architects
Patricia & John Patkau

Patricia Patkau: 1974 Bachelor of Interior Design, University of Manitoba und 1978 Master of Architecture, Yale University; John Patkau: 1972 Master of Architecture, University of Manitoba; 1978 gründen beide Patkau Architects in Vancouver; über 200 Veröffentlichungen in Büchern und Fachmagazinen, drei Bücher über die Projekte des Büros, 20 Solo-Ausstellungen in Kanada, USA und Europa, zahlreiche nationale und internationale Auszeichnungen
www.patkau.ca

Patricia Patkau: 1974 Bachelor of Interior Design, University of Manitoba and 1978 Master of Architecture, Yale University; John Patkau: 1972 Master of Architecture, University of Manitoba; 1978 both founded Patkau Architects in Vancouver; more than 200 publications in books and professional magazines, 3 books about the office's projects, 20 solo exhibitions in Canada, USA and Europe, numerous national and international awards
www.patkau.ca

perraudin architectes
Gilles Perraudin

1977 Diplom an der L'École d'Architecture de Lyon; 1974–1981 Dozent an derselben; 1990 Dozent an der The Oslo School of Architecture and Design und der Rice University, Houston; 1996 Dozent an der Michigan University, Ann Harbor; 1997 Dozent an der The Royall Academy of Fine Arts in Kopenhagen; seit 1996 Professur an der École d'Architecture Languedoc-Roussillon; zahlreiche Auszeichnungen und Veröffentlichungen; Büro in Lyon
www.perraudinarchitectes.com

1977 degree at Lyon School of Architecture; 1974–1981 university lecturer at Lyon School of Architecture; 1990 university lecturer at Oslo School of Architecture and Design and at Rice University, Houston; 1996 lecturer at Michigan University, Ann Harbor; 1997 lecturer at The Royal Academy of Fine Arts in Copenhagen; since 1996 professorship at Languedoc-Roussillon School of Architecture; numerous awards and publications
www.perraudinarchitectes.com

porcella+morgan
Melanie Porcella, Steven Morgan

Melanie Porcella: 1994 Master of Architecture, Kent State University, Ohio; Steven Morgan: 1992 Bachelor of Architecture, Kent State University, Ohio; seit 1999 bietet das Büro in Berlin neben eigenen Projekten hauptsächlich Unterstützung im Bereich Design und Architektur für zahlreiche Architekturbüros in und um Berlin, u. a. auch CAD-Schulungen, 3D-Visualisierung, technische Übersetzungen deutsch-englisch

Melanie Porcella: 1994 Master of Architecture, Kent State University, Ohio; Steven Morgan: 1992 Bachelor of Architecture, Kent State University, Ohio; since 1999 the office in Berlin not only deals with its own projects but, in the field of design and architecture, mainly supports numerous architect's offices in and around Berlin, among other things CAD training courses, 3D visualisation, technical translations German-English

Jan Reuter Einrichtungen
Jan Reuter

Kaufmännische Ausbildung; Arbeitsaufenthalt in Großbritannien, den Niederlanden und Italien; Mitarbeit in einem Münchner Einrichtungsgeschäft; Tätigkeit als freier Kreativdirektor und Stylist; seit 1998 eigenes Büro in München für Inneneinrichtung (Objekt- und Privatkunden) mit besonderem Schwerpunkt auf Struktur bildende Eingriffe und Detaillösungen mittels Sonderanfertigungen
www.jan-reuter-einrichtungen.de

Commercial training; lived and worked in Great Britain, the Netherlands and Italy; worked for a Munich furnishing business; freelance creative director and stylist; since 1998 own office in Munich for furnishings (office and private customers) with particular emphasis on structure-building measures, details and customer-specific assignments
www.jan-reuter-einrichtungen.de

Allmann Sattler Wappner Architekten
Amandus Sattler

Schwarz.Jacobi Architekten BDA
Wolfgang Schwarz

Tillner & Willinger
Silja Tillner

Christopher Unger

Arkitektgruppen i Gävle
Marita Wallhagen

Gründung der Studiengemeinschaft für Kunst und Architektur »Sprengwerk« 1982 während des Architekturstudiums an der TU München; 1985 Diplom; 1987 Bürogründung in München, heute 52 Mitarbeiter; seit 2005 Lehrauftrag Architektur und Städtebau an der Akademie der Bildenden Künste, München; seit 2007 Lehrauftrag Semaine Internationale an der L'Ecole Superieure d'Architecture in Nancy
www.allmannsattlerwappner.de

1974–1981 Architekturstudium an der Universität Stuttgart; bis 1988 Mitarbeit in den Büros Klipper sowie Auer & Weber, Stuttgart; ab 1988 eigenes Architekturbüro; ab 1989 Büropartnerschaft mit Ehefrau Susanne Schwarz; ab 1991 Büropartnerschaft mit Freimut Jacobi in Stuttgart; 1985–2000 Lehrtätigkeit an der Universität Stuttgart und der FH Dessau; seit 2005 Mitglied des Vorstands der Architekturgalerie am Weißenhof

Studium der Architektur an der TU Wien und an der Akademie der Bildenden Künste in Wien (Meisterklasse Prof. Peichl) mit Diplom 1988; 1988–1990 Master Degree in Urban Design an der University of California, Los Angeles; 1989–1994 Arbeit im Bereich Urban Design in Los Angeles in diversen Büros; seit 1995 Architektin in Wien; Lehrtätigkeit an verschiedenen Universitäten; diverse Auszeichnungen
www.urban-design.at

1994–1996 Studium an der FH Hildesheim/Holzminden; 1996–2001 Studium und Diplom an der Universität Kassel; 2000–2002 Zusammenarbeit mit A_lab Architekten, Berlin; 2001 freie Mitarbeit bei Garbin Ambrosone Architetti, Vicenza; 2001 freie Mitarbeit bei Prof. Hans Frei, Zürich; 2002–2007 Mitarbeit in der Architektei Mey, Frankfurt/Main; seit 2007 Mitarbeit im Büro Schneider + Schumacher, Frankfurt/Main

2003 Diplom an der Universität Lund; seit 2003 Mitarbeit bei Arkitektgruppen in Gävle; 2006 Trainee bei Organic Architect Eric Corey Freed, San Francisco; Betreuung zahlreicher Projekte als verantwortliche Architektin; diverse Veröffentlichungen im Fachmagazin Arkitekten; Vorträge u. a. an der Universität Gävle; Ausstellungen u. a. in Helsingborg und Lund
www.arkitektgruppen.se

Founded "Sprengwerk", a study group for arts and architecture, in 1982 while studying Architecture at the University of Technology in Munich; degree 1985; 1987 founded an office in Munich, which has 52 staff members today; since 2005 teaching assignment for Architecture and Urban Development at the Academy of Fine Arts in Munich; since 2007 teaching assignment for International Week at L'Ecole Superieure d'Architecture (School of Architecture) in Nancy
www.allmannsattlerwappner.de

1974–1981 studied architecture at the University of Stuttgart, until 1988 worked with Klipper as well as Auer & Weber, Stuttgart; from 1988 own architect's office; from 1989 office partnership with wife Susanne Schwarz; from 1991 office partnership with Freimut Jacobi; 1985–2000 lecturer at University of Stuttgart and Dessau University of Applied Sciences; since 2005 member of the board of the Architekturgalerie am Weißenhof

Studied Architecture at Vienna University of Technology and at the Academy of Fine Arts in Vienna (master class Professor Peichl), degree 1988; 1988–1990 Master's Degree in Urban Design at University of California, Los Angeles; 1989–1994 worked in urban design sector in various offices in Los Angeles; since 1995 architect in Vienna; teaching at different universities; various awards
www.urban-design.at

1994–1996 studied at Hildesheim/Holzminden University of Applied Sciences; 1996–2001 studies/degree University of Kassel; 2000–2002 cooperation with A_lab Architekten, Berlin; 2001 freelancer at Garbin Ambrosone Architetti, Vicenza; 2001 freelancer with Professor Hans Frei, Zurich; 2002–2007 worked at Mey architect's office, Frankfurt/Main; since 2007 working at Schneider + Schumacher's office, Frankfurt/Main

2003 degree at Lund University; since 2003 worked with architect groups in Gävle; 2006 trainee with organic architect Eric Corey Freed, San Francisco; supervision of numerous projects as architect in charge; various publications in the Arkitekten trade journal; lectures at University of Gävle and elsewhere; exhibitions e.g. in Helsingborg and Lund
www.arkitektgruppen.se

Bildnachweis

Alle Fotos von Rainer Hofmann außer:

Dow, James/Dow Associates, Alberta: 15
Ensamble Studio, Madrid (Molina, Debora Mesa; Verzier,
Marina Otero; Nicanor, Cayetana): 18, 19
Reuter, Jan, München: 22
Sönnecken, Eibe, Frankfurt: 26
Unger, Christopher, Frankfurt: 27 li. u.
Domenicale, Daniele/MCA, Bologna: 56
Calan, Jean de, Paris: 57
Franken, Bernhard, Frankfurt: 60
Schittich, Christian, München: 70
Shinkenshiku-Sha, Tokio: 71

Illustrationen:

Reuter, Jan, München: 23
Unger, Christopher, Frankfurt: 27 o., 27 mi., 27 re.
Wallhagen, Marita, Stockholm: 37
Franken, Bernhard, Frankfurt: 60 mi., 61
Malter, Ralf, Berlin: 65 u.
Kuma, Kengo, Tokio: 70
Gruber, Heiko, Rüdesheim: 91
Jaenecke, Jan, Dresden: 95
Bürk, Nicola, Berlin: 99
Schwarz, Wolfgang, Stuttgart: 105
Fröhlich, Martin, Berlin: 120, 121
Porcella, Melanie, Berlin: 135

Illustration credits

All photos by Rainer Hofmann except:

Dow, James/Dow Associates, Alberta: 15
Ensamble Studio, Madrid (Molina, Debora Mesa; Verzier,
Marina Otero; Nicanor, Cayetana): 18, 19
Reuter, Jan, Munich: 22
Sönnecken, Eibe, Frankfurt: 26
Unger, Christopher, Frankfurt: 27 bottom left
Domenicale, Daniele/MCA, Bologna: 56
Calan, Jean de, Paris: 57
Franken, Bernhard, Frankfurt: 60
Schittich, Christian, Munich: 70
Shinkenshiku-Sha, Tokyo: 71

Illustrations:

Reuter, Jan, Munich: 23
Unger, Christopher, Frankfurt: 27 top, 27 middle, 27 right
Wallhagen, Marita, Stockholm: 37
Franken, Bernhard, Frankfurt: 60 middle, 61
Malter, Ralf, Berlin: 65 bottom
Kuma, Kengo, Tokyo: 70
Gruber, Heiko, Rüdesheim: 91
Jaenecke, Jan, Dresden: 95
Bürk, Nicola, Berlin: 99
Schwarz, Wolfgang, Stuttgart: 105
Fröhlich, Martin, Berlin: 120, 121
Porcella, Melanie, Berlin: 135

Impressum

Produktion: food und text, München, in Zusammenarbeit mit der Redaktion DETAIL
Koordination Kochveranstaltungen in Kooperation mit der Siemens-Electrogeräte GmbH:
Hanna Pitzl
Redaktion: Birgit Dauenhauer, Astrid Donnert, Alexander Felix, Andrea Wiegelmann
Lektorat und Texte Kochveranstaltungen: Gabriela Beck, München
Layout: Gesine Juliusson, Hamburg
Fotografie: Rainer Hofmann, München (Ausnahmen siehe Bildnachweis)
Fotoassistenz: Simone Kreisbeck
Styling: Jan Reuter, München
Rezeptbearbeitung und Foodstyling: Hans Gerlach, Alexander Kühn und
Silvio Knezevic, München
Übersetzung: Pamela Seidel und Marieke Söffker, Hannover

© 2007 Institut für internationale Architektur-
Dokumentation GmbH & Co. KG, München
Ein Buch der Redaktion DETAIL

ISBN 978-3-920034-19-5

Gedruckt auf säurefreiem Papier, hergestellt aus chlorfrei gebleichtem Zellstoff.

Alle Rechte vorbehalten, einschließlich das des auszugsweisen Abdrucks, der Übersetzung,
der fotomechanischen Wiedergabe und der Mikrokopie. Die Übernahme des Inhalts und
der Darstellung, ganz oder teilweise, in Datenbanken und Expertensystemen ist untersagt.

Reproduktion: Martin Härtl OHG, München
Druck und Bindung: Aumüller Druck GmbH & Co. KG, Regensburg
1. Auflage 2007

Institut für internationale Architektur-
Dokumentation GmbH & Co. KG
Sonnenstraße 17, 80331 München
Telefon: +49/89/38 16 20-0
Telefax: +49/89/39 86 70
www.detail.de

In Zusammenarbeit mit der
Siemens-Electrogeräte GmbH

SIEMENS

Imprint

Production: food und text, Munich, in cooperation with DETAIL editorial office
Coordination cooking events in cooperation with Siemens-Electrogeräte GmbH
(electric appliances): Hanna Pitzl
Editorial: Birgit Dauenhauer, Astrid Donnert, Alexander Felix, Andrea Wiegelmann
Proofreader and text cooking events: Gabriela Beck, Munich
Layout: Gesine Juliusson, Hamburg
Photography: Rainer Hofmann, Munich (exceptions, see illustration credits)
Photo assistant: Simone Kreisbeck
Styling: Jan Reuter, Munich
Recipe editing and food styling: Hans Gerlach, Alexander Kühn and
Silvio Knezevic Munich
Translation: Pamela Seidel and Marieke Söffker, Hannover

© 2007 Institut für internationale Architektur-
Dokumentation GmbH & Co. KG, Munich
A DETAIL book

ISBN 978-3-920034-19-5

Printed on acid-free paper, produced from chlorine-free bleached paper pulp.

All rights reserved, including reproducing in parts, translating, photomechanical reproduc-
tion and microcopying. Transferring the content and the depiction, whether wholly or par-
tially, to databanks and expert systems is prohibited.

Reproduction: Martin Härtl OHG, Munich
Printed and bound: by Aumüller Druck GmbH & Co. KG, Regensburg
First printed 2007

Institut für internationale Architektur-
Dokumentation GmbH & Co. KG
Sonnenstraße 17, 80331 Munich, Germany
Telephone: +49/89/38 16 20-0
Fax: +49/89/39 86 70
www.detail.de

In cooperation with
Siemens-Electrogeräte GmbH

SIEMENS